WORKING WITH IMAGES

THE THEORETICAL BASE
OF ARCHETYPAL PSYCHOLOGY

EDITED BY
Benjamin Sells

Spring Publications
Woodstock, Connecticut

Classics in Archetypal Psychology 4

© 2000 by Spring Publications, Inc. All rights reserved.

Published by Spring Publications, Inc.;
299 East Quassett Road;
Woodstock, Connecticut 06281

Printed in Canada on acid-free paper.

Book designed by C. L. Sebrell and JFL.
Cover designed by Christopher Ludwig.

A NOTE ABOUT THE COVER: The image, from the cover of *Spring 1970*, is of a bearded Hermes in his role as a god of death. It is said to have been painted at the same time the Parthenon was built (440-430 B.C.E.) and is attributed to the painter of the Boston Phial.

Library of Congress Cataloging-in-Publication Data
Working with images : the theoretical base of archetypal psychology / edited by
Benjamin Sells
p. cm
Includes bibliographical references.
ISBN 0-88214-376-X
1. Jungian psychology. 2. Psychoanalysis. 3. Jung, C. G. (Carl Gustav), 1875-1961. I.
Sells, Benjamin.

BF173 . W7 2000
150.19'54--dc21
00-036549

TABLE OF CONTENTS

INTRODUCTION

BENJAMIN SELLS

The question for archetypal psychology is this. How can it articulate a psychology in a manner that is itself psychological? How can it craft psychological theories that are psychologically attuned and appropriate? How can it maintain "psyche" as its guide and "psychological" as an adjective having actual significance? And how can it sustain consistently psychological attitudes?

Okay, that's four questions. But such is the nature of theoretical inquiry. Paracelsus, the Renaissance doctor and philosopher, saw long ago that "every theory is also a kind of speculative practice,"[1] and so our theories must necessarily proliferate to meet the many varieties of experience. Paracelsus was equally clear that both theory and practice must arise from experience, and that no matter how all-covering the crowns of theory might become, they must always remain rooted in the ground that gives them rise. Archetypal psychology follows this view, blurring the line between theory and practice by recognizing that theory is practice and that what we practice is theory.

For archetypal psychology the generative ground for both theory and practice is "psyche" or soul. It is psyche that makes psychology possible, and if psychology loses this connection with psyche it ceases to exist as a proper discipline unto itself. Once psychology loses its basis in soul, its remaining duties can be reassigned to others; physical matters can be better left to medical doctors and other scientists,

[1] Paracelsus, *Selected Writings*, trans. N. Guterman, ed. J. Jacobi (Princeton: Princeton UP, 1988), 51.

spiritual concerns to theologians and philosophers. Without soul, psychology is at best redundant of these other theoretical practices.

This simply-stated goal—to have a psychology based in soul—has become almost impossible to achieve. As moderns we readily acknowledge the hard world of material things. And we also acknowledge that there are things, at least in our minds, that transcend these worldly things—ideas, memories, concepts, fictions, beliefs, etc. But that about does it by way of alternatives. According to the dualistic view, anything not physically in the world must be only in the mind. Thus the matter/spirit dualism lumps everything into one of two camps, while within these camps things are assumed to be of a piece. Mystical experience might differ in degree from my occasional religious thoughts, but not in kind. Matter, too, though we might value it according to various properties, is still, in the end, simply stuff you can't take with you.

Modern culture is dominated by this dualism, and this is so whether we ever formulate it in our minds, or even if we do formulate it and decide to reject it. There is no escaping tyranny while there is still tyranny, and the matter/spirit dualism tyrannizes the modern age, habitually persisting in all of our perceptions and ideas (there's the dualism right there), big and small. And lest we think we can overcome this dualism by declaring that matter and spirit are "One," we must recognize that this is precisely how dualism already presents itself—as one, all-encompassing view. The matter/spirit dualism, like all dualisms, is already a monism and must be seen as expressing a deeper, sustaining single-mindedness.

But here is the curious thing. The dualistic view of things is a view of things. That is, the perspective that sees in dualistic terms of matter and spirit cannot properly be said to fall within either camp, else it could not provide the overall perspective. The perspective that makes dualism possible is already present by the time it posits dualism. Similarly, "Oneness" is itself is a limited view that can account for everything except its own perspective.

Scientists, philosophers, and theologians have long recognized that neither spirit nor matter can account for themselves or their methods in purely spiritual or material terms. Nor especially can they account for the very fact of their accounting. Rather all such accounts fold back on themselves, resting finally on the very realities being

accounted for. All theories beg basic questions, which does not negate our theories but should alert us to their essential mystery. Theories are akin to prayer, as the alchemists properly saw. They are attempts to articulate the ineffable.

More importantly though, at least in a book about psychological theory, is that the very existence of theorizing implicates something else already going on. Perhaps we begin our theorizing with a resolution to be thoroughly skeptical. Is this move not already theoretical? Perhaps we begin with a desire for transcendence, or unified theory, or encompassing system—do not these beginning steps already indicate direction and intent? Or perhaps we declare just to be open and receptive. Again the theoretical question is "Why so?" Here is a great mystery—that whatever we do, no matter how rigorous or objective we proclaim our methods, is always presupposed by something prior, more basic, than our theorizing. "Method" itself comes from *meta-hodos*, which means "an existing road." Our methods, no matter how extensively rationalized, can never account for the fact that we find ourselves already on the road, already underway. The very existence of any method or theory whatsoever therefore seems to bespeak a necessary third (at the very least).

Archetypal psychology declares this missing third to be the realm of psyche, and the exploration of this third realm to be psychology's charge. *Psyche-logos*, we call it, the telling of the soul. Unfortunately the matter/spirit dualism excludes the very possibility of "psyche" or soul. This is a critical point because, although archetypal psychology never refuses reality to matter and spirit, dualism refuses to similarly honor psyche, which is defined out at the beginning. This loss of psyche naturally results in a culture spun off into material and spiritual excesses, while psychology, now homeless, is forced to find shelter wherever it can, squeezing into clothes from somebody else's closet. Archetypal psychology insists that to exclude soul in this manner is to exclude something primary, original, basic, and necessary. Without the soul's perspective we are destined to mistake entire worlds for one another. The stakes, therefore, could not be higher.

Archetypal psychology responds to this situation by reestablishing a psychology based in psyche. Archetypal psychology not only acknowledges the existence of the mysterious third, it proclaims psyche a reality on par with matter and spirit, where "reality" itself must be

taken psychologically when applied to soul instead of limited only to the concrete and literal (the material view) or the ontological and transcendent (the spiritual view). Archetypal psychology theorizes, on the basis of psychological experience, that soul provides the many perspectives that enliven our minds, thereby positing "psyche" as the animating mystery at the heart of all psychological life, the third that gives rise to all experience of whatever kind.

Because "psyche," like "matter" and "spirit," points to mysteries always beyond mortal comprehension, it cannot be clearly defined. From psyche's perspective, the demand for definition itself emanates from the spirit's abstracting and categorizing habits. Archetypal psychology resists such presumptive moves from other quarters, arguing that psychology's theories and claims must be thoroughly psychological and that psychological judgments about them must likewise issue from a basis in soul. To toss aside psyche because it is not amenable to material or spiritual definitions is merely to aid and abet the very tyranny that leaves modern culture hopelessly in search of soul.

Given its basis in soul, archetypal psychology offers an entirely different approach to things than do material and spiritual approaches. It gladly leaves literal debates to the scientists, metaphysical debates to the philosophers, and religious debates to the theologians, reclaiming for itself the middle ground of psychological life and experience. This middle ground becomes both the sustaining mystery to which psychology is dedicated and the final arbiter of any methods used to explore this mystery. Archetypal psychology is very clear that material and spiritual theories and criteria cannot simply be imported into psychological discourse. Neither syllogism nor spiritual enlightenment may dictate to soul about its own concerns. Rather, it is soul that dictates psychological theory and practice.

If archetypal psychology has no theoretical recourse to anything other than psyche, then it must find theories that always lead back to soul. The focal points of this theoretical practice are "images," which archetypal psychology takes to be the particular manifestations of soul that are given with psychological life. Although we cannot know what psyche "is" in any final way, we can investigate its precisely presented images in terms of their psychological significance (i.e. their basis in soul). For archetypal psychology, psyche is present only

in and through images, which means that the appropriate modality for psychological investigation must therefore be imaginative.

This coupling of psyche and image is fundamental to the long tradition to which archetypal psychology is heir.[2] Archetypal psychology's most direct ancestor, C. G. Jung, said that "every psychic process is an image and imagining,"[3] where "image" is not taken as a picture, symbol, memory, or perceptual after-image but instead is derived "from poetic usage, namely, a figure of fancy or fantasy image."[4] James Hillman, archetypal psychology's founder and leading voice, has summarized the idea that psychological life is thoroughly imaginative by suggesting a "poetic basis of mind."[5] According to this view, every act, every thought, every gesture, every dream, every impulse of whatever kind, if experienced at all is mediated and presented through the soul's images and imagining capabilities.

The equation of psyche and image ("Psyche is image," said Jung[6]) dictates that archetypal psychology must be thoroughly imaginative. Another archetypal theorist, Raphael Lopez-Pedraza, summed this up in his classic motto: "We must stick to the image!" Thus archetypal psychology must rely on methodologies that attempt to appreciate and respond to an image in terms presented by the image itself. Thus if a woman in a flowered dress appears in a dream, it is this woman who is of interest. For archetypal psychology, this woman is not representational but presentational. She appears and does not refer to your mother, the Great Mother, your repressed anima, your flowering femininity, or any other interpretation that would translate the woman's given image into other terms. Rather she is who she is and must be engaged on her own terms. Archetypal psychology therefore proceeds through a kind of imaginative phenomenology of the image, where the image is not only what is experienced but how it is experienced. For archetypal psychology there is nowhere else to go than into the precisely qualified imaginative world given by the image.

 [2] For commentary on this tradition, see: Gilbert Durand's "Exploration of the Imaginal," herein. Also three by James Hillman: *Archetypal Psychology: A Brief Account*, (Woodstock: Spring Publications, 1997), 1-5; "Plotino, Ficino, and Vico as Precursors of Archetypal Psychology," *Loose Ends* (Zürich: Spring Publications, 1975), 146-69; and *Re-Visioning Psychology* (New York: Harper & Row, 1975), *passim*.
 [3] C. G. Jung, *CW 11*, trans. R. F. C. Hull (Princeton: Princeton UP, 1953), § 889.
 [4] *Ibid.*, *CW 6*, § 743.
 [5] *Re-Visioning Psychology*, xi; *Archetypal Psychology*, 2-10.
 [6] *CW 13*, § 75.

By "archetypal," archetypal psychology further indicates that although an image is only an image, all images also carry archetypal value. Hillman points out the many benefits of "archetypal," a term owing to Jung, in his postscript to *Spring 1970*, but more than anything else it denotes a style of approaching images that opens both us and them to their richest and deepest resonance. Thus "archetypal" does not denote preexistent patterns or structures (a spiritual view more strictly in keeping with Jung's usage), but rather connotes a style or genre of imagination that values images as "universal, trans-historical, basically profound, generative, highly intentional, and necessary."[7] Recognizing and respecting the impersonal and autonomous nature of the image is basic to archetypal psychology and points to a numinous value assumed inherent in every image as a direct expression of soul.

This numinous value was observed by archaic peoples through rituals and articulated through mythical tellings. As heir to these traditions, archetypal psychology therefore relies upon their imaginative, aesthetic, and polytheistic styles as modalities for psychological work. The world, said the old Greeks, is full of gods, and so archetypal psychology attempts a psychological polytheism that envisions a world immanent with soul and finds there the faces of the many gods. To be clear, this is not an attempt to resurrect any kind of religious belief, which would again pull us into spiritual domains, but rather to sustain a religious sensibility that is required by the facts of psychological experience.

The ramifications of the various moves I have sketched out here are difficult to overstate, and nowhere are they more strongly implicated than within the world of psychology itself. It makes sense, after all, that loss of soul would appear nowhere more clearly than in the soul's namesake discipline, which for a long time now has attempted to proceed without soul. It is ironic, sad really, that archetypal psychology has had to devote so much time and effort to reclaiming the soul's rightful territory from the misshapen claims of psychology itself. For too long psychology has either refused to speak of soul at all or has subsumed it under various theories and programs derived from and directed toward spiritual and material goals. And so psychology has been mistaken as either a spiritual path of self-actualization

[7] *Archetypal Psychology*, 13.

or as an ultimately base exercise of reducing psychology to physiology. It is incredible, though understandable given the tenor of the age, how little modern psychology, from the wards to the universities to the self-help shelves in the bookstore, attempts to address soul on and in its own terms.

Archetypal psychology mounts a radical attack on all bastions that imprison the soul. By declaring soul as the intermediary mystery that makes all experience of any kind possible, archetypal psychology releases psyche from the twin cuffs of laboratory and high church to once again breathe freely in the many things of the world. Archetypal psychology declares that soul is contemporaneous with culture, and, as "archetypal" implies, is eternally so. Soul is both here in this particular image and always here as that which imagines in the fashion of the image.

For archetypal psychology, psychology itself is a cultural manifestation of soul, a view that proves too much for the analyses of orthodox psychology which in the name of soul would reduce culture and psyche to human subjectivity. From this orthodox perspective, culture is seen as a projection of human psychodynamics subject to analysis by those expert in such psychodynamics. Missing from this view, of course, is a psychological appreciation of this closed shop mentality, complete with the usual hierarchies, as itself a culturally ensouled artifact. How tragic that of all disciplines it has been psychology that has been most blind to its own psychology. By contrast, archetypal psychology restores the old view of *anima mundi,* the soul in the world, where all things, including psychology, are seen as cultural manifestations of soul and are therefore open to archetypal analysis. Little wonder that orthodox psychology, given its self-ascribed place above the fray, has tended to project its own inflations upon archetypal psychology. But a supplicant is not inflated by the proximity of gods. Inflation lies with those who would proclaim themselves divine.

Thus we return to where we began. The problem for archetypal psychology is how to craft a psychology from and for soul. Education and training are of enormous importance in this work but are not enough. The main thing is to sustain consistently psychological attitudes. The psychologist's job, then, is simply to make whatever is there more psychological, more soulful, more attendant to the mystery inherent in "psyche" itself. To this end, archetypal psychology works

to foster a *psyche-logos* worthy of the name, a psychology of imagination that senses soul in all things, thereby returning soul to culture and beauty to life.

<div align="center">* * *</div>

W hat I have just said is said much more completely and beauti-
fully in the essays you are about to read. All of the essays collected here, except James Hillman's "Peaks and Vales," first appeared in *Spring: A Journal of Archetype and Culture*, the world's oldest Jungian journal and, since 1970, the leading journal in archetypal psychology. They are among the finest theoretical essays that archetypal psychology has produced and are offered as a limited selection among archetypal psychology's considerable bounty. They are intended, frankly, to whet your appetite for more. It is my wish that this slim volume will encourage you to travel along for awhile with archetypal psychology as it explores soul's many roads. May you go forward with senses alert for where you already are, a willingness to follow where soul leads, and a heart mindful that, as Heraclitus said long ago: "You could not discover the limits of the psyche, even if you traveled every road to do so; such is the depth of its meaning."[8]

[8] Philip Wheelwright, *Heraclitus* (Princeton: Princeton UP, 1959), 58.

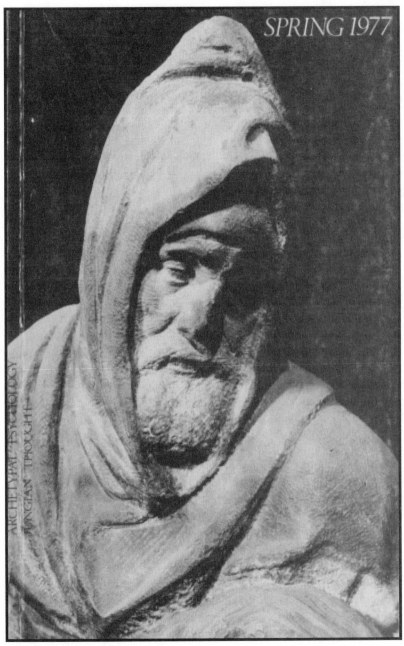

SPRING 1977

ARCHETYPAL PSYCHOLOGY
JUNGIAN THOUGHT

Cover of *Spring 1977*. The image is of Michelangelo—his carved self portrait as Nicodemus—detail from La Pietà in the Duomo (Florence).

Editor's Note

In this short postscript to *Spring 1970*, James Hillman steers psychological thought away from its well-traveled roads. In a patient and impassioned search for the right word to call these new directions, Hillman places us in the midst of the very approach archetypal psychology seeks to articulate. Not "Jungian," says Hillman, which embroils us in subjective attachments to a man-now-legend, nor "analytical," which unjustifiably posits the psyche as problematic, nor even "complex," with its scientistic pretensions and pathological connotations, will do. All three terms unduly limit the psyche's natural diversity and profundity, and none seem capable of placing themselves within the broader context of culture. Worse, they bring our ideas about soul under the control of preexisting theories and the assorted experts that these theories necessitate. "If the unconscious calls for analysis," says Hillman, "analytical psychology necessitates an unconscious."

Hillman instead offers "archetypal," which has the advantage of paying homage to Jung and his "characteristic approach" while also extending psychology beyond personal history to realms "which cannot legitimately be considered altogether human." By reconnecting psychology to myth (another gift from Jung), archetypal psychology "gives the psyche a chance to move out of the consulting room. It gives an archetypal perspective to the consulting room itself." Here is Hillman's new direction—a "polytheistic psychology" that imagines the world in terms of many impersonal dominants acting in and through our everyday experiences, including our ideas about those experiences. "By reflecting this plurality and freedom of styles with the structures of myth," says Hillman, "the archetypal perspective to experience may be furthered."

In a word, "archetypal" reminds us that we are always already somewhere in the company of invisibles. Our questions then naturally switch from what, why, or how (the search for meaning) to who. Who, among the pantheon of impersonal dominants that archaic peoples called "gods," is present in our talk about analysis, and indeed makes possible such talk? Who would posit the soul a problem and have plenty of ideas how to fix it? And who would limit the soul's education to a mind-numbing fixation on persons and cases? Such questions open psychology, and life, to "many varieties of consciousness, styles of existence, and ways of soul-making." Archetypal psychology thus seeks soul in the natural diversity of the world through "a profound appreciation of history and biography, of the arts, of ideas and culture." The goal is to further soul-making "by finding the cultural in the psyche and thereby giving culture to the soul."

WHY "ARCHETYPAL" PSYCHOLOGY?

An Editorial Postscript to Spring 1970

JAMES HILLMAN

(*Spring 1970*; Post-Postscript in *Loose Ends*, 1975)

Jungian, analytical, and complex are the three generally used terms for the psychology represented in this publication during the past thirty years. The subtitle of *Spring 1970* introduces a fourth, *archetypal*. Quite likely there are contrasts in these terms that are more than accents, and it seems worthwhile to characterize some of these differences.

The eponym Jungian is more than a common adjective; it evokes the emotional attachment to a man, to a history, to a body of thought and, especially, experience. Some who speak of themselves as "Jungians" had personal experience with Jung; nearly all have had experience of Jungian analysis. Because "Jung" continues to play a numinous role in the ideas, dreams, and fantasies of Jungians, the term musters psychic energy as an intimate symbol, stirring vital beliefs and feelings of loyalty. The name touches upon what Grinnell elsewhere in this volume [*Spring 1970*] discusses as "psychological faith" and "personality."

Since the appearance of "Jung" is unique to each person, so is this designation intensely subjective. What makes a Jungian? Is "being a Jungian" truly a kind of being, that is, a way of existing in accordance with certain beliefs (even if unformulated) and practices (even

if uncodified)? Or, have we become Jungians through association in a community of interests, through professional qualifications, or through tracing psychological lineage back to Jung by means of an analytical family tree? This last question raises further ones, since many feel themselves sympathetic to "the Jungian thing" and take part in it, and yet they have never been analyzed. Moreover, strictly speaking, "Jungian" derives from a family name and belongs to an actual family rather than to a following.

By meaning many things to many people, Jungian, like any symbol, provides an emotional atmosphere. But just because of the emotions which the word conjures, Jungian also constellates kinship libido with attendant passions of family feeling, sometimes called transference, sometimes called sibling rivalry, trailing eros and eris along. This shows in the exogamous hostility between the Jungian community and its ideas and "non-Jungians," and it shows within the Jungian community itself. Whitmont and Guggenbühl above [*Spring 1970*] have each reflected upon aggression and destruction in relatively closed situations. The aggression and destruction released by Jungians against Jungians in the name of Jungian psychology may not be resolved merely through shifting terms, but it might be ameliorated by reflecting upon this familic designation and what it can imply. These thorny issues have led us to use Jungiana to refer to the actual person of C. G. Jung, and "Jungian Thought" in tribute to a tradition that is difficult to describe otherwise.

<p style="text-align:center">* * *</p>

The difference between complex and analytical was made clear in 1935 by T. Wolff:[1]

> Recently Jung uses the term "complex psychology" mostly when he speaks of the whole area of his psychology particularly from the theoretical point of view. On the other hand, the description "analytical psychology" is appropriate when one is talking about the practice of psychological analysis.

[1] T. Wolff, "Einführung in die Grundlagen der Komplexen Psychologie," in *Die kulturelle Bedeutung der Komplexen Psychologie* (Berlin: Hrsg. Psychologischer Club Zürich), 1935, 7, translation mine.

As the name indicates, complex psychology builds upon the complex for its theory. This basis is empirical because it takes up the complex mainly through the association experiment, where measurements play the major role. Perhaps, because of this empirical origin, complex psychology inclines towards models from the natural sciences and their fantasies of objectivity. The association experiment is that part of Jung's work which can best be measured and demonstrated publicly. It is independent of therapy, an objective method that can be used with anybody. Upon it a theory of the psyche can be presented that attempts general validity and does not need the witnessing material of analytical cases. Individuals and their psychic material provide data for collections with which to advance psychology in general, rather than the psyche of a specific analytical case. However, when theory follows scientific models, there are corresponding methods: statistics, questionnaires, measurements, and machines for the study of dreams, types, psycho-somatics and -pharmaceutics, and synchronicity. The patient now may become an empirical subject and the clinic a laboratory-setting in the interests of objective research into the general laws of complex behaviour. A hope of complex psychology is to establish Jung's hypotheses, objectively and among a wider audience of the scientific and academic world beyond the one limited to Jungians or by analysis.

One could still use the description "complex" psychology, conceiving theory, not on the models of science, but in regard to the archetypal core of the complexes. Then we would be engaged more with symbolic thinking, and then psychological theory might better reflect both Jung's concerns with the metaphysical and imaginal, and the soul. Nevertheless, the designation has one great disadvantage: it evokes Jung's first idea of the complex as a disturbance of consciousness. Despite all that he wrote afterwards concerning its value in all psychic life, the word retains pathological connotations—power-complex, Oedipus-complex, mother-complex.

* * *

In 1896 Freud[2] first joined the word analysis to psyche in his new term "psychoanalytic" for describing a new method of therapy. Jung commented upon the naming of the new psychology in 1912:

[2] S. Freud, "Heredity and the Aetiology of the Neurosis," *CPI* (London, 1953),148.

One could describe the psychology invented by him
[Freud] as "analytical psychology." Bleuler suggested the
name "depth psychology," in order to indicate that Freud-
ian psychology was concerned with the deeper regions or
hinterland of the psyche, also called the unconscious.
Freud himself was content just to name his method of
investigation: he called it psychoanalysis.[3]

In 1929 Jung wrote:

...I prefer to call my own approach "analytical psychol-
ogy" by which I mean something like a general concept
embracing both psychoanalysis and individual psychol-
ogy [Alfred Adler] as well as other endeavors in the field
of complex psychology."[4]

In the following paragraphs Jung says that "analytical" is the word he
uses for all the different psychological attempts "to solve the problem of
the psyche." Clearly, analytical refers to the practice of therapy as
problem-solving, to analysis as the work of making-conscious. When
"analytical" defines our field, we are mainly occupied with what used
to be called "the practical intellect." Several consequences flow from
this.

With the practical in the foreground, analytical psychology is natu-
rally interested in therapy and in the many questions of profession. It
will also be searching for improved methods for problem-solving.
New directions are mainly practical: therapeutic techniques, groups,
clinics, provide fantasies for new ways "to solve the problem of the
psyche." There is also an obsessive focus upon analysis itself, espe-
cially the transference. Then, too, analytical psychology has interests
naturally aligned with pastoral psychology and the "cure of souls,"
another path of problem-solving.

Unlike Freud's earliest use of the term, analysis today is more
than a method. We are as well a profession, a mentality which analyzes
(people, their "material," their "relationships"), and we have a big
stake in a system: analysts, analysands, and an unconscious to be made
conscious. Indeed, we can hardly get along without the unconscious.
What is by definition a hypothesis has reified into a hypostasis filled
with "real," "hard" and "tough" problems to be analyzed. If the

[3] C. G. Jung, "New Paths in Psychology," *CW 7*, 2nd ed., § 10.
[4] C. G. Jung, *CW 16*, 2nd ed., § 115.

unconscious calls for analysis, analytical psychology necessitates an unconscious.

In analytical psychology, the analyst is the psychologist and our psychology consists mainly in insights gained through analysis. This tends to limit our horizon. The idea of amplification may show what I mean. Even when analytical psychology extends into wide areas, such study is for the context of therapy. We feel that amplification must be brought down to actual cases, else it becomes speculative fantasy. For analysts, the problem of the psyche is "located" in the soul of the individual and his situation as a case.

* * *

Jungian, analytical, and complex were never happy choices nor were they adequate to the psychology they tried to designate. It seems right to turn to a word that does reflect the characteristic approach of Jung, both to theory and to what actually goes on in practice, and to life in general. To call this psychology today archetypal follows from its historical development. The earlier terms have, in a sense, been superseded by the concept of the archetype, which Jung had not yet worked out when he named his psychology. The archetype is the most ontologically fundamental of all Jung's psychological concepts, with the advantage of precision and yet by definition partly indefinable and open. Psychic life rests upon these organs; even the self is conceptually subsumed among the archetypes; and they are the operative agents in Jung's idea of therapy. This designation reflects the deepened theory of Jung's later work which attempts to solve psychological problems at a step beyond scientific models and therapy in the usual sense, because the soul's problems are no longer problems in the usual sense. Instead, one looks for the archetypal fantasies within the "models," the "objectivity" and the "problems." Already in 1912 Jung placed analysis within an archetypal frame, thereby freeing the archetypal from confinement to the analytical. Analysis may be an instrument for realizing the archetypes but it cannot embrace them. Placing archetypal prior to analytical gives the psyche a chance to move out of the consulting room. It gives an archetypal perspective to the consulting room itself. After all, analysis too is an enactment of an archetypal fantasy.

According to Jung[5] myth best represents the archetypes. But myth proceeds from a realm which cannot legitimately be considered altogether human. Like the mythical, the archetypal too transcends the human psyche, which implies the psyche's organs do not altogether belong to it. A true depth psychology is obliged by the nature of the psyche to go below or beyond the psyche. This fortunately offers a way out of the impasse of psychologism, which has hindered the collaboration of some who too take their perspective from the archetypes but do not allow their location in the psyche. But we do not have to take the archetypes as only or altogether psychic structures: the psyche is only one place in which they manifest. By psychologizing I also mean the tendency to attribute too much to the human and the psychic, burdening our lives with an overweening sense of responsibility for matters that are not ours, but are archetypal, i.e., historical, mythical, psychoid—or instinctual in the sense of Robert Stein above [*Spring 1970*].

Insights for this approach call for an archetypal eye that is difficult to acquire through focus upon persons and cases. This eye needs training through profound appreciation of history and biography, of the arts, of ideas and culture. Here, amplification becomes a valid way of doing psychology, necessary and sufficient in itself. Amplification can be a method of soul-making, by finding the cultural in the psyche and thereby giving culture to the soul. A great deal can be done for the psyche and its healing, indirectly, through archetypal elucidation of its problems.

The mythical perspective may get us around another kind of psychologism: the humanization of the Gods which goes hand in hand with an awesome esteem for the personal psyche in its concrete existence—confrontations, reactions, immediacy. A psychology that is designated archetypal dare not be only a secular humanism; anyway, involvement is basic for all psychology, for all human existence, and hardly needs inflating by still more emphasis. The problems of the psyche were never solved in classical times nor by archaic peoples through personal relationships and "humanizing," but through the reverse: connecting them to impersonal dominants.

The dominants in the background permit and determine our personal case histories through their archetypal case histories which are myths, the tales of the Gods, their fantasies and dreams, their

[5] C. G. Jung, *CW 8*, § 325; *9i*, § 260.

sufferings and pathologies. The plurality of archetypal forms reflects the pagan level of things and what might be called a polytheistic psychology. It provides for many varieties of consciousness, styles of existence, and ways of soul-making, thereby freeing individuation from stereotypes of an ego on the road to a Self. By reflecting this plurality and freedom of styles within the structures of myth, the archetypal perspective to experience may be furthered. In this spirit *Spring* hopes to proceed.

POST-POSTSCRIPT

Gerhard Adler (London) and Wolfgang Giegerich (Stuttgart) in written communications have each pointed out that my use of "complex psychology" is not the way that Jung or Toni Wolff originally meant. As the quote from Wolff shows, Jung used the term to refer to the whole area of depth psychology as a theoretical field of complex problems requiring complex methods. He called this field complex because it was complicated; his intention was the study of phenomena of complexity in distinction to simple, partial, elementary phenomena. Moreover, as Giegerich reminds me, referring to the same Toni Wolff article from which I quote above, the complexity of the psyche has to be met with a "complex method."[6]

Unfortunately, as so often happens in the history of thought, movements, and words, this original intention has turned into its direct opposite, and my sense of "complex psychology" derives from the way the designation is mainly used today. And today, it is just in those who most speak of Jung's work as "complex psychology" that we find the fractioning of complexities into simple events which can be handled by quantitative and mechanical methods: association experiments, typological tests, physiological dream research. This is not theoria but empirics, as C. A. Meier calls his work, *Die Empirie des Unbewussten*, the first volume of his projected *Lehrbuch der Komplexen Psychologie*, thereby expressly limiting Jung's multifaceted field requiring a variety of methods to one literalization, the method of natural science.

The designation can no longer be employed in Jung's (and Toni Wolff's) original sense, owing both to the implications of the word "complex" in English (which is not the equivalent of the German

[6] T. Wolff, *op. cit.*, 20*ff.*

komplexe, complicated), and to the subsequent historical events that now color "complex psychology" so that we see it in the light of the empiricism fantasy.

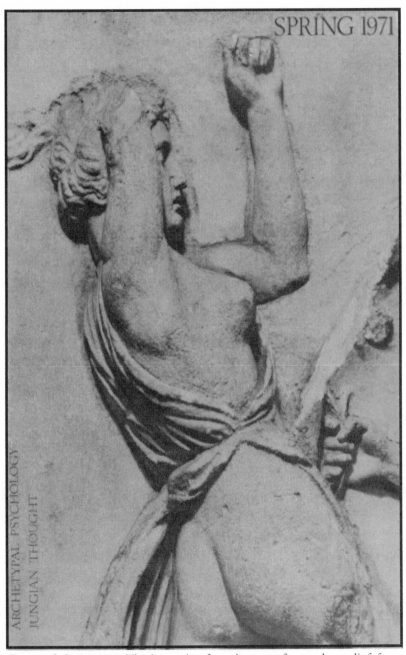

SPRING 1971

ARCHETYPAL PSYCHOLOGY
JUNGIAN THOUGHT

Cover of *Spring 1971*. The image is of an Amazon from a bas-relief from
the Mausoleum of Halicarnassus, in the British Museum, London.

Editor's Note

In the following essay, James Hillman articulates one of the most important issues presented by archetypal psychology—how do psychology at all? What styles and approaches are appropriate for a field nominally devoted to the inherent diversity of psychological experience? How can we be precise in what we say about the soul when it is full of ambiguity and mystery? In short, how do we honor *psyche-logos*, the telling of the soul?

Much of modern psychology has adopted styles taken from elsewhere, notably science and religion, and has repeatedly fallen into speaking from and in favor of Unity and the One. Think of the enormous attention that psychology pays to getting it all together and of finding ways to integrate the soul's many voices into a harmonious choir singing from the same page. For much of psychology's recent past, it has worked to overcome the messy and discordant reality of the soul either through eliminating perceived excesses, supplementing perceived deficiencies, or compensating through the principle of opposites so as to achieve balance, wholeness, and unity. Never mind that each of these moves assumes more than it can know. In no event is psychology allowed to take the soul at its word or to be instructed by it as it is.

The psychological perspective implicated by this integrating and ingratiating style is monotheism. Monotheism proclaims the Many to be under the control of the One, thereby answering an alleged antagonism that is itself already given by monotheism's perspective. As Hillman points out, the One and the Many is one of the ways monotheism imagines, one of the ways it presents itself, one of its habitual rhetorics. This stance in turn necessitates dualism and choice, and so embroils us in single-minded battles over belief, over which voice to elevate above others, and which god to declare the One True God. And monotheism confuses an already confused situation by carelessly mingling religion and psychology, repeatedly trying to translate psychological statements into theological proscriptions.

Hillman argues for a psychology free from the bindings of belief. Psychological life is not about belief, he says, but rather about imagination. So archetypal psychology speaks of gods not as objects of belief, but because they are "more adequate psychological backgrounds to the complexity of human nature." Such a view allows imagination to follow its own course, now falling within the purview of this god, now that one. "[E]ven the myths may change in a life," says Hillman, "and the soul serve in its time many Gods."

PSYCHOLOGY:
MONOTHEISTIC OR POLYTHEISTIC

JAMES HILLMAN
(*Spring 1971*; Postscript in David L. Miller's
The New Polytheism, 1981)

In the Conclusion to his late work, *Aion*, heavily occupied with Christian symbolism, Jung writes: "The anima/animus stage is correlated with polytheism, the self with monotheism."[1] Although he pays high respect to the "numina, anima and animus"[2] and conceives the self as a conjunction, he nevertheless also implies that as anima/animus is a pre-stage of self, so is polytheism a pre-stage of monotheism. Moreover, he there also states that the self is "the archetype which it is most important for modern man to understand."[3]

The preference for self and monotheism presented there strikes to the heart of a psychology which stresses the plurality of the archetypes. (What I have called "archetypal psychology" begins with Jung's notion of the complexes whose archetypal cores are the bases for all psychic life whatsoever.) A primacy of the self implies rather that the understanding of the complexes at the differentiated level once formulated as a polytheistic pantheon and represented, at its best, in the psyche of Greek antiquity and of the Renaissance, is of less significance for modern man than is the self of monotheism. Were

[1] C. G. Jung, *CW 9ii*, § 427.

[2] *Ibid.*, § 425.

[3] *Ibid.*, § 422.

this all, archetypal psychology would be nothing but an anima fantasy or an animus philosophy. Then, explorations of consciousness in terms of the Gods—Eros and Psyche, Saturn, Apollo, Dionysos—would be only preliminary to something more important: the self. Then, the self archetype would be paramount, and one should be investigating its phenomenology in the *quaternio*, the *coninuctio*, mandalas, synchronicity, and the *unus mundus*. The question "polytheism or monotheism" represents a basic ideational conflict in psychology today. Which fantasy governs our view of soul-making and the process of individuation—the many or the one?

The very sound of the question shows already to what extent we are ruled by a bias towards the one. Unity, integration, and individuation seem an advance over multiplicity and diversity. As the self seems a further integration than anima/animus, so seems monotheism superior to polytheism.

Placing the psychological part of this question to one side for the moment, let us first depose the ruling theological notion that in the history of religions or in the ethnology of peoples monotheism is a further, higher development out of polytheism. Paul Radin devoted a monograph to this subject.[4] He concluded: "...as most ethnologists and unbiased students would now admit, the possibility of interpreting monotheism as part of a general intellectual and ethical progress must be abandoned..." (24). He argues forcefully and cogently against the evolutionary view: that monotheism emerges from, or is later or higher than, polytheism or animism (29-30).

Radin bases monotheism not upon developmental stages but rather upon the idea of temperament. Some people everywhere are by temperament monotheistic; they have a monotheistic psychology. "All the monotheists, it is my claim, have sprung from the ranks of the eminently religious" (25). "Such people are admittedly few in number..." "It is the characteristic of such individuals, I contend, always to picture the world as a unified whole..." (25). These are the theological thinkers, a small elite in any culture, sharing a common temperament, and their influence upon their brethren in the same culture is stubborn and effective.

[4] P. Radin, *Monotheism Among Primitive Peoples* (Ethnographical Museum), Basel, Bollingen Foundation, Special Publ. 4, 1954.

The inexpugnable persistence of monotheistic religion could be psychologically accounted for by Jung's theory of the self. Then we might be tempted to conclude that monotheism is so strong because it is the theological equivalent of a more complete, integrated, and powerful (numinous) psychic condition. But already two objections crop up. First, Radin says monotheism "has obviously not been the triumph of the unifying principle over the disruptive" (29). I take this to mean that religious and social order and disorder, unity and disunity, cannot be correlated with monotheism and polytheism. Second, to base the strength of religious monotheism upon analogy with the psychologically more complete state of the self begs the same question which is nowhere established: the superiority of monotheism to polytheism. Persistence does not necessarily demonstrate the superiority of monotheism, nor even its victory. Gray[5] points out that two varying attitudes toward God can exist at one and the same time; the monolatry of Jahweh did exist among the Jews (even as late as the Exile period) side by side with the worship of other deities.

Despite the historical evidence of religions, there is a fond notion without adequate foundation that monotheism is the pinnacle and that "the evolution of religion thus manifests, it would seem, a definite tendency toward an integration of our mental and emotional life..." (Radin, 6). Jung may not be borne out by the historical facts of religion, but he is borne out by the psychological bias of the historians of religion who put monotheism on top in the name of integration.[6]

Two examples help to show this bias towards evolutionary monotheism. In his examination of the decline of Greek religion, Nilsson[7] finds the movement of religion from single, well-delineated Gods to

[5] C. B. Gray, *Hebrew Monotheism* (Oxford Society of Historical Theology, Abstract of Proceedings, 1922-23), cited by Radin, 22. On the polytheism that existed side by side with Greek monotheism, see M. P. Nilsson, "Monotheism," *Greek Piety* (New York: Norton Paperback, 1969), 116-17. Judeo-Christian monotheism in its conflict with Greek paganism, however, was intolerant of co-existence, cf. Nilsson, 124.

[6] Two historians of religion who attempt a re-valorization of polytheism are A. Brelich, "Der Polytheismus" *Numen*, VII, 1960, 121ff., and Jean Rudhardt, "Considerations sur le Polytheism," *Rev. de Theol et de Philos.* (3. ser. 16), 1966, 353-64 (his inaugural lecture at the University of Geneva).

[7] M. P. Nilsson, "The Dionysiac Mysteries of the Hellenistic and Roman Age," *Skr. utg. Svenska Inst. Athen*, 8, V, Lund, 1957. Cf. Greek Piety, *op. cit. sup.*, last chapter.

a multiplicity of powers and daimons, a degeneration. The magic, superstition, and occultism that prevailed in later periods was, according to Nilsson (of Protestant Sweden), a disintegration. A century earlier Schelling fantasied a vague *Urmonotheismus*, which developed later into a clearly formulated monotheism of the Old Testament as the highest product of religious consciousness. Between the first primitive monotheism and the later highly developed stage, there occurred Babel, which for Schelling represented the incursion of polytheism.[8]

The hypothesis of the superiority of the self and monotheism over anima/animus and polytheism finds companions among historians of religion. Consequently, Jung's hypothesis may be one more expression of the theological temperament. This temperament has been more narrowly described as introversion, for Jung writes: "The monistic tendency belongs to the introverted attitude, the pluralistic to the extroverted."[9] As in other areas of human activity, Jung sees the two tendencies in theology, where they are expressed as monotheism and polytheism, to be also "in constant warfare."[10] Neither of these two attitudinal tendencies is superior to the other and neither is an evolution of the other. They are givens and given as equals.

So, too, we must keep distinct the ideas of individual and of cultural development, the self stage of the individual and the monotheistic stage of religion. It is nowhere established (despite E. Neumann) that the stages of religious thought (if there are such things, and Radin doubts it) necessarily parallel stages of individual consciousness (if there are such things). Moreover, according to Radin, we should not think in developmental terms at all about the kinds of religion. Culture and religion do not move upwards from the many to the one, from disorder to order, from Babel to Jahweh: monotheism is not identical with superiority except from within its own *Anschauung*.

[8] There has been a long tradition of attempting to harness Plato to Western Judeo-Christian monotheism, for, how account for the superiority of his thought if he were a pagan polytheist? For strong denials of this Christian reading of Plato, see F. M. Cornford, "The 'polytheism' of Plato: An Apology," *Mind* (N.S.) XL, 1938, 321-30; Christopher Rowe, "One and Many in Greek Religion," *Eranos Jahrbuch* 45, 1976.

[9] *CW 6*, § 536 (my quote from first edition, 1923). From Jung's viewpoint, James' pluralism belongs to his extroverted bias.

[10] *CW 5*, § 149.

The idea of superior monotheism,[11] and progressive stages towards it, has been instrumental to the notion of a superior self, attained through the progressive stages of individuation. Now since monotheistic superiority is questionable, so the superiority of monotheistic models for the self should as well be questioned.

Perhaps linear thinking in stages is but another reflection of a monotheistic temperament, whose Judeo-Christian fantasies favour historical development and hierarchical improvement, whereas the anima/animus and its model of polytheism tend toward a multiple field of shifting foci and complicated relations. Perhaps we should be less certain about stages of development in religion and in the individual, and more questioning of the kind of consciousness that perceives in terms of stages.

Our argument has already turned psychological. We are no longer examining the religious evidence presented by Radin, but rather the psychological theory he proposes, that is, monotheism results from "an intellectual-religious expression of a very special type of temperament and emotion."

We have already suggested[12] which specific archetypal pattern tends to manifest in descriptions of the self. The self is personified as the Old Wise Man; its images are so often said to be ordering, e.g., geometric figures, crystals and stones, and abstractions beyond imagery; the behaviour associated with the self and the process which leads to it is usually presented in the language of introversion, generic to "children of Saturn." From the viewpoint of an archetypal psychology "the special type of temperament and emotion" that produces monotheism and favours the self above anima/animus and views their relation in stages would be the senex. This archetype might also help account for theological monotheism's obdurate persistence, religious intolerance, and conviction of superiority. It might also account for the peculiarity of the self concept, which works symbolically to unite the realms of religion and of psychology. This leads not only to theological confusions about psychologizing God—a problem with which Jung was ever bothered. It leads also to psychological confusions about

[11] Further well-chosen examples of the superiority fantasy of monotheism can be found in Alessandro Bausani, "Can Monotheism be Taught?" *Numen* X, 1963, 167-201.

[12] J. Hillman, "On Senex Consciousness," *Spring 1970*, 153.

theologizing the psyche, producing dogmas, propitiatory rites, priest-hoods and worship. Likewise, the emphasis upon the self of psychological monotheism may help explain the theological interests of contemporary Jungians (as well as the Jungian interest of contemporary ministers) and the peculiar blending of analytical psychology with Christianity which we shall discuss below as the "Protestant direction."

II

What then about polytheism and the anima/animus? Let us first suspend monotheism, both in our theological judgments and our psychological convictions about stages, about unity, and about linear and even spiral advancement. Let us also try to suspend the pervasive influence of our monotheistic desires for a utopia of integration (Kronos' Golden Age), and that fantasy of individuation which characterizes it mainly as movement towards unity, expressed in wholeness, centering, or in figures like the Old Wise Man or Woman. This fantasy of individuation subtly obscures the differences between the psychological and the theological. Thus the ground is prepared for a monotheistic elite (to use Radin's language) of "eminently religious individuals" "admittedly only few in number." (Have these become our "senior analysts" and "training supervisors," our masters of individuation supported by the mana of the monotheism of self?) By putting in suspension the senex domination of our attitudes, we might regard polytheism afresh, and psychologically.

Jung used a polycentric description for the objective psyche. The light of nature was multiple. Following the traditional descriptions of the anima mundi, Jung wrote of the lumen naturae as a multiplicity of partial consciousness, like stars or sparks or luminous fishes' eyes.[13] A polytheistic psychology corresponds with this description and provides its imagistic formulation in the major traditional language of our civilization, i.e., classical mythology. By providing a divine background of personages and powers for each complex, poly-theistic psychology would find place for each spark. It would aim less at gathering them into a unity and more at integrating each fragment according to its own principle, giving each God its due over that portion of consciousness, that symptom, complex, fantasy, which calls for an archetypal background. It would accept the multiplicity of voices, the Babel of the anima and animus, without insisting upon

[13] *CW* 8, § 388*ff.*

unifying them into one figure, and accept too the dissolution process into diversity as equal in value to the coagulation process into unity. The pagan Gods and Goddesses would be restored to their psychological domain.

We would consider Artemis, Persephone, Athene, Aphrodite, for instance, as more adequate psychological backgrounds to the complexity of human nature than the unified image of Maria, and the diversity expressed by Apollo, Hermes, Dionysos and Hercules, for instance, to correspond better with psychological actualities than any single idea of self, or single figure of Eros, or of Jesus and Jahweh. Not that Maria, Eros, Jesus, and Jahweh are false—far, far from it; only that they, like Zeus too, tend to present themselves in descriptions which dominate through unification,[14] thus losing the values shaped by each of the other Gods and Goddesses.

Focus upon the many and the different (rather than upon the one and the same) also provides a variety of ways of looking at one psychic condition. There are many avenues for discovering the virtues in a psychic phenomena. Depression, say, may be led into meaning on the model of Christ and his suffering and resurrection; it may through Saturn gain the depth of melancholy and inspiration, or through Apollo serve to release the blackbird of prophetic insight. From the perspective of Demeter depression may yield awareness of the Mother-Daughter mystery, or, through Dionysos, we may find depression a refuge from the excessive demands of the ruling will.

This emphasis upon many dominants would then favour the differentiation of the anima/animus. Quite possibly—and now this is my claim and contention—closer interest in a variety of divine hypostases and their processes displayed in myth will prove more psychological, even if less religious (in the monotheistic sense of religion). This interest will more likely produce more insights into emotions, images and relationships, even if it will be less encouraging for a theology of evolutional wholeness. It will more likely reflect accurately the illusions and entanglements of the soul, even if it satisfies less the popular vision of individuation from chaos to order, from multiplicity to unity, and where the health of wholeness has come to mean the one dominating the many.

[14] Hence the easy and frequent identification between Jupiter and Jahweh among both pagans and Jews, cf. Marcel Simon, "Jupiter-Yahve," *Numen*, XXIII, 1, 1976, 40-66.

Polytheistic psychology obliges consciousness to circulate among a field of powers. Each God has his due as each complex deserves its respect in its own right. In this circularity of *topoi* there seem no preferred positions, no sure statements about positive and negative, and therefore no need to rule out some configurations and *topoi* as "pathological;" pathology itself will require a polytheistic revisioning. When the idea of progress through hierarchical stages is suspended, there will be more tolerance for the non-growth, non-upward, and non-ordered components of the psyche. There is more room for variance when there is more place given to variety. We may then discover that many of the judgments which have previously been called psychological were rather theological. They were statements about dreams and fantasies and behaviour, and people too, coming from a monotheistic ideal of wholeness (the self), that devalues the primal multiplicity of souls.

Monotheism or polytheism, self or anima/animus pose still another either/or: theology or psychology. Traditionally psychology deals with the second order of things, i.e., the emanated world of flux, diversity, and the phenomenally imperfect. Its concern has traditionally been with the actualities of the soul, its modes of existence, its fantasies, emotions and experiences; whereas, theology considers the soul eschatologically, from the viewpoint of self. Wholeness defined by psychology means everything—all the phenomena as phenomena, things as they present themselves. Wholeness defined theologically means the one—things as they are in God. From this difference can arise two views of completion, a psychological wholeness where individuation shows itself as being what one is as one is in multiple relations, and a theological wholeness where individuation shows itself in degrees of approximation to an ideal or unity. The more I am occupied by the anima or animus the more will I be concerned with the welter of psychological phenomena. The more I am occupied by the self the more will I show concern for goal-states, peak-experiences, and universality.

From this superior vantage point, Babel and the proliferation of cults in the Hellenistic period always seem a degeneration. Likewise an "animus court" and its ambivalence, or the multiplicity of dream women, become but an inferior pre-stage of unity. (Remember how the Prophets warn against the promiscuity and harlotry of Israel.)

The many-faceted world of Olympus must fade before a single God (even if in three persons).

One might, however, consider the proliferation of cults as a *therapeia* (worship, service, and care) of the complexes in their many forms. Then one could understand the psychic fragmentation supposedly typical of our times as the return of the repressed, bringing a return of psychological polytheism. Fragmentation would then indicate many possibilities for individuation and might even be the result of individuation: each individual struggling with his *daimones*. If there is only one model of individuation can there be true individuality? The complexes that will not be integrated force recognition of their autonomous power. Their archetypal cores will not serve the single goal of monotheistic wholeness. Babel may be a religious decline from one point of view and it may be a psychological improvement, since through the many tongues a fuller discordant psychic reality is being reflected. So the current delight in superstitions, astrology, witchery, and oracles has a psychological significance even if they be considered inferior religion. Through these images and practices anima/animus aspects of the psyche begin to find traditional reflection and containment in an impersonal background. Without the Gods, who offer differentiated models for the peculiar psychic phenomena of anima and animus, we see them as projections. Then we try to take them back with introverted measures. But "The individual ego is much too small, its brain much too feeble, to incorporate all the projections withdrawn from the world. Ego and brain burst asunder in the effort; the psychiatrist calls it schizophrenia."[15] Without a consciously polytheistic psychology are we not more susceptible to an unconscious fragmentation called schizophrenia?

Monotheistic psychology counters what it must see as disintegration and breakdown with archetypal images of order (mandalas[15a]). Unity compensates plurality. Polytheistic psychology would meet this so-called disintegration in its own language, by means of archetypal likeness: *similis similibus curantur*. Each particular phenomenon in an experience of breakdown would be viewed less in terms of the construct "breakdown." Instead it would be led back (*epistrophe*) to its

[15] *CW 11*, § 145.

[15a] Not only the mandala figures presented by Jung and his school, but also, for instance, the Islamic ones in H. Corbin "Le Paradoxe du monotheisme" in *Eranos Jahrbuch* 45, 1976, 89, 97.

archetypal source—and the idea of breakdown itself would be articulated more precisely in terms of the hero, the puer, Hermes, Dionysos, Demeter, and their differing styles. There would be less need for compensation through opposites.

The contrast between anima/animus and self appears in *Aion* as a contrast between pagan Gods and the *imago Dei*. Here Jung recapitulates on a psychological level the conflicts formerly lived in religious controversies and religious wars. Of the anima/animus Jung writes:

> They are quite literally the father and mother of all the disastrous entanglements of fate and have long been recognized as such by the whole world. Together they form a divine pair, one of whom…is characterized by *pneuma* and *nous*, rather like Hermes with his ever-shifting hues, while the other…wears the features of Aphrodite, Helen (Serene), Persephone, and Hecate. Both of them are unconscious powers, "gods" in fact, as the ancient world quite rightly conceived them to be. To call them by this name is to give them that central position in the scale of values which has always been theirs whether consciously acknowledged or not…[16]

The self of psychological wholeness, briefly, more clearly reflects the God of monotheism and the senex archetype.

> Unity and totality stand at the highest point on the scale of objective values because their symbols can no longer be distinguished from the *imago Dei*. Hence all statements about the God-image apply also to the empirical symbols of totality. Experience shows that individual mandalas are symbols of *order*, and that they occur in patients principally during times of psychic disorientation or re-orientation. As magic circles they bind and subdue the lawless powers belonging to the world of darkness, and depict or create an order that transforms the chaos into a cosmos.[17]

Let me hasten to make clear that a polytheistic psychology is also religious.[17a] In following Jung we are regarding the anima and animus

[16] *CW 9ii*, § 41.
[17] *CW 9ii*, § 60.
[17a] See below, "Postscript 1981," and *Re-Visioning Psychology*, Chapter IV.

in their divine forms and are giving "them the central position in the scale of values which have always been theirs." Religion is defined not by the number of its Gods, but rather in terms of the observance or binding of events to divinity. Relating psychic events to many Gods and Goddesses and many powers and *daimones* should not be assumed to be a lessening of the glory of a single high God or on the other hand a broadening of the single high God into something bigger and better. We can get away altogether from "better and worse" once we leave theological thinking and its monotheistic bias which sets the question in that kind of language. Polytheistic psychology has room for the preferential enactment of any particular myth in a style of life. One may be Protestant, or Herculean, or Dionysian, or a melancholic child of Saturn, according to the archetypal core governing one's dominant complex, and thus one's fate. And even the myths may change in a life, and the soul serve in its time many Gods.

Here several distinctions must be made. First, we must discern between serving Gods and worshipping them, or idolatry. The Biblical battle is not against myths of pagan Gods. In fact, the archetypal perspective of the *Bible*, as Kaufmann authoritatively says, ignores completely the mythic pagan world, so that a consciousness in that monotheistic mode is obliged first of all to face its own mythological lacuna, its own "ignorance of the meaning of paganism"[18] when entering polytheistic precincts. Even the terms themselves—"pagan," "heathen," "polytheistic"—derive from this lacuna and expose it. What the Bible is most fervently against is not the myths of the pagan Gods; it does not even mention them. Anathema is the worship of images of "wood and stone."[19] Polytheistic psychology takes its fundamental structures, the Gods, mythically, in their own language, and not literally, idolatrously, as objects of belief, for who can believe

[18] Y. Kaufmann, *The Religion of Israel*, trans. M. Greenberg (Chicago: Chicago UP, 1960), 20. Further, on the place of polytheism within Biblical monotheism and its development toward exclusivity, see the essays by Othmar Keel, H. -P. Muller, and F. Stoltz in *Monotheismus im Alten Israel und seiner Umwelt*, ed. O. Keel (Fribourg: Katholisches Bibelwerk, Verlag Schweizer, 1980).

[19] "A large part of biblical literature is dedicated to the battle against idolatry, striving to expose its absurdity and discredit it in the eyes of its believers. When this material is examined it appears (a) that the Gods, whom the pagans believe to inhabit heaven and earth, are never said to be non-existent; (b) that nowhere is the belief in myths or their telling prohibited; (c) that no biblical writer utilizes mythological motifs in his polemic; (d) that the sole argument advanced against pagan religion is that it is a fetishistic worship of 'wood and stone.'" Kaufmann, *ibid.*, 13.

in the ancient Gods and Goddesses as real existents. It is neither the fact of their multiplicity nor the imaginal mythical mode of their presentation that constitutes the Biblical warning. No, it is the fixed concretism (wood and stone), the literal relation to myths and images and Gods, a proscription to which we too subscribe.

The second distinction would make even more precise the difference between monotheistic religion and monotheistic psychology—a distinction difficult to bear in mind owing to the monotheistic hold on our consciousness that keeps them so indistinguishable. But we may nonetheless try to keep literal belief and metaphoric attitude apart. We may have one without the other, as for instance in Judaism. It seems definitely monotheistic in religion, but not so in psychology. In Judaism, En-Sof, JHWH is not defined[20] and the Torah may have six hundred thousand faces, one for each Jew in Exile. The content of belief is left suspended, God is uncodified, and the psyche free to fantasy a multiplication of laws and distinctions. The volumes of Jewish commentaries exhibit the endless richness of these fantasies. Heresy is rare although differentiation is highly accentuated. Where the religion remains monotheistic, the psychological attitude within it displays all the variety of multiplicity. Schism is seldom (except for that major one, Christianity, which literalized God into history, body, Church, and doctrine).[20a]

[20] Judaism's definition of God by many names (or none at all), as infinite and beyond measurement, admits a multiplicity in the definition itself. There is evidence as well for an ambiguity of number in the Hebrew expression for God in the *Bible*, where God is rather like the corporate "we," an extended personality. This accounts for the oscillations between plural and singular forms in many Biblical (Hebrew) mentions of God, allowing the word to be read both as God and Gods. Aubrey R. Johnson, *The One and the Many in the Israelite Conception of God,* 2nd ed. (Cardiff: Univ. Wales, 1961), § 3.

[20a] Cf. Ernest Barker, *From Alexander to Constantine* (Oxford: Clarendon, 1956), 430-34. Celsus (fl. 180)—whose work *Alethes Logos* (*True Reason*) was destroyed by the Christians and who is known through references to it in its refutation (*Contra Celsum*) by Origen—had already explained that heresy and schism result directly from the Christian literalization of monotheism: the elevation of one particular over others, i.e. the insistence upon a particular partial view over the whole world of diverse religions. "Heresy," meaning to take for oneself, to choose, is disastrous in a polytheistic psychology: witness the choice of Paris that unleashed the Trojan War, the choice of Hippolytus and his subsequent doom. For Celsus, Jewish monotheism was part of the Hellenistic world; it was the religion of one nation (*ethnos*) among others in a broadly polytheistic social order. But when Christians "believed" that the Redeemer had come and thus absolutized truth into history, so that one man cannot serve many masters, schism ensued. (Cf. my "Schism" in *Loose Ends* (Zürich: Spring Publications, 1975.)

The third distinction follows on these. It is a distinction between religious faith and psychological faith, even between religious truth and psychological truth. Let me refer here to a passage from my Terry Lectures for it seems to put the position most succinctly:

> Because our polytheistic psychology is not making theological claims, because it is not approaching Gods in a religious style, theology cannot repudiate psychological polytheism as heresy or false religion with false Gods. We are not out to worship Greek Gods—or those of any other polytheistic high culture...We are not reviving a dead faith. For we are not concerned with faith [in God] or with the life or death of God. Psychologically, the Gods are never dead; and archetypal psychology's concern is not with the revival of religion, but with the survival of soul. [Faith in soul is our main concern.][21]

Polytheistic psychology would not suspend the commandment to have "no other Gods before me," but would extend that commandment for each mode of consciousness. Then, each archetypal possibility of the psyche—including those we now call psychopathological—could follow its principle of individuation within its particular divine model. No one model would be "before" another, since in polytheism the possibilities of existence are not jealous to the point of excluding each other. All are necessary in that they together serve one law only: necessity. Polytheism gives archetypal psychology a religious mode even for psychopathology by suggesting an adequate background in myth for each of the sufferings of the soul.

III

The theme monotheism/polytheism is immensely complex and packed with energy. The best minds of the early centuries of our era were obsessed with this issue and from that conflict of paganism with Christianity[22] our historical psyche and our psychological theory have been cast in what eventually became the current Protestant direction.

[21] My *Re-Visioning Psychology*, (New York: Harper & Row, 1975), 170.

[22] A. Momigliano (ed.), *The Conflict Between Paganism and Christianity in the Fourth Century*, London, 1963; see too E. R. Dodds, *Pagan and Christian in an Age of Anxiety*, Cambridge, 1965, for concise psychological characterization of the age and for references.

The essence of this direction reflects the Christian victory over
the pagan world which can be summed up in a phrase from Gregory
of Nazianzus, who, while praising the pagans for their culture,
epitomized the method for integrating it into Christianity: "we take
prisoner every thought for Christ."[23] The one God swallows all the
others; Pan was dead because monotheism had conquered. The var-
iegated natural totality (Pan) of the pagan world's modes of being
together with their attributes and traits and kinds of consciousness
were taken prisoner through binding them to the one central image
and myth. Monotheism fed like Kronos on the Gods it swallowed. As
Christianity swelled, imprisoned "Greek philosophy [read psychol-
ogy] sank exhausted into the arms of religion."[24] Even were we to
grant that this historical event was beneficial for religion—and there
are others besides Nietzsche who would grudge any value to this
victory—it was not necessarily beneficial for psychology. This
because specific patterns of consciousness were deprived of their
archetypal backgrounds and imprisoned by the Christian model whose
perspective now made them seem pathological. They could return
but through the back door of mental aberration.[25] A pathological view

[23] Gregory of Nazianzus, "In Praise of Basil" (*Pat. Gr.* 36, 508), quoted from J.
Shiel, *Greek Thought and the Rise of Christianity*, London, 1968, 76. See, B. Delfgaauw,
"Gregor von Nazianz: Antikes und christliches Denken," *Eranos Jahrbuch 36*, Zürich,
1967. One example of "taking every thought a prisoner" is the Christianization of
Greek multiplicity in regard to the word "God." While the Greek Church Fathers
could still find five etymological accounts for *theos*, the Latin translation into *deus* re-
duced the root to a single one. (Cf. Ilona Opelt, "Christianisierung Heidenischer
Etymologien," *Jahrbuch f. Antike und Christentum*, 1959, 70-85.)

[24] "Here knowledge is replaced by revelation in ecstasy. After Greek philosophy
had performed this self-castration it sank exhausted into the arms of religion; as Proclus
expresses in one of his hymns to the Gods: 'And so let me anchor, weary one, in the
haven of piety'." E. Zeller, *Outlines of the History of Greek Philosophy* (London, 1931), 313-
315, quoted from J. Shiel, *op. cit. sup.*

[25] The most marked of all these resuming aberrations is the notion of the uncon-
scious. In classical times there was an underworld that housed our dreams and the
nightside of our soul. But monotheistic psychology harrowed Hades and turned it into
Hell so that underworld phenomena became sinful or sick. At least, however, Hell
housed some powerful phantoms of the imagination until it too dried up in the En-
lightenment (Cf. D. P. Walker, *The Decline of Hell* (Chicago: University of Chicago
Press, 1964). Wallace Stevens writes: "The death of Satan was a tragedy/For the imagi-
nation. A capital/Negation destroyed him in his tenement/And, with him, many blue
phenomena... Phantoms, what have you left? What underground?/What place in which
to be is not enough/To be? You go, poor phantoms, without place." "Esthetique du
Mal" vii, *Collected Poems of Wallace Stevens* (New York: Knopf, 1978), 319.

towards many of the psyche's phenomena is inevitable if psychology does not keep alive the individuality and variety of archetypal forms and their different ways of viewing the soul and life. Remember— even Christian alchemy warns against conjunctions and unifications that create the monstrum, that is, psychic monstrosities. Should psychology prefer instead to merge the many ways into a wholeness determined by monotheism, ego towards self, "single one to single One,"[26] will it not too—has it not already—sink exhausted into the arms of religion?

The protestant direction of analytical psychology crops out in many large and small ways. Currently we see it in: the emphasis upon love as a panacea, without differentiation of the faces of love and awareness of tradition in regard to its constellations; the merit of hard work upon oneself; the inculcation of a "strong ego" in therapy through the ennobling of choice, responsibility, commitment, and the consequent manipulation of guilt; trust in simplicity, naivete and group emotion; an anti-intellectual, anti-logos bias where trust (*pistis*) in the "unconscious" or the "process" is enough; or, as the reverse of *pistis*, a clean scientistic objectivism together with the classical worries of capitalism—payments, contracts, clients, laws, insurance; emphasis upon revelation (from dreams, from oracle, imagination, psychosis, analyst, or from Jung); a peculiar combination of introverted religiosity and missionary popularization.

We see it as well in the sole model for psychological suffering in which death's value is dislocated onto rebirth, a linear process of gaining a better condition in exchange for a worse. This model fundamentally devalues the existential importance of depression and the descent into dissolution *per se*. Downward phenomena are good, not in themselves, but rather because they offer hope for resurrection. It appears especially in the theological obsession with evil, which, let us recall, was not an issue in Greek polytheism. The Greeks had no Devil; each form of consciousness had its specific component of wrong-doing and tragedy. Evil was not a separate component, but a strand so woven throughout everything that the "integration of the shadow" was already given in the patterns of life rather than a task

[26] "...this is the way to pray as single one to single one." Plotinus, *Enneads*, V, 1, 6 (Shiel trans.), or "alone towards the alone" (Mackenna trans.). Cf. V.9.11: "solitary to solitary."

for an ego to do. And the Protestant direction appears in the notion of the "ego-self axis," the confrontation between them, the new mid-point as a new covenant, and "Christ as a paradigm of the individuating ego."[27]

When our model of individuation is governed by monotheistic psychology in its Protestant direction, every fantasy becomes a prisoner for Christ. Every fantasy cannot help but find meaning in terms of the one path, like the pilgrim on his progress towards integration. Even those that do not willingly fit in can be taken prisoner through the idea of a "pagan anima," a "chthonic animus," a "puer inflation," or the "problem of evil." These concepts bind psychic events to the dominant myth of the Protestant direction. Where once science, and then clinical pragmatics were the enemies of the psyche, today the threat to the psyche's freedom of symbol formation is nothing else than fading Christianity coming back in the guise of a theology of the Self to claim the soul for its own. Releasing the swallowed Gods or the prisoners for Christ means realizing first how limited must be our hermeneutic for psychic phenomena when we have a simplistic monotheistic model for totality.

[27] For basic formulations of the Protestant direction see particularly the writings of E. Edinger: "Christ as Paradigm of the Individuating Ego," *Spring 1966*, New York; "The Ego-Self Paradox," *Journal of Analytical Psychology*, V. 1, London 1960; "Ralph Waldo Emerson: Naturalist of the Soul," *Spring 1965*, New York, where we find (97) the following passage: "In the process of assimilating the old culture to the new psychology, we discover again and again colleagues of the spirit. Emerson is such a colleague. He was a dedicated forerunner of the new world view that is only now beginning to reach its full emergence. The essence of this new view is well expressed by another colleague of the spirit, Teilhard de Chardin." The emphasis in both Emerson and Teilhard de Chardin is clearly upon a transcendental evolutionary wholeness. But Jung has been given many other kinds of spiritual colleagues. In textbooks he is grouped with Freud and Adler; in his own writings we find suggestions that he looks back upon a spiritual line that includes Goethe, Carus, Kerner, and the French alienists of the nineteenth century; that abrasive scandal to authority, Paracelsus, and Nietzsche too, can be colleagues of the spirit. (I have often seen Neoplatonism in Jung.) Jung has also been placed alongside Tillich and Buber, called the true successor of William James, and given for spiritual colleagues the Masters of the East, Albert Schweitzer, the Gnostics, and others too numerous and irrelevant to mention. The fact that there are these many views regarding Jung and his work is further witness to his multiple psychology and the multiplicity of viewpoints, i.e., polytheistic psychology, in general. The Protestant direction is only one ray in the spectrum.

Jung has pointed out that "the extermination of polytheism" goes hand in hand with the suppression of individual fantasy, and as "the Christian idea begins to fade, a recrudescence of individual symbol-formation may be expected."[28] We may draw the conclusion that "individual symbol-formation" requires a polytheistic psychology, because the symbols refer to their likenesses in the variety of archetypal forms through which they find their authentication. Did Jung foresee that his stress upon totality and wholeness could be turned by the influential monotheism of our culture, and thus lead to a new one-sidedness? The *imitatio Christi*,[29] fading as a religious dogma or practice, becomes a psychological dogma subtly channeling the vital flow of individual fantasy back into the old vessel, now called "wholeness," its eight-sided cross of typology, now become holy through scientistic objectification.

Jung's contrast of the Christian with the polytheistic suggests a tension between them in his soul. In the tribute to Jung at his funeral, the pastor spoke of Jung as a heretic. Jung's heresy, if we may follow his pastor in calling it so, was however one of extensions and revision, not of denial. He added a fourth to the trinity and therewith the dimension of psychic reality to Christian dogma. Therewith too, the God within was re-affirmed. The experiential and phenomenological God of psychology included a fourth dimension, an underside which Jung saw as shadow, femininity, Mercurius, and the pagan past. He added to the Christ of orthodoxy the wealth of alchemical imagery, and like the Christian philosophers of earlier ages he connected his explorations again and again with the Christ image. Moreover, his description of the *imago Dei*[29a] as the Self follows the monotheistic model, by subsuming the many opposites under the highest goal, union. Sharper heresy was avoided.

The East[30] (where the self notion, the mandala, and the Old Wise Man image are first at home) and alchemy provided Jung with ways

[28] *CW 8*, § 92.

[29] Cf. James Yandell, "The Imitation of Jung: An Exploration of the Meaning of 'Jungian'," *Spring 1978*.

[29a] Cf. James Heisig, *Imago Dei: C. G. Jung's Psychology of Religion* (Bucknell UP, 1979).

[30] For one instance of the Eastern reinforcement of monotheistic psychology, see Jung's "Psychological Commentary on 'The Tibetan Book of the Great Liberation,'" *CW 11*, § 798, beginning: "'There being really no duality, pluralism is untrue.' This is certainly one of the most fundamental truths of the East..."

around the desperate issue of heresy which so obsessed the Renaissance giants and the more profound of the Romantics. Bruno, who posited a plurality of worlds, was forced out of the Dominican order and later burned, Ficino took another tack and in his mid-life was ordained into the Church's service. Wordsworth's mystical pantheism declined into woolly support of established religion. Coleridge, immersed fully in the dilemmas of Neoplatonist polytheism (appearing in his day as pantheism), "regarded himself as an orthodox Church of England man."[31] The tension between his imaginal, sensuous life and his Christian convictions was said to have been at the core of Coleridge's private agony. Blake's extraordinary power of imagining his own cosmos and its persons allowed him to follow the method of Gregory Nazianzus by taking every fantasy into the Judeo-Christian nexus, yet without losing imagination thereby. Those who started boldly into paganism—Shelley, Keats, Byron—died before the issue was fully upon them. Berdyaev believed the issue insoluble: "A pagan Renaissance is impossible in a Christian world, forever impossible."

Is this also true in the realm of psychology? Is the restoration of the pagan figures to their place as archetypal dominants of the psyche impossible in a monotheistic psychological world? If so, then we must abandon our attempts at an archetypal approach based on polycentricity and accept analytical psychology a prisoner for monotheism in its current Protestant direction and let psychology sink exhausted where it may. Or: counterphobic to that sinking, monotheistic psychology strives heroically for a rationalist, secular, humanist Ego in which religion is either an illusion or a component "drive" to be integrated into human wholeness.

The task of psychology, let us stress, is not the reconciliation of monotheism and polytheism. Whether the many are each aspects of the one, or emanations of the one or its hypostases and persons is discussion for theology, not psychology. So, too, attempts to integrate the anima/animus into the self (as, for instance, the notion of stages) tend also to be theological: they present theories in the senex mode for integrating differences into a single order. The result generally disfavours the plurality of individual differences. And precisely these differences are what we wish to keep in mind, following one of Jung's

[31] T. McFarland, *Coleridge and the Pantheist Tradition* (Oxford, 1969), 220; see further, 223.

definitions of individuation as differentiation.[32] Therefore, polytheistic psychology does not focus upon such constructs as identity, unity, centeredness, integration—terms that have entered psychology from its monotheistic background. Instead, a polytheistic psychology favors differentiating, elaborating, particularizing, complicating, affirming and preserving. The emphasis is less upon changing what is there into something better (transformation and improvement) and more on deepening what is there into itself (individualizing and soul-making).

The "way out" of the polytheistic/monotheistic dilemma is perhaps less theoretical than empirical. Which pattern offers my psyche in the mess of its complexes better options for meaning? Heuristic pragmatic criteria have always been decisive in choosing between rival structures of consciousness. Constantine became Christian (and through him our civilization) because the new monotheistic religion then offered redemption to lost areas of his psyche, which the paganism of the time could not quicken.[33] "...The pagan cults were nothing but a confused medley, very loosely bound together by the customary dedication to 'all gods.' They had no common organization and tended to break up into their atoms."[34] The independence of the Greek city-states and of the Renaissance Italian cities, the cry of liberty in the name of paganism during the Romantic Revolution, as well as the contemporary separatist movements show on the political level a psychological dissociation away from central authority.[35] Translating these polytheistic and separatist phenomena into a psychological metaphor, we have Jung's vision of the objective psyche where the atoms reflect the multiple sparks.

Monotheism evidently provided Constantine's psyche with the central focus then needed. Today, may not the situation be the reverse? Can the atomism of our psychic paganism, that is, the rash of individual symbol-formation now breaking out as the Christian cult fades, be contained by a psychology of self-integration that echoes its expiring Christian model? If so, then indeed, the self is "the archetype which is most important for modern man to understand."

[32] *CW 6*, § 755, 761.

[33] A. Alfoldi, *The Conversion of Constantine and Pagan Rome*, (Oxford, 1948, rpt. 1969), 8.

[34] Alfoldi, *op. cit.*, 12, where the presentation of the Christian victory over paganism is put as a conquest by monotheism over polytheism.

[35] Cf. James Ogilvy, *Many Dimensional Man: De-centralizing Self, Society, and the Sacred* (New York: Oxford UP, 1977).

The answer hangs in the historical balance; and the scale, so loaded
with recrudescent individual fantasies is surely tipping away from
monotheism's definition of order and its *imago Dei*. The danger is
that a true revival of paganism as religion is then possible, with all its
accoutrements of popular soothsaying, quick priesthoods, astrologi-
cal divination, extravagant practices, and the erosion of psychic
differentiations through delusional enthusiasms. These opium poppies
bloom all around us. The self does not provide bulwark since its
monotheistic descriptions, mainly in senex images, and the protestant
interpretation leave too much out—or cover too much by the com-
forting blanket of "wholeness." But when self can be re-imagined
with precision, as a value relation with a variety of ambiguous arche-
typal perspectives and less assuredly through the senex, consciousness
can find containers for its individual symbol-formations. To meet the
revival of paganism as religion we need adequate psychological
models that give full credit to the psyche's inherent polytheism, thereby
providing psychological vessels for the sparks. They may burst into
religious conflagrations[36] when left psychologically unattended or
when forced into monotheistic integrations that simply do not work.

The restoration of the Gods and Goddesses as psychic domi-
nants reflects truly both the varied beauty and messy confusion, and
tragic limitation, of the anima/animus, their fascinating multiplicity,
their conflicts, their lack of ethical cohesion, their tendency to draw
us deep through life and into death. Polytheistic psychology can give
sacred differentiation to our psychic turmoil and can welcome its
outlandish individuality in terms of classical patterns.

The elaboration of these patterns in psychological terms is yet to
be done. We have yet to understand Artemis and Persephone, Apollo
and Poseidon, in terms of our soul-images and behaviour. Although
Jung did devote much space in his works to the divine couple and
their configurations, and also to the personal aspects of the anima
and animus in our lives, he concentrated mainly upon the phenom-
enology of the self archetype. The same thorough work needs to be
done upon the anima/animus. But before this work can be done we
would have to recognize their importance and see things from within
their archetypal perspective, i.e., in terms of a polytheistic psychology.

[36] E.g., the catastrophic Christian cult of Jonestown in Guyana.

Hence the urging in these remarks. (The idea of four stages,[37] of the anima and animus, inspired mainly from Goethe and where progression moves away from the physical and toward the spiritual, is only an attempt at an anima/animus phenomenology in terms of classical mythology.[38]) Until we follow Jung in examining the differentiation of wholeness with the same care that he applied to the integration of wholeness our psychology does not meet the psyche's need for archetypal understanding of its problems.

If there are other psychological options for our need I cannot find them. These ideas and their presentation leaves much unsatisfied, and so others who may see the question and its answers more clearly are invited to respond to this issue along lines laid out here.

IV

P*ostscript*—1981: So concluded the original paper published ten years ago. It was followed by ten responses—notably that of Kathleen Raine on Blake's Christian polytheism—which can be found in the Kraus reprint edition of back issues of *Spring.* Then in October 1976 at meetings of the American Academy of Religion in St. Louis, there were another ten discussants of the theme monotheism/polytheism. Both David Miller and I were engaged in this panel, together with Elizabeth Sewell, Richard Underwood, Tom Moore, William Paden, Daniel Noel, and others. These responses attempted to clarify errors of thinking—philosophical, historical, theological. The psychological issue remained pretty well avoided. Once more, in 1979, when the above revised version of the article appeared in German in *Gorgo: Zeitschrift fur archetypische Psychologie und bildhaftes Denken,* it was followed by comments of which those of Wolfgang Giegerich and Ulrich Mann especially stand out.

These discussions made clear the need to emend (not amend). Some of this has already been done in subsequent essays. That is, the concern of this 1971 piece was articulated in detail in my 1972 Terry Lectures (*Re-Visioning Psychology,* 1975) and in my "Anima" articles in

[37] On the four levels of the anima, see *CW 16,* § 361; on the four levels of the animus, taken from Faust, see, Emma Jung, *Animus and Anima* (Woodstock: Spring Publications, 1996), 2f. For an elaboration of the anima in terms of the Greek Kore figure, see *CW 9i,* § 306-383.

[38] My articles on "Anima" in *Spring 1973* and *1974* are an attempt at a phenomenology of this.

Spring (1973 and *1974).* This piece has been a groundwork for what came later, as David L. Miller was the first to espy. Though emendations are still needed, I cannot possibly encompass in this postscript all the issues raised by the discussants nor give them due justice. I don't even want to try. I just want to use this ring to get in one or two more licks.

1. What I have suggested as a polytheistic psychology has inescapably been taken as a polytheistic theology whose target is Christianity and Judeo-Christian monotheism. The psychological issue here is not whether that was or is my aim, disguised or plain, but rather can one do psychology without at the same time doing theology? In 1971, Philipp Wolff's response said that this was precisely the dilemma of Jungian psychology: it uses religious categories for describing the psychic world and hence is willy-nilly entangled in theology. He is right. The Jungian context of this piece is nowhere more visible than in the deliberate interpenetration of psychology and theology. Jung's psychology always has theological implications and where it was often ignored by psychiatrists it was vividly, even rabidly, engaged with by theologians. The collaboration in this book of Miller's [*The New Polytheism*], between him, Corbin, and myself exhibits the interpenetration of theology and a psychology of soul. If we want to move psychology and therapy we have to move its baggage, too.

And no baggage more weighs down our every psychological step than the monotheism of our culture, which, because the culture has slid into secularism, no longer appears with the devout and fanatic visibility of Islam; instead monotheism appears in hundreds of inevitable psychological presuppositions about how things are and how they should be. *E pluribus unum* is only a tiny manifestation of the ubiquity of singleness whose ultimate magnifico is the Western Ego, monotheism wholly subjectivized and reduced to secular humanistic psychology. Miller's excellent new Introduction showing the contemporary rise of plurals nevertheless assumes as background a vast, louring, and tacit monotheism against which these plurals seem mere cries and whispers.

Because the opposition of monotheism to polytheism is so much the baggage of the culture, it is deep in the collective unconscious of each of us. Whatever we say, whatever we write, is so packed with

monotheistic assumptions, that an understanding of the polytheistic psyche is almost impossible. Never mind that a pagan Renaissance, as Berdyaev said above, is forever impossible in a Christian world: what is more seriously impossible, because so unconscious, is simply an understanding of our cultural foundations—Homer, Plato, Aristophanes, Plotinus—because we approach the polytheistic world freighted with monotheistic baggage. That we still call "pagan" what in fact is classic and the very soil of our mythical imagination is a piece of that baggage. Even the Christian texts used to back up its viewpoint have narrowed to such singleness of meaning that their rich classical echoes are lost. Take singleness itself. *Matthew* 6:22 (cf. *Luke* 11:34): "if therefore thine eye be single, thy whole body shall be full of light." Single (*haplous*) means open, plain, frank, natural, downright, straightforward and simple. But now that the word single only means univocal, monocular singleness, the passage itself will be read in a puritan and fundamentalist manner, demonstrating that inherent tendency within monotheistic consciousness to take its rhetoric with singleness of meaning, i.e., literally. When the One means "only" (one-ness, one-sidedness), literalism is inevitable.

It hardly matters to me whether theology or psychology brings awareness to our baggage as long as awareness comes. Rather than separating the theo-psychic mixture, let it continue. It will anyhow. It's an authentic compound, for the soul itself is just this sort of mixture. By definition soul has a religious concern and is naturally involved with theological questions. We can no more leave that concern and those questions to professional theologians (staggering under their suitcases) than could C. G. Jung.

2. Of course this welcoming of theology leaves polytheistic psychology open to theological corrections such as were brought by colleagues from Religion at St. Louis and again most intelligently by Ulrich Mann in *Gorgo*. For instance: how can we assume that Christianity is fading; have I not missed the piety and probity of the very Protestant direction I attack; and have I not simplified the beautiful complexity, mystery, and (inherent polytheistic) wealth of Christian monotheism? Most important, however, have I not been promulgating a religious ground to psychology which then leaves it short by not following through with the elaboration of praxis: cult, rite, prayer, sacrifice, and community. And what about belief?

As I have spelled out in several later writings, psychological polytheism is concerned less with worship than with attitudes, with the way we see things and place them. Gods, for psychology, are neither believed in nor addressed directly. They are rather adjectival than substantive; the polytheistic experience finds existence qualified with archetypal presence and recognizes faces of the Gods in these qualifications. Only when these qualities are literalized, set apart as substances, that is, become theologized, do we have to imagine them through the category of belief.

Do polytheistic cultures have a category of belief like ours, with credal disputes and credal affiliations? Egyptians and Polynesians, Peruvians and Mesopotamians, Greeks and Hindus and Celts—did they, do they take doctrinal oaths, make theological statements in order to belong, in order to experience their Gods? Let's steer clear of belief, just like the Greeks. As Tom Moore pointed out, myths are read with humor, not belief. The Gods don't require my belief for their existence, nor do I require belief for my experience of their existence. It's enough to know I am mortal to feel their shadowing. It's enough just to look around with open eyes. Belief helps only when one can't see, or must see through a glass, darkly. Faith as I think of it is an animal faith (*Santayana*): what is there is there and not because I believe it, nor will it go away when I stop believing. The dog who sniffs the wind doesn't believe in the wind: he simply tries to pick up on it and get what it is saying. Not so simple, by the way.

Psychology can do very well without the category of belief. We will still go on dreaming, even if we "don't believe in dreams" and we will still go on loving and hating and struggling with our *daimones* whether we declare belief in them or not. Belief leads us into so many of the old alleys, closed in by walls: subjectivism; evidence; the status of the "objects of belief;" delusion, illusion, and belief; the problem of doubt and all those guilty torments. Merely by letting go of this one bag, how straightly, easily we walk into the wind.

There is another reason not to follow through with prescriptions for religious practices. Maybe cult, rite, sacrifice, prayer, and community are already going on—if we look at psychotherapy with a religious eye. Maybe a sort of polytheistic religion—propitiation of daimones, active engagements with images of imagination, creative dialogue (one of Corbin's definitions of prayer), is already being practiced in the

communities around the consulting room. It wouldn't be too forced to use the metaphors of religion when looking at what goes on in psychotherapy. And then we would not be so obliged to be literally religious, that is, devise and proscribe practices which are not necessary if one sees what is already taking place with a religious eye. And it is this eye, not the promulgation of a New Church of Polytheism, that my article and David Miller's *The New Polytheism* is all about.

3. We would have been spared these sorts of debate had the 1971 article not been cast in debate form. Its rhetoric of conceptual argument (mono or poly) remains monotheistic in spite of itself. This shows again the difficulty of trying to enter the polytheistic mode of consciousness after Pan is dead. We are forced to fire up old Hellenistic and Patristic thought patterns: whose system is better, yours or mine. Psychology vanishes in that steam. We are left with the monotheistic conundrums of dualism.

These appeared in the discussions. Spiegelman used a Kundalini model of many centers, no single one of which had supreme authority. However, the one remains invisibly as the energy flowing within the system as a unified whole, so that essentially the many are contained by and expressions of the one. Cowan paradoxically blended one and many by means of the Greek word Pan, which means both "all" and "every." But Pan is dead, and didn't he die and that paradox split at that time in antiquity when the new God of Christian monotheism appeared ending the possibility of the Greek resolution Cowan proposes? Kathleen Raine gave our dualism another dimension: spirit and soul, spiritual monotheism and psychological polytheism. But, here Radin's caution must be recalled: monotheism sets itself higher than polytheism. In *Gorgo*, Giegerich turned it the other way. Monotheism is a narrowed and extremest partial truth, while polytheism is higher because it is more basic, ubiquitous, and lasting.

So, I preferred Lopez' formulation: "The many contains the unity of the one without losing the possibilities of the many." This restates the Neoplatonist idea of *skopos*: the thematic unity of intention, the aim or target which gives an internal necessity and fittingness to each part of a work of art. Here the one is not something apart and opposed to the many, leaving them as inchoate fragmented bits, but it appears as the unity of each thing, that it is as it is, with a name and a face.

As a psychic reality, the one appears only as this or that image: a voice, a number, a whirlwind, a universal idea, etc. And, it appears as the unity of each particular event, discoverable phenomenally only within eachness. The arguments that the one is ground of the many, their continuity, or the whole which embraces them all are again biases of monotheistic consciousness attempting to usurp a more ultimate, more basic and superior place in a metapsychological system, where system itself belongs to senex rhetoric. We must watch out for words like "ground" and "whole," and "all," and remember that unity too can be imagined polytheistically. To polytheistic consciousness, the one does not appear as such but is contained as one among many and within each of the many, as Lopez says. Corbin's prefatory letter above, and his masterly essay on the paradoxes of monotheism in a book dedicated to this theme, *Oneness and Variety* (*Eranos Jahrbuch 45*, 1976) can carry the reader deeper into the bewildering dualisms of monotheism.

This helps us remember that dualism is a function of monism. Arguments between "the One and the Many" play themselves out in an arena already set up by monotheistic consciousness. Pluralism, however, is a wholly different kettle of fish which gets emptied out when put into the dualistic framework of the One versus the Many, as if, as some discussants indicated, this is really what the whole game of mono-poly comes down to. Philosophy enjoys these games, these reductions often considering all questions ultimately to be footnotes to Plato (e.g., the One/Many eristics in the *Parmenides*). Where philosophy literally means Plato, psychology is more interested in the footnotes, the midrashim below the line. That's where the deviations and twists are, and that's where it gets under your skin.

For example: the connections made by Lopez (*Hermes and His Children*, 67) between classical polytheism and Freud's polymorphous sexuality puts the Problem of the Many in a freshly threatening manner. Polytheism becomes polysexuality, no longer merely for philosophers, but a host of devils in our own backyard of desire. Another example: that Pan and Priapus, Dionysos, Hermes, Aphrodite and Ares are Gods and Goddesses means that the images, fantasies and behaviors they offer us—all the obscenity, riot, trickery, and war—are divine, backed by divinity, with an ethos and a logos. What a radical revolution in our philosophical surety about good and bad, right and wrong, sick and well. No wonder philosophy has to defend itself against this radicality (root-going, rooted) with terms such as "relativism."

What monotheistic consciousness sees only as radical relativism is from a polytheistic point of view radical facticity: for there is no need to put it all together. That need is itself a fantasy or a paranoid drive toward unified meaning that has not been seen through to its archetypal base in what I called above, the senex. It can be argued that the polytheistic hypothesis "puts it all together" even if in a different way: at least it gives a coherent account. True; but also not true, because there is no "polytheistic hypothesis" when within its perspective. There is merely the method of epistrophe and a consistent attitude, but no attempt at overall coherence. Henri Frankfort explains it like this:

> The ancients did not attempt to solve the ultimate problems confronting man by a single and coherent theory;... Ancient thought—mythopoeic, "myth-making" thought—admitted side by side certain limited insights, which were held to be simultaneously valid, each in its own proper context, each corresponding to a definite avenue of approach. I have called this "multiplicity of approaches"...this habit of thought agrees with the basic experience of polytheism. (*Ancient Egyptian Religion* [Harper & Row Torchbook, 1961], 4)

The dualism with monotheism is one way philosophy holds polytheism in tandem. Philosophical rhetoric works with comparison, antinomies, the law of contradiction. It pairs darkness with light, whereas a poem can shade in qualities of darknesses ("Thirteen Ways of Looking at a Blackbird") without reference to light, and a painting can differentiate any *topos* without having to contrast it with another. Polytheism is not necessarily half of a philosophical pair, requiring monotheism for its other side. In itself polytheism is a style of consciousness—and this style should not even be called "polytheistic," for strictly, historically, when polytheism reigns there is no such word. Where the *daimones* are alive "polytheism," "pantheism," "animism," and even "religion" do not appear. The Greeks had *daimones* but not these terms, so we ought to hold from using monotheistic rhetoric when entering that imaginative field and style we have been forced to call "polytheistic."

Then we might better discover this other psychological eye by imagistic, mythic, poetic means, releasing intuitive insights from sensate

particular events. The psyche, and the world's psyche too, would show its patterns in tales and images and the physiognomic qualities of things. The whole show would be different, and indeed psychic life is show, both the comedy and agony of drama, and *schau*, each appearance an imagistic essence, a showing forth; revelations, theophanies.

When William James described *A Pluralistic Universe* (Dutton 1971, 183), he set this sentence in italics: *"Reality MAY exist in distributive form, in the shape not of an all but of a set of eaches, just as it seems to be."* Then he added: "There is this in favor of eaches, that they are at any rate real enough to have made themselves at least appear to everyone, whereas the absolute [wholeness, unity, the one] has as yet appeared immediately to only a few mystics, and indeed to them very ambiguously."

Eachness: that is the place I share with James with Jung, for what else is individuation but a particularization of the soul. For James, eachness is not so much achieved through an individuating process as it is already there "just as it seems to be." James plays his eachness on a Blue Guitar, "things as they are," the blue bush of imagination inextricably embedded in the plain sense of things. Only with these individual eaches can we be intimate, says James. The pluralist vision opens towards intimacy, love, and the immediate green world of the senses. O taste and see! As Jung said, the archetypes cannot be understood without the feeling function. Psychic life is particularized in the vale of the world, and this vale is endlessly alive with qualities, an embeddedness (Whitehead) of concretely felt individualities which are not, no, not at all, sufficiently described as the Ten-Thousand Things, atomic particles, plurality, the Many, or by any of the other terms of perception theory, physics' theory, or religious doctrine enunciated by a detached monotheistic consciousness that sits in judgement so far above the vale that it seems only unqualified statistical data, a blooming buzzing confusion of quanta, faceless and threatening.

Here within and below we are embedded in immediate contexts and the idea of the Many only serves to sever us, and the strings of the guitar. The Many is a defensive idea against the experiences of things as they are. That hat you're wearing, the pain in your eyes, my last dream this morning, the dog scratching her collar. Each image holds itself together. Gone the fragments, the bits, and so gone too are the needs for a unified world view and a unified personality to

uphold the world, and a Self to hold it all. Each event showing its own face is the way the world comes and our lives are, and these events have a *kami* (Japanese), a *theos* (Greek), bespeaking the holiness of things as images of Gods.

Too quickly we monotheize this "images of Gods;" as if the images were one-to-one representations, mirror images of actual Gods we admire in museum statuary. As if we had to match eachness with its multiple background. No; myth-matching is only an eye exercise: we must look for mythic images in order to see imagistically. Once the imagistic mode is in the eye, then the phrase "as images of Gods" is less literal and instead refers to a theophanic kind of consciousness where psychic reality is omnipresent; no palpable distinction between soul and vale-of-the-world, *anima mundi*.

This last leads to another, an aesthetic, sense of life, to polytheistic psychology as an aesthetic psychology. But that must be left for another time, even if adumbrations are already here in this piece. For, an aesthetic psychology derives from a world ensouled whose qualities are given directly as physiognomic accordances with the nature of each event in its interplay with others. All things signed, signifying; a calligraphy of inherent intelligibility. And this language we already know in our animal souls.

4. I have spent so many words on theological and philosophical aspects because this is a postscript to an addendum in a book by a Professor of Religions. The book's concern is a theological revision. Still, my concern is more the revisioning of psychotherapy. A polytheistic model of the psyche seems logical and helpful when confronting the many voices and figments that pop up in any single patient, including myself. I can't even imagine how we could ever have got on in therapy without a polytheistic background. For a long time I was not able to understand why clinicians had such an investment in the strong ego, the suppressive integration of personality, and the unified independence of will at the expense of ambivalence, partial drives, complexes, *imagos*, vicissitudes—to say nothing of hallucinations and split personality—until I heard sounding through this clinical language the ancient and powerful *basso profundo* of the One. Clinical rhetoric has been so persuasive (especially when lent a helping hand and brass knuckles by clinical pharmacology and the legal system) because it

speaks with the superior rhetoric, that rhetoric of superiority, of mono-
theistic consciousness. In clinical situations, this consciousness reinforces
the notion of the "I" (*le moi, das Ich*) and then what else can the Gods do
but become diseases, which is where Jung found them.

This is also where William James found his plurals, his eaches. I
refer to the very same passage (268) which Miller quotes in opening
his introduction. James' view rises from "analogies with ordinary
psychology and with the facts of pathology, with those of psychical
research…and religious experience." Or what he also calls there: "the
particular, the personal, and the unwholesome."

How sorry, how sick, literally, that we get to this style of con-
sciousness only through "the facts of pathology and psychical
research." But this is our monotheistic culture. As James Frazer wrote:

> the divisibility of life, or…the plurality of souls, is an
> idea suggested by many familiar facts, and has commended
> itself to philosophers like Plato as well as to savages. It is
> only when the notion of a soul…becomes a theological
> dogma that its unity and indivisibility are insisted upon as
> essential. The savage, unshackled by dogma, is free to
> explain the facts of life by the assumption of as many
> souls as he thinks necessary. (*The Golden Bough*, abr. ed.
> [NewYork: MacMillan, 1947], 690).

What a different experience of breakdown and clinic emerges when,
unshackled by dogma, we may assume as many souls as necessary. Is
not this very dogma what has made these souls "sick?" Has not this
dogma made the world soul in our civilization sick by turning it away
from the facts of life, things as they are, our savage selves?

Perhaps the clinical revisioning I have been struggling with ever
since I entered into an analysis of my own piece of that sickness, and
then repeatedly in writings since 1960, does find its logos in the
polytheistic premise of this article which works, by means of old-
fashioned disputations, to release the divine soul figures, anima and
animus, from the dogma of self domination. Therapy of the individual
and of the anima mundi proceed apace. Clinical revisioning is simulta-
neously revolution of *Weltanschauung*. To quote Frankfort again (4):

> Polytheism is sustained by man's experience of a universe
> alive from end to end. Powers confront man wherever he

moves, and in the immediacy of these confrontations the
question of their ultimate unity does not arise.

By suspending the question of ultimate unity we may become like
those savages, sylvan, animals in the woods, tracing our paths
according to impinging necessities and the presence of powers. And
this savage is not a rough beast slouching—or is only so, if Bethlehem
be the capital word in the last line. That beast has been savaged by
the same dogma; our conversion perverting him into the wild man
whose return we fear, unable to distinguish the second coming from
the return of the repressed.

Nor is the savage Rousseau's, although deep in that nostalgia are
the stirrings of Pan, the only animal-haunched God in the Greek
pantheon. Pan has fled nature's arcadia. All the Gods are within. So
now he resides in the wild imagination, its caves, its chases, its natural
freedom to form as it pleases, that "recrudescence of individual symbol-
formation" which Jung, above, says may be expected "as the Christian
idea begins to fade." Maybe Pan is not altogether dead, nor Julian
either, nor Celsus' pages wholly burnt; and if polemical strife is the
father of each and every event, maybe this appendix whose eristics
attempt to constellate Eris, goddess of strife, will continue to mother
new psychic life by rehearsing in our day once more the ancient
claim of polytheism.

Editor's Note

"The basic disease from which our culture may be dying," writes Gilbert Durand, "is man's minimization of images and myths, as well as his faith in a positivist, rationalist, aseptized civilization." Durand then gives a compact and rich description of the modern mind's assault on the image, and of the countervailing movements that have been unwilling to reduce imagination to concept, or psyche to a mere epiphenomenon of perception or reasoning.

As Durand shows, the "classical devaluation of the imaginal, from Aristotle to the Cartesians, is related to its devaluation of the soul." This anti-imaginal train of Western thought, which holds sway now as mightily as ever, Durand claims a "phantom type of spiritualism." But other lines also have been traveled, and Durand introduces some of their main conductors, including romantic poets such as Novalis and Coleridge, Gerard de Nerval (whom Durand calls their French equivalent), Bachelard, and, of course, Jung, to name only a few of the many explorers named by Durand.

These other lines carry us elsewhere than where we are accustomed. Calling especially upon the work of Henry Corbin, Durand describes an intermediary world that is the place of image and dream. "Beyond the transcendental self, beyond the self fragmented by existence, beyond the world of phenomena," says Durand, is "the modality of the *mundus imaginalis* [Corbin's "the world of the image"], that gigantic net, woven by the dreams and the desires of the species, in which the little realities of everyday life are caught despite themselves." This is the world explored by the imaginal traditions Durand introduces, and it is this world he calls upon us to explore.

Along the way, Durand points out some of the notable features gracing this other world, and relates some of the accounts of it given by others who have gone before. In so doing, Durand repeatedly advocates an appreciation of the soul's integrity by insisting that images be granted their own place and their own manner of existence. Images and and dreams are not merely the "reproductive hand-maidens of perception," says Durand, but present a reality of their own. Images are as images are, and they come complete with many more ways of establishing relationships than do concepts. And images also display their own logic, a logic that is not subject to rules originating from other worlds. "Imagination is the product of imagining forces," writes Durand, forces that reveal themselves through "the ambiguous filigree work of destiny."

EXPLORATION OF THE IMAGINAL

GILBERT DURAND
(Spring 1971)
Translated from the French by Ruth Horine

At a time when man has set foot on the moon, thanks to a triumphant feat of technology, it may seem paradoxical that anyone would wish to dwell on the time-worn realm of reverie. Let us dispel such misapprehensions at the very outset: compared to the few men who have actually landed on the grey, limy surface of the moon, countless others have made "dream voyages" from the earth to the moon in the course of the millennia, voyages which have accompanied, submerged and amplified the rather scant story of the astronauts. One might even say it is precisely because the moon has given rise to ever recurrent dreams throughout the centuries that the technocracies of our time have set in motion the stupendous apparatus which made it possible to reach the moon in July 1969.

Taking our desires for objective realities, i.e., confusing the mythical with the utilitarian dimension, constitutes one of the greatest mystifications of our time—so intent on de-mythologizing everything. The basic disease from which our culture may be dying is man's minimization of images and myths, as well as his faith in a positivist, rationalist, aseptized civilization. At the very moment when—along with the failure of symbolism, the theoretical principle underlying all mythologies—Western man proclaimed that "God is dead," he also "dreamed" the extravagant birth of a planetary, democratic and equalitarian superman, capable of compressing all theologies and

metaphysics into a radiant form of positivism—a superman able to reduce even this positivism to the regular and dispassionate rhythm of computerized thinking.

However, the vengeance of the Gods was not long in coming. Behind the hypocritical facade of official iconoclasm, images reared their heads in profusion and clandestine myth began to proliferate. Paradoxically, technology provided a sort of pictorial extension for the imaginal world of our ancestors. Far from shredding the images of the orally transmitted tale, of the saga retold countless times, the discovery of the art of printing supplied an additional dimension. As Bachelard put it, the written, literary image was added to what was once a mere exchange of words. With the art of printing the imaginal became an asset that could be put to use; i.e., it laid the groundwork for the modern form of poetic expression.

How are we to assess the subsequent developments of the nineteenth and twentieth centuries? As a result of the "fantastic" expansion of the printed media, and later the technological progress in iconographic reproduction—the development of photography and its still or animated derivatives—the image once again became vital to the transmission of ideas. Expressing some anxiety, anthropologists, psychologists and sociologists alike have accused our civilization of being a "civilization of the visual image."[1]

By the second half of the twentieth century, the task of studying the imaginal was entrusted to the disciplines of anthropology. Fifty years ago James said that the unconscious was the greatest discovery of the twentieth century. Now we might say that the contents of the unconscious (images) will be the most important field of exploration for the twenty first century. To this end, the work of Freud has no doubt been a decisive step forward, though a very limited one which soon required Adlerian and Jungian amplifications. Psychoanalysis partly resulted from a whole movement dedicated to the rehabilitation of the imaginal by means of a systematic study of the image and the modalities of the imagination. This movement was no other than the great romantic revolution, the tremendous effort made by the romantics toward restoration of the imaginal, an effort which resounded like a shout of protest at the dawn of the iron centuries of technocracy and cybernetics. To gauge the breadth of this movement it is indis-

[1] R. Huyghe, *L'Art et l'âme* (Paris, 1960).

pensable to look at it both in terms of what it tried to guard against and in terms of what it discarded as a source of future corruption and alienation. It might be useful to recall that the classical devaluation of the imaginal, from Aristotle to the Cartesians, is related to its devaluation of the soul. Perhaps it might be better to say that the soul is reduced to an interchangeable rationality which alienates creative uniqueness, the ontological value, in favour of an undefined power to communicate. Intercommunication became the trade-in value whereby the artist indulges in grammatical copulae, beclouds the issue by means of logic, reducing the soul to a wan phantom state, where it is but *cogito*, an anaemically functioning "organon" or "method." The reason why classicism from Aristotle to Descartes was only a form of pseudo-spiritualism, a phantom type of spiritualism, is that it denied the concrete reality of the soul by separating form from matter and hence the reflecting soul from the body. Whether we read Aristotle or Saint Anselm, Saint Thomas or Descartes, the mind is always conceived according to the modalities of objective experience: *res cogitans* is conceived according to the method of *res extensa*.

Herein resides the fundamental alienation, the anthropological disaster, which all the romantics—poets, politicians, novelists and historians alike—denounced with equal vigour. Henry Corbin[2] attributes this disaster, on which Western metaphysics foundered from the very beginning, to Averroes and Latin Averroism which gave direct rise to Thomist Aristotelianism),[3] i.e., to the moment when Western philosophy, with the support of the authoritarian teachings of the Roman Catholic Church, repudiated Plato's and Avicenna's theory of an *intellectus agens*. As a result prophetic and theosophist inspiration, the very opening of the soul, was made to give way to a human mind that was nothing but a tool, an organon or a method for adaptation to the material world or—as Bergson, that belated romantic, put it— "the world of solids." From then on, the human soul turned towards causal experience and reason. Psyche was reduced to perception and reasoning, while memory and imagination were abandoned as belonging to the prehistory of the method. All the sources of prophetic inspiration became suspect: they were branded as heretical in the eyes

[2] H. Corbin, *Avicenne et le récit visionnaire*, 2 vol. (Paris-Teheran, 1964, trans. Bollingen Series LXVI, New York, 1960).

[3] E. Gilson, *La Philosophie au Moyen Age* (Paris, 1962).

of Western rationalist orthodoxy. Because they were pure content, because they propounded the scandal of spiritual concretism—both imagination and memory were confined to the realm of the superfluous, of incoherence, folly or bias, rejected so vigorously by the Cartesians. Image and myth constituted but the "rubbish"[4] of rational discourse.

Since romanticism[5] we have, however, witnessed a gigantic effort to re-establish the image. At the same time, attempts were made to retrieve the concrete spiritual principle, the soul, as distinct from the "small change" principle of reason. In the course of the eighteenth century, the tide of rationalism gradually ebbed, eventually leading— via Hume, Rousseau and Kant—to the substitution of experimental reasoning by emotional sensitivity. Classic consciousness was, of course, torn apart: pure reason was mutilated, relegated to the task of drab experimentation with utilitarian things and exchange of infor- mation. In his *Critique of Judgment* Kant held out a future for a creative spiritual reality, which by its very act escaped the antinomies of reason. However it was the poets, the direct explorers of the newly found spiritual reality, who, in the early nineteenth century, made the greatest strides in the rediscovery of this *mundus imaginalis*. In addi- tion, romanticism was a gnosis as opposed to the agnostic tide of classicism, which split the realm of faith from the realm of knowledge. Alienation is always agnostic: it works to the detriment of knowl- edge; rationalist philosophy was but the hand-maiden (turned increasingly agnostic mistress!) of theology.

With romantic poets the exploration of the imaginal became a real field of knowledge, while the awareness of "supernaturalism" became itself a source of revelation. Herein lay the heart of the great romantic revolution. After the long period of Aristotelian positivism and formalism, a Platonic reminiscence suddenly took on significance: theology turned theosophy and was internalized in the poetic search. With the sudden devaluation of ecclesiastic and scholastic teachings, the Hellenic myth of the Muse was revived; and that which half a century earlier had found expression in Rousseau's rebellion against the encyclopedists on behalf of those things granted by nature— actually the indefeasible right of every soul—was affirmed by the romantic poets Holderlin, Novalis, Carus, Ritter and Coleridge as a

[4] The expression was coined by C. Levy-Strauss in *La Pensée sauvage* (Paris, 1962, trans., London and Chicago, 1966).

[5] A. Beguin, *L'Âme romantique et le rêve* (Paris, J. Corti, new edition, 1967).

state and a right conferred by a super-nature. The theories evolved by the poets were used for poetic exploration. Thus, almost a century before Freud, Schubert[6] laid the foundations for the significance of dreams, while Coleridge[7] dissociated creative imagination—the true "imaginer," to use one of Corbin's expressions—from the simply reproductive hand-maiden of perception, the mere spilling over of fancy. With this conception Coleridge anticipated the Jungian theory of a collective unconscious, the repository of recollections of the human psyche.

Despite the merits of a book fully revealing the century's interest in dreams, we would not be satisfied to turn to Hervey de Saint-Denis[8] to find a French equivalent to Novalis or Coleridge, but rather to that master explorer, Gerard de Nerval. Thanks to him, the image acquired ontological depth. In fact, until the development of contemporary depth psychology and dream therapy, no one equalled Nerval in regard to penetration of the imaginal. Let us recall the famous opening sentence of *Aurelia*:

> Dreams are like another life. It was not without trembling that I opened those gates of ivory and horn, which separate us from the invisible world. The first instants of sleep are the image of death...

Here we leave the field of minor exploration, to which all those like Maury, Hildebrandt, Binz and later Foucault, Dumas, Bergson and even Freud have accustomed us. For Freud the dream was a revalued faculty, no doubt, but just one along with many others. With Nerval and Baudelaire, and later Rimbaud, Novalis and Holderlin, a New World opened up for exploration, a world beyond the gates of "horn and ivory," one that belongs to the specific spirituality of unreason. The initial assimilation of dreams and death in Aurelia embodied the gnostic certainty. According to it, spirituality is not of this world; it does not belong to the bourgeois world of Daumier, of the "haves" and of Joseph Prud'homme. The soul is, on the contrary, made for another world, or, in Kantian terms, for a world beyond the phenomenal one. Imagination is therefore the possibility of experiencing the

[6] G. H. von Schubert, *Symbolik der Traume* (Berlin, 1812).

[7] P. Deschamps, *La Formation de la pensée de Coleridge* (Paris, 1964).

[8] Hervey de Saint-Denis, *Les Rêves, les moyens de les diriger,* (Paris, [Tchou, new edition], 1964).

noumenal, and the imaginal is the New World that allows the revival of this gnosis.

Investigation into dreams shows us that here the famous "*a priori* forms of sensible intuition*,*" which provide the necessary mold for all waking experiences, are abolished:

> After a few minutes of drowsiness, a new life begins, one that is devoid of the notion of time and space and is undoubtedly similar to that which awaits us after death. Who knows, but there may be a relationship between the two forms of existence and the soul may be able to establish it right now.[9]

First of all dreams, and all "active images" as we would say, abolish special limitations, preserving only the freedom of extension: active images are ambiguous—an entire Anglo-Saxon literary school was devoted to studying the strata of this ambiguity[10]—and ubiquitous. In dreams, the here is elsewhere, places are telescoped, losing both their geographic and geometric context.

More than anything else, the time (one is almost tempted to say the tempo) of the active image burkes the causal antecedencies, blending the extasis of time (past-present-future) into concrete "pure duration," as Bergson later pointed out"[11] Memory ceases to be restoration, repetition and *mimesis*, becoming instead creative reminiscence (*anamnesis*) and, above all, creator of self. Through this concrete exploration of romanticism, we rediscover true Platonism, stripped of its Aristotelian and rationalist tawdriness, a Platonism that places the accent on *intelligentia agens*, which is none other than inspiration, the Muse so dear to the hearts of our romantics.

If we went even deeper into this rupture of chronicity revealed by active images, we would find in the effect of reminiscence the prolegomena of a philosophy of Eternal Return, i.e., the indestructibility of creativeness, the very substance of the mind. Thus, Nerval, meditating on Goethe's *Faust*, anticipated both Nietzsche and Jung in saying:

> It would indeed be comforting to believe that nothing which has touched intelligence is lost and that eternity

[9] G. de Nerval, *Aurelia*.
[10] P. Deschamps, "La notion d'ambiguité."
[11] H. Bergson, *Matière et Memoire*.

> preserves a sort of UNIVERSAL HISTORY [this expression
> is so Jungian before its time we wanted to stress it] which
> can be perceived by the soul's eye as a divine synchro-
> nism, perhaps one day initiating us into the science of
> those who can see at a glance the entire future and the
> entire past.[12]

As the associationists laboriously discovered later on, images have
many more ways of establishing relationships than do concepts: to
the four causes of Aristotle the image adds the whole gamut of
synchronicities, spatial relationships, relationships that are due to the
multiple manifestations of colour, form and assonance. The image
has a specific logic of its own, which requires complete surrender of
the principle of identity as well as its famous corollaries: non-contra-
diction and exclusion of the middle. Having abolished the
chronology of time and the three-dimensionality of space, the image
is not bound by linear thinking and bivalent logical sequences. It relates
on the basis of analogies, or even better said, of "homologies," using
the entire arsenal of rhetoric—so much vaster than that of logic:
litotes, hypotyposis, catachresis, etc.[13] The ambiguity of the symbol
means above all that there is no choice, that the symbolic image compels
recognition as a result of its logical, existential presence. Gerard
strongly experiences the multiplication and, at the same time, the
concentration of the self, which first doubled is then multiplied
indefinitely. The Count of Saint-Germain experienced this loss of
identity as follows: "I seemed to perceive an uninterrupted chain of
men and women, in whom I was and who were I."[14]

Here, phenomenal space is abolished and replaced by extension—
i.e., a concrete representation—where states of dissociation,
multiplication and concentration concretize the ubiquity of the self
and of the values pertaining to it. The time involved in this experi-
ence also differs radically from the time on the clock, inasmuch as
the anachronism of the dream, the experience of re-living and
"re-miniscing," weakens the exigencies of old Chronos.

All this results not only in the famous disorientation of the senses,
or the well-known correspondences recognized by the poets, but also

[12] G. de Nerval, "Les deux Faust de Goethe."

[13] G. Durand, *Structure anthropologiques de l'imaginaire* (Part 3, "Structures et figures de style"), 3rd ed., Bordas, 1969.

[14] G. de Nerval, *Cagliostro*.

in the total subversion of rationalist logic. In this synchronic universe, of which the eternal return and the redundance of the imaginary tale are typical,[15] linear causality and determinisms based on identity and noncontradiction no longer work, submerged as they are by the tide of ambiguous relationships: the thread of the discourse is caught in the synchronic mass of meanings. Through the poetic exploration of the imaginal, romanticism discovered a way of being which is neither a part of the world of phenomena, subject to pure reason, nor is it a part of the "transcendental subject," thinking this world and made for thinking this world, nor is it able to escape this essential mirror condition except by the absurd furor of existentialist fragmentation.

Beyond the transcendental self, beyond the self fragmented by existence, beyond the world of phenomena, another modality of being is revealed: the modality of the *mundus imaginalis*, that gigantic net, woven by the dreams and the desires of the species, in which the little realities of everyday life are caught despite themselves.

Via surrealism this exploration extends right to contemporary poetics. Without detracting from the genius of Freud, it should, however, be recognized that this experiment was continued irrespective of him. In comparison with contemporary explorations of the imaginal, Freud played the role which was played in the nineteenth century by Hervey de Saint-Denis or the psychologists: he was the popularizer and codifier, reducing the exploration of the poets to the level of the mechanistic epistemology of that time. The exploration of a profound world, begun by Nerval, Arnim or Holderlin and carried on by Breton and his followers, had to straddle, as it were, Freudianism. For despite its very great merits, the Freudian interpretation, as Ricoeur[16] pointed out, represents a Viennese physician's timid attempts at hermeneutics. Freud did not give the image the bold status which the poets and even Nietzsche conferred upon it. For Freud the image was but a symptom of something else, which again reduced the imaginal to a way of being alien to its nature and structure.[17] Not until Jung and Bachelard was the imaginal recognized as royal.

With all the necessary romantic vigour, Jung took up the investigation of the profound individuating world which we meet in dreams

[15] Levy-Strauss wrote in *L'Anthropologie structurale* (Paris, 1958) that myths are characterized by "redundancy." It is thanks to this "redundancy" that it is possible to study a tale or a series of tales thematically (trans., New York and London, 1963).

[16] P. Ricoeur, "Essai sur Freud," *De l'interpretation* (Paris, 1965).

[17] G. Durand, *L'Imagination symbolique* (Paris, 1964, 1968).

and symbols. Repudiating the dream as a form of simple disinterest, Bergson[18] looked upon this world from afar as a confused promised land. However, he never entered it, thus leaving the gates—made neither of ivory nor of horn—open to the existentialists, those desperate neo-classicists, catering to the nihilistic tastes of our times. Thanks to his knowledge of ethnology and traditional philosophy, Jung understood the spiritual meaning of this deeper world. At the same time, Gaston Bachelard provided the epistemological basis for drawing up a statute of the poetic as opposed to the positivistic mind.

Elsewhere we described the strange, spiritual adventure of Gaston Bachelard,[19] French chemist and author of *Formation de l'Esprit Scientifique* (The Development of the Scientific Mind). Initially he set out to demonstrate the inanity and harmfulness of irrational residues, using the dramatic example of the symbolism of fire.[20] However, undergoing a sort of poetic conversion, he became aware of the coherence and poetic reality of mental imagery.

From this moment on, Bachelard proceeded to reestablish the importance of both reverie and the dreamer, placing them on a level equal to that of the scientific approach. He demonstrated that the philosophers of our day should show the same devotion to the two polar concerns of the intellect: science and poetry. The vague form of intuition, which Bergson used as an antithesis to "science" (i.e., rational thought), was defined by Bachelard as "poetics" and studied as such. The half-converted epistemologist then devoted an important part of his exploration to literary reverie. Using the matrix of the four "elements," Bachelard came to discover that, unlike the sterile functioning of scientific methodology, images are dynamic matter derived from our active participation in the world and constitute the spiritual "flesh," the efflorescence of what is most profoundly felt and expressed by man in his innermost self. And finally, in his last, more syncretic writings *Poetique de la Reverie* (*Poetics of Reverie*) and *Poetique de l'Espace* (*Poetics of Space*), where he took up the results of his research published in *L'Air et les Songes* (*Air and Dreams*), Bachelard was to make the major discovery, which constituted the basis for my

[18] Bergson, *L'Energie spirituelle.*

[19] G. Durand, *L'Imagination symbolique, op. cit.*

[20] G. Bachelard, *La Psychanalyse du feu* (Paris: Gallimard, 1968 [new edition], London, 1964).

own investigations, that imagination is the product of *imagining forces,* that the common denominator of all imaginal construction is "verbal" (dynamic) rather than "substantive" (static) or even "qualifying" (descriptive).

Bachelard's main merit was to have had the courage—he, a professor of the philosophy of science at the Sorbonne—to raise poetic imagination to a level equal in importance with scientific knowledge. In recent times philosophical thought has tended to waver between existentialism, with its negative attitude toward science as well as its alienation from poetics, on the one hand, and formalist structuralism, which vainly attempted to reduce the study of man, anthropology, to the formalism of the sciences and matter, on the other. Bachelard, however, naively showed that there was a third approach. It was the same that had been so brilliantly affirmed by the romantic poets: the royal path of creative imagination. It is, of course, true that Bachelard, unlike some of the surrealists, never completely cast off his positivist attitudes.[21] It remains nonetheless true that Bachelard's study of poetry constitutes the most solid baggage for anyone wishing to embark on more far-reaching explorations of the imaginal.

Ultimately, however, Jung was the one to have earned the greatest merit with his pursuit of research into the imaginal in his autobiography,[22] in his search for imaginal truths outside our own civilization, and in clinical research. Jung's dual devotion to the realm of poetry and to psychoanalysis made him Freud's continuator in one way. In another, of course, it also set him apart, in that he placed his depth psychology on a totally different level from psychoanalysis.

Picking up experimentation where the romantics had left off, Jung insisted on the finality of the symbolism expressed by dream images. For him the image is not simply a record of something that has happened before, a reproduction, but more than that a plan, a design. Freud reduced the meaning of dreams to a simplist, symptomatic screen woven by the limited manifestations of libido. Jung, on the other hand, attributed an intrinsic value to the polymorphous wealth of dream images. This efflorescence of images is even more than a

[21] In this Bachelardian differentiation we can, however, discover the traditional distinction made between purely arbitrary fantasy or fancy, and true creative imagination.

[22] C. G. Jung (with A. Jaffe), *Memories, Dreams, Reflections* (New York, 1963).

design; it is the ambiguous filigree work of destiny. Moreover Jung, like the romantics, insisted on a genetic approach to the exploration of dream images. The soul of the dream is not just a form of individual prospection, but it is archaic. More than the expression of one individuating fate, it is the recollection of the ancestral destiny of the entire species. To this radical function of certain images (the archetypes or primordial images) Jung gave the highly debatable name of "collective unconscious."

One can easily imagine the extent to which the Jungian research into the world of images was a terrible source of embarrassment to Western scientism and even to the mild caution of Freudianism. As a result of Jung's work, the good conscience of classic psychologism, first questioned by romantic poetics, was subverted to a point of no return. Not only did the imaginal assert itself on a surreal level but, to make matters worse, it turned out to have at useful purpose, an eschatological necessity. Jung shook traditional Western philosophy at its very foundations. The surrealists were the first to have attempted a philosophical rehabilitation of Lautreamont, Arnim, Nietzsche, Sade, Arcimboldo, Meryon, Bresdid and all those discarded by the good science of the rationalists. With Jung, as with Bachelard, alchemy resumed its place among the philosophies. With Jung, Goethe replaced Hume; Paracelsus, Descartes; and Boehme, Galileus. We begin to see the outlines of an anti-history of philosophy, about which much could be written: it would be the history of all the opportunities missed by the West and, in particular, the opportunity of remaining feminine, which Levi-Strauss deplored so much as having been missed by our culture.

Thanks to Bachelard and Jung, a link was established between the works of imagination—literature and the arts—and the psychic manifestations of the imaginal. Unlike Freud's reduction of culture to a mere misadventure of the libido, theirs was not a one-way, but a two-way approach. They assumed that culture and its works both inspire and guide the visions of desire, without necessarily censoring or mutilating them.[23] The exploration of art took on new dimensions: works of art were no longer considered mere subjective expressions of the limitations of desire and its sublimating projections, but were

[23] This has not always been achieved by Charles Mauron's psycho-criticism which is limited by too strictly a Freudian point of view.

also assumed to have a genetically and socially compensatory function. Works of art are the guide, the anti-fate (according to Malraux), which gives any human society the possibility of compensating for the pressing needs of its socio-historical destiny.

* * *

With the total subversion of the typically iconoclast Western way of thinking, a relationship was established between the philosophy of the *mundus imaginalis* and traditions that were non-Western and not mere reflections of reason. Bachelardian or Jungian synchronism was the product of anti-history, a form of human existence that manifests itself obstinately, in spite of and counter to the history of technological progress or the succession of political events. Similarly, the ruptured cultural habits of Western philosophy resulted in the introduction of Oriental philosophy—the Orient here meaning that which is at variance with the Occident.

No wonder that, just like Jung, Nerval—in the manner typical of so many other romantic painters, poets and musicians—set out for the "Orient" to seek cultural confirmation of certain psychic experiences. In Nerval's writings the deadly insufficience of Western pseudo-spirituality was a *leitmotiv* for his initiatory quest: his *Voyages en Orient and Notes de Voyage* went hand in hand with his essays in *Illuminés et Illuminisme* as well as his tales of initiation, such as "*L'Histoire de la Reine du Matin et de Soliman.*" Nerval's association with Free Masonry, whose Oriental and Templar filiations are well known, indicates that the defender of the dream, the author of *Aurelia*, was looking outside Christianity for a philosophical palliative. For Western esoteric attempts were concealing the true spiritual realities.

We might do well to engage in some reflections on the fashion of exoticism, which started in the eighteenth century and is becoming ever more popular. It is easy to talk about the "results" of colonial conquests. But the course marked by the imaginary Persians and Hurons of the eighteenth century and the *Zarathustra* of the nineteenth cannot be reduced to a mere epiphenomenon of politico-economic history. The Japanese world discovered by Van Gogh at Arles was infinitely more profound than that discovered by Loti. The Egyptomania expressed in *The Magic Flute*, in Sethos and the Martinish lodges preceded and prefaced Napoleon's Egyptian

campaign and the Empire style. The soul's miseries can carry us as far as any technological means of transportation.

Jung's many trips to North Africa, to Kenya, Uganda, India or his visit to the Pueblo Indians were, like those of his romantic predecessors and contemporary ethnologists, designed to obtain anthropological "confirmation" of the truths he had encountered while exploring the imagination of the people around Zürich. To his own amazement, the father of depth psychology discovered that the most intimate, the most predestinating constructions in the dreams of ignorant Westerners were structurally and materially comparable to those in Indian and Tibetan myths and rites. Similarly, at the end of Aurelia's ultimate inner quest, after having opened and passed beyond "the portals of horn and ivory," Nerval was able to compare his penetration into the depths of the self to the initiation rites he had observed in the course of his travels to the geographic Orient:

> However, I am pleased with the convictions I was able to
> gain and I can only liken the trials I had to go through to
> what our ancestors would have called a descent into Hell.[24]

Nerval's and Jung's accounts of their pilgrimages to the East, their return to the source, are clear evidence of the important role played by ethnology and Orientalism in the exploration of the imaginal over the past century. Contrary to ours, other cultures did have what Levi-Strauss so aptly called "the privilege of remaining feminine" (or better said, the privilege of androgeny), of not neglecting the feminine guide of imagination, the creative Sophia.

In this connection, it is useful to recall two anthologies published in the last few years: *Les Songes et leur Interpretation and Le Rêve et les Sociètés Humaines.*[25] These volumes demonstrate the value which all non-Occidental cultures placed on the experience of pure imagery, i.e., the dream. They recognized in the dream the authentic manifestation of man's most spiritual self. These volumes present histories of civilizations reaching far beyond our little Faustian history of the last thousand years and describe man's history in ethnological space—the space of man as he really is, of the individual who is beyond the Western illusion of representing the Civilization.

[24] *Sources orientales* (Paris: du Seuil, 1959).

[25] Prepared with the collaboration of various authors and edited by R. Caillois and G. E. von Grunebaum (Paris, 1967).

From the immense repertory of ethnology, we can glean innumerable examples, amplifying and clearly describing the romantics' rediscovery. Disregarding what some people still persist in calling "primitive" cultures, we need only turn to Tantric Buddhism[26] for a minute exegesis of research into a world where the dream blends with the *post mortem* (*Bardo*) state, just as Nerval had intuited it. The science of guiding images is outlined with astonishing precision for example in the *Tibetan Book of the Dead*, which describes how the soul is guided to the *Bardo*[27] state after death. In the West the science of guiding dreams, sketched by Hervey de Saint-Denis, had never been developed on the basis of such accurate research.

However, let us now turn to another great culture, one closer to ours—since, like ours, it had far-off Abrahamic origins—and which was in fact even closet prior to the Averroist misunderstanding. I am referring to Islamic culture, in which for thirteen centuries the imaginal was the focal point, the crossroads where the tangible world (*le sensible*) met the world of meaning (*le sense*). Islamic thinking is entirely focused on the place, not on time as in Christian historicism,[28] where the soul, modeled on the example of the Prophet, draws the meaning that establishes order in matter. This privileged place of *Alam al-Mithal* (*mundus imaginalis*) is the place of spiritual revelation, and all images, all symbols as well as all dreams, gravitate around this intermediary world.

It is rather overwhelming to see that even before the year one thousand A.D. (in just four centuries) Islamic literature was enriched by 7500 treatises on dreams. Al Khallal cited 600 authorities on the subject.[29] As did Coleridge, Bachelard, and Paracelsus, all these authors carefully differentiated between the purely humoral dream, or that involving distorted perception, and the true dream, which gives us pure and full access to our mental faculties. Just as the romantics and especially Gerard de Nerval compared the dream experience to experience of the beyond, many *hadiths* and even the

[26] Lama Anagarika Govinda, *Les Fondements de la mystique thibetaine* (Paris, 1960).

[27] *The Tibetan Book of the Dead*, ed. W. Y. Evans-Wentz (New York, 1957.

[28] On the "spatialization" of Islamic thought," cf. F. Schnon, *Comprendre l'Islam* (Paris, 1962).

[29] Toufy Fahd, "Les Songes et leur interpretation selon l'Islam", *Les Songes et leur interpretation, op. cit.* Cf. also L. Massignon, "Les Themes archetypiques en onirocritique musulmane," *Eranos Jahrbuch XII*, Zürich, 1945.

Koran equated the dream with the survival of the soul after death: "God will receive the souls at the moment of their death, and those that are not dead, during their sleep..." (*Koran* 34:42; cf. 42:50-51).

However, the most important aspect of the phantasmological tradition in Islam was not the likening of dreams to a prophetic vision or a prediction (a perfectly common practice in non-Western societies), but the valuing of that other world revealed by dreams, symbols and visions. For Western and Christian philosophy there is a void between the mind and the body, the mind going only as far as bodily extension and beyond that vanishing into thin air, as if melted by the limited method of positivism. In contrast, for the Islamic Orient, as for Tantrism, there is an intermediary world (*barẓakh*), the *Alam al-Mithal*,[30] the mundus imaginalis, the imagining of which constitutes an exploration.

The explorers and theoreticians of this *mundus imaginalis* found their most brilliant representatives in the great Avicenna (d. 1037), Sohrawardi (d. 1191), Ibn 'Arabi (d. 1240) and Molla Sadra. They all delved into the world of the image, this intermediary world which Kantian pre-romanticism only began to dream of seven centuries later. It is the world where ideas, i.e., the pure spiritual forms of Platonism (the dynamic patterns, as modern psychologists would put it) are actually embodied, where they take on symbolic form or "body" and polarize desire. Here the bodies, i.e., the objects of the tangible world, are in turn spiritualized, acquiring meaning and extending desire to its semantic and eschatological horizons.

Like the Prophet's exemplary *mi'raj*, visions and dreams give direct access to the world of meaning, i.e., the juncture of the signifying with the signified. The great scholar of visionary Islamic literature and thought, Henry Corbin, pointed out that the world of images is quite real; it retains the rich and diverse manifestations of the tangible world, just like Nerval's dreams. At the same time, they are removed from the world of fixed time and the limitations of space. "The existence of this world presupposes the ability of being able to transcend tangible space without leaving extension." Thinking of

[30] Fazlur Rahman, "Le Rêve, l'imagination et Alam al-Mithal," *Le Rêve et les societes humaines, op. cit.* Cf., above all, H. Corbin "Le Songe visionnaire et la spiritualité islamique," *Le Rêve et les societés humaines, op. cit.*; *L'Imagination creatrice dans le Soufisme d'Ibn 'Arabi* (Paris, 1958, trans. Princeton and London, 1969); *Avicenne et le récit visionnaire, op. cit.*; *L'Oeuvre philosophique et mystique de Shihabaddin Yahya Sohrawardî,* edition with French prefaces, 2 vols. (Paris-Teheran: A. Maisonneuve, 1952).

Nerval's dream experience as well as the intuition of Bergson (though he missed the point!), we might even add: one can transcend time without giving up the individuation of concrete duration, i.e., the anticipating concentration, as a result of which the individual defines himself by means of a *super-cogito*,[31] as constituting a sufficient though non-essential presence for himself.

And in the same manner in which the romantics, surrealists and depth psychologists rediscovered concrete spiritual experience through the image, the Shi'ite and Sufi thinkers developed a theory of "creative imagination"[32] whose scope, precision and depth surpassed anything ever discovered in the West. Imagination, the queen of faculties, was demonstrated and experimented with. Their research into non-perceptual visions, dreams, reverie, symbolic epiphanies enables us to reach and to visualize a level of truth which is inaccessible to the ways of reason or the utilitarian impact of tangible perceptions.

On the basis of the invaluable contribution made by "Oriental" research into the imaginal and into depth psychology, we are bound to a course of exploration which gives clear pre-eminence to the imaginal, precluding its reduction to the beaten tracks of rationalism and classical perceptionism. Anthropologically, we are obliged to take account of what Islamic authors would call the confluence or harmony of the two exploratory approaches: the Sophianic approach of the Orient and the more recent and more didactic one of a Western culture that has been de-mystified by a thousand years of alienating shortsightedness. This shortsightedness, which "when someone points to the moon sees only the tip of the finger," and the mutilated, downgraded, intellectual attitude of narrow-minded rationalism and simple-minded historicism—those frustrating blindspots of Western genius—have been thrown off by the exploratory exegesis of the imaginal.

[31] That is, in the very core of being, which is not the "transcendental self," but the principle of the "self" that transcends necessity.

[32] H. Corbin, *L'Imagination creatrice dans le Soufisme d'Ibn 'Arabi, op. cit.* and *Terre celeste et corps de resurrection* (Paris, 1961).

SPRING 1972

Cover of *Spring 1972*. The image is of Flora and Chloris from Botticelli's painting, "La Primavera," in the Uffizi Gallery in Florence.

Editor's Note

Henry Corbin (1903-1978) is the second immediate father of archetypal psychology after Jung. In this masterful, if difficult, essay, Corbin shows many of the reasons why. Through his careful articulation of Islamic thought regarding the imaginal, Corbin connects the world of the archetypes (*mundus archetypalis*) with the world of the image (*mundus imaginalis*). This imaginal world presents an order of reality all its own, says Corbin. He describes this reality as an intermediary world of image possessing an integrity on par with the world of bodily sensation and the world of abstract intellect, thereby positing an ontological foundation for imaginal work in general and archetypal psychology in particular. He completes this move by recognizing that "Imagination is the cognitive function of this [intermediary] world." In one swoop he thus frees imagination from its modern exile as the missing third of the matter/spirit dualism.

The significance of Corbin's views are difficult to overestimate. Here is a perspective that reestablishes the world of the image as "perfectly real" while simultaneously refusing to limit "reality" to literalized physical phenomena. Corbin, and the tradition he presents, provides a way through the obfuscating dilemmas presented by the rational intellect and the everyday misperceptions presented by the senses. Refusing to be caught in either bramble, Corbin instead articulates a world between these other places. The *mundus imaginalis*, he insists, is a median and mediating place requiring methods and styles different from those of the intellect or physical sensation. According to Corbin, the world of images "is hidden behind the very act of sense perception and has to be sought underneath its apparent objective certainty." Here is one of Corbin's many extraordinary ideas— that the sensate world rests on imaginal fundaments.

Given the integrity of the *mundus imaginalis*, and the correspondences between it and others worlds, the world of the image therefore "provides the foundation for a rigorous analogical knowledge." An imaginal world implies and necessitates imaginal capabilities, says Corbin, and he thus identifies imagination as the primary capacity and activity of the *mundus imaginalis*. Corbin's perspective thereby establishes the ontological reality of the psychological world while also teaching us how to proceed within it psychologically.

Corbin's is an impassioned and intelligent plea, nay demand, for the integrity and independence of the soul. The "imaginal" is not "imaginary," he says, but a real place that is both everywhere and nowhere (*Na-Koja-Abad*); an intermediary place of the image in which all other places find a place.

MUNDUS IMAGINALIS:
OR THE IMAGINARY
AND THE IMAGINAL

HENRY CORBIN
(*Spring 1972*)
Translated from French by Ruth Horine

My intention in proposing the two Latin words *mundus imaginalis* as a title for this paper was to circumscribe a very precise order of reality, which corresponds to a precise mode of perception. Latin terminology has the advantage of providing us with a fixed and technical point of reference against which we can compare and measure the various, more or less vague equivalents suggested by modern Western languages.

To begin with, I shall make a confession. The choice of the two words had begun to become inevitable for me some time ago, because I found it impossible to content myself with the word imaginary for what I had to translate or to describe. This is by no means intended as a criticism of those whom language usage compels to have recourse to this word, since all of us are trying merely to revalue it in the positive sense. However, despite all our efforts, we cannot prevent that, in current and non-premeditated usage, the term imaginary is equated with the *unreal*, with something that is outside the framework of being and existing, in brief, with something utopian. The reason why I absolutely had to find another expression was that, for a good many years, my calling and my profession required me to

interpret Arabic and Persian texts, whose meaning I would undoubtedly have betrayed had I simply contented myself—even by taking all due precaution—with the term "imaginary." I had to find a new expression to avoid misleading the Western reader, who, on the contrary, has to be roused from his old ingrained way of thinking in order to awaken him to another order of things.

In other words, if in French (and in English) usage we equate the imaginary with the unreal, the utopian, this is undoubtedly symptomatic of something that contrasts with an order of reality, which I call the mundus imaginalis, and which the theosophers of Islam designate as the "eighth clime." After a brief outline of this order of reality, we shall study the organ which perceives it, i.e., imaginative consciousness, cognitive Imagination; and finally, we shall draw some conclusions from the experiences of those who have really been there.

1. *NÂ-KOJÂ-ABÂD* OR THE EIGHTH CLIME

I just mentioned the word utopian. Strangely enough—or perhaps it is the poignant example—in Persian, our authors use a term that seems to be its linguistic transfer: *Nâ-Kojâ-Abâd*, "the country of nowhere." And yet, this place is anything but a utopia.

Let us look at the very beautiful narratives, which are both visionary tales and tales of spiritual initiation, written in Persian by Sohrawardî, the young sheikh who was "the resurrector of ancient Persian theosophy" in the Islamic Iran of the twelfth century. At the beginning of each narrative, the visionary finds himself in the presence of a supernatural being of great beauty, whom he asks who he is and whence he comes. Essentially, these tales illustrate the Gnostic's experience, lived as the personal history of the Stranger, the captive aspiring to return home.

At the beginning of the narrative, which Sohrawardî entitles *The Crimson Archangel*,[1] the captive, who has just escaped the watchful eyes of his gaolers, i.e., who has momentarily left the world of sensible experience, finds himself in the desert in the presence of a being

[1] Cf. the author's French translation of this little treatise (written in Persian by Sohrawardî) in *En Islam iranien, aspects spirituals et philosophiques*, vol. II, book II: "Sohrawardî et les Platoniciens de Perse" (Paris: Gallimard, 1971). For a more complete study of the topics dealt with here, cf. *ibid.*, particularly vol. IV, book VII on the 12th Imam or the "Imâm caché."

who appears to him to be endowed with all the graces of adoles-
cence. He therefore asks him: "Whence do you come, oh Youth!"
And the answer is: "How so? I am the eldest child of the Creator [in
Gnostic terms the *Protokistos*, the First-Created] and you call me a
youth?" His origin gives the clue to the mysterious purple-red colour
in which he appears: it is the colour of a being that is pure Light,
whose brilliance is attenuated to a twilight purple by the darkness of
the world of earthly creatures. "I come from beyond Mount Qâf...
This is where you were at the beginning and it is where you will
return, once you are free of your shackles."

Mount Qâf is the cosmic mountain, which, summit after summit
and valley after valley, is built up of celestial spheres, all enveloping
one another. Where then is the road that leads out of it? What is the
distance? "However far you may journey," it is said, "you will always
come back to the point of departure," just as the needle of the compass
always swerves back to the magnetic point. Does this simply mean
that you leave yourself to come back to yourself? Not quite, because,
in the meantime a very important event will have changed everything.
The *self* one finds yonder, beyond Mount Qâf, is a higher self, the
self experienced as a "Thou." Like Khezr (or Khadir, the mysterious
prophet, the eternal wanderer Elijah or his double), the traveller has
to bathe in the Spring of Life.

> He who has discovered the meaning of True Reality has
> arrived at this Spring. When he emerges from the Spring,
> he is endowed with a Gift that likens him to the balsam
> of which a drop, distilled in the hollow of one's hand
> held up against the sun, trans-passes to the back of the
> hand. If you are Khezr, you, too, can pass beyond Mount
> Qâf without difficulty.

The expression *Nâ-Kojâ-Abâd* is a strange term. It is not listed in
any Persian dictionary, and, as far as I know, it was forged by
Sohrawardî himself by using purely Persian roots. Literally it means
the city, the land (*abâd*) of nowhere (*Nâ-kojâ*). This is why we are
confronted here with a term that, at first sight, may seem to us to be
the exact equivalent of the term *ou-topia*, which in turn is not listed in
any of the classical Greek dictionaries and was created by Thomas
More as an abstract concept to denote the absence of any localiza-
tion, of any given situs in the kind of space that can be explored and

controlled by our sense experience. Etymologically and literally it might be correct to translate *Nâ-Kojâ-Abâd* by *outopia* or utopia, and yet I believe that this would be a misinterpretation of the concept, the intention behind it, as well as its meaning in terms of lived experience. It therefore seems to me exceedingly important at least to try to find out why it would be a mistranslation.

I believe it is indispensable here to be clear in our minds as to the real meaning and impact of the mass of information about the topographies explored in a visionary state, i.e., the intermediary state between waking and sleeping, including the information that, for the spiritualists of Shî'ite Islam, concerns the "country of the hidden Imâm." In alerting us to a differential that relates to an entire area of the soul, and hence to an entire spiritual culture, this clarification would lead us to ask: under what circumstances does what we currently call a utopia, and therefore the type of man called utopist, become possible? How and why does he make his appearance? I am in fact asking myself whether anything like it can be found in traditional Islamic thought. I do not believe, for example, that the descriptions of the "Perfect City" by Fârâbi in the tenth century, or, along the same lines, the "Rule of the Solitary"[2] by the Andalusian philosopher Ibn Bâjja (Avempace) in the twelfth century, were projections of what we call today a social or political utopia. To understand these descriptions as utopias, we would, I fear, have to abstract them from their own premises and perspectives, imposing our own dimensions instead. Above all, however, I fear that we would have to be resigned to a confusion of the Spiritual City with an imaginary city.

The word *Nâ-Kojâ-Abâd* does not denote something that is shaped like a point, not having extension in space. In fact, the Persian word *abâd* stands for a city, a cultivated region that is inhabited and consequently an expanse. What Sohrawardî therefore describes as being located "beyond Mount Qâf" is what all the mystical cities, such as Jâbalqâ, Jâbarsâ, and Hûrqalyâ, represent for him and through him for the entire theosophist tradition of Islam. It is made quite clear that topographically this region starts at the "convex surface" of the ninth Sphere, the Sphere of Spheres, or the Sphere that envelops the Cosmos as a whole. This means it begins at the very moment one

[2] Cf. Henry Corbin, *Histoire de la philosophic islamique*, vol. I, (Paris: Gallimard, 1964), 222*ff.*, 317*ff.*

leaves the Supreme Sphere, which defines all the types of orientation possible in our world (or on our side of the world), the "Sphere" to which the cardinal points refer. It becomes obvious that, once this border has been crossed, the question "where" (*ubi, koja*) becomes meaningless at least in terms of the meaning it has in the realm of sensible experience. Hence we find the expression *Nâ-Kojâ-Abâd*, which is a place out of space, a "place" that is not contained in any other place, in a *topos*, making it possible to give an answer to the question "where" by a gesture of the hand. What precisely do we mean, however, when we talk of "leaving the where"?

Undoubtedly what is involved is not a movement from one locality to another,[3] a bodily transfer from one place to another, as would occur in the case of places in the same homogenous space. As suggested at the end of Sohrawardî's tale by the symbol of the drop of balsum in the hollow of the hand held up to the sun, it is essential to go inward, to penetrate to the interior. Yet, having reached the interior, one finds oneself paradoxically on the outside, or, in the language of our authors, "on the convex surface" of the ninth Sphere, in other words "beyond Mount Qâf." Essentially the relationship involved is that of the outer, the visible, the exoteric (in Greek *ta exô*, in Arabic *zâhir*) to the inner, the invisible, the esoteric (in Greek *ta esô*, in Arabic *bâtîn*), or the relationship of the natural to the spiritual world. Leaving the where, the ubi category, is equivalent to leaving the outer or natural appearances that cloak the hidden inner realities, just as the almond is concealed in its shell. For the Stranger, the Gnostic, this step represents a return home, or at least a striving in this direction.

Yet strange as it may seem, once the journey is completed, the reality which has hitherto been an inner and hidden one turns out to envelop, surround, or contain that which at first was outer and visible. As a result of internalization, one has moved out of external reality. Henceforth, spiritual reality envelops, surrounds, contains so-called material reality. Spiritual reality can therefore not be found "in the where." The "where" is in it. In other words, spiritual reality itself is the "where" of all things. It is not located anywhere and it is not

[3] Therefore the representation of the Sphere of Spheres is only a schematic indication in peripatetic or Ptolemean astronomy; it continues to be valid, even though this astronomy has been given up. This means that no matter how high you might be able to go by rockets or Sputniks, you will never have progressed one inch toward *Nâ-Kojâ-Abâd*, because the "threshold" will not have been crossed.

covered by the question "where," the *ubi* category referring to a place in sensible space. Its place (*abâd*) as compared to the latter is Nâ-kojâ (nonwhere) because, in relation to what is in sensory space, its *ubi* is an *ubique* (everywhere). Once we have understood this, we perhaps understand the most important thing enabling us to follow the topography of visionary experiences. We may discover the way (*sens* in French), both in terms of meaning and in terms of direction. Moreover, it may help us to discover what distinguishes the visionary experience of spiritualists, like Sohrawardî and so many others, from such pejorative terms in our modern vocabulary as "figments of the mind" or "imaginings"—to wit, utopian fantasies.

At this point, however, we must make a real effort to overcome what one might call Western man's "agnostic reflex," since it is responsible for the divorce between thinking and being. A whole host of recent theories have their tacit origin in this reflex, and it is expected to help us escape the other realm of reality that confronts us with certain experiences and evidence. We try to run from this reality, even when we are secretly attracted by it. As a result we give it all sorts of ingenious explanations but discard the only one which would by its very existence suggest what this reality is! To understand the hint we would in any event have to have a cosmology that cannot even be compared with the most outstanding discoveries of modern science in relation to our physical universe. For as long as we are exclusively concerned with the physical universe, we remain tied to the mode of being "on this side of Mount Qâf." The traditional cosmology of Islamic theosophers is characterized by a structure consisting of the various universes and intermediate as well as intermediary worlds "beyond Mount Qâf," i.e., beyond the physical universes. It is intelligible only to a mode of existence whose act of being is an expression of its presence in these worlds. Conversely, owing to this act of being, these worlds are present in it.[4] What then is the dimension of this act of being that is, or will be in the course of future palingeneses, the place of these universes which are outside our natural space? And first of all, what worlds are these?

[4] On this notion of presence, cf. in particular the author's introduction to Mollâ Sadrâ Shîrâzî, *Le Livre des Pénétrations métaphysiques* (*Kitâb al-Mashâ'ir*), French edition and translation, Bibliotheque Iranienne, vol. 10, (Paris: Adrien Maisonneuve, 1964), index s.v.

There is the physical, sensible world encompassing both our terrestrial world (governed by the human souls) and the sidereal universe (governed by the Souls of the Spheres). The sensible world is the world of the phenomenon (*molk*). There is also the supersensible world of the Soul or Angel Souls, the *Malakût*, in which the above mentioned mystical Cities are located, and which starts at the "convex surface of the ninth Sphere." And there is the world of pure archangelic Intelligences. Each of these three worlds has its organ of perception: the senses, imagination, and the intellect, corresponding with the triad: body, soul and mind. The triads govern the threefold development of man extending from this world to his resurrections in the other worlds.

We realize immediately that we are no longer confined to the dilemma of thought and extension, to the schema of a cosmology and a gnoseology restricted to the empirical world and the world of abstract intellect. Between them there is a world that is both intermediary and intermediate, described by our authors as the *'âlam al-mithâl*, the world of the image, the *mundus imaginalis*: a world that is ontologically as real as the world of the senses and that of the intellect. This world requires its own faculty of perception, namely, imaginative power, a faculty with a cognitive function, a noetic value which is as real as that of sense perception or intellectual intuition. We must be careful not to confuse it with the imagination identified by so-called modern man with "fantasy," and which, according to him, is nothing but an outpour of "imaginings." This brings us to the heart of the matter and our problem of terminology.

What is this intermediary universe, i.e., the one we referred to earlier as the "eighth clime"?[5] For all our thinkers the sensible world of space consists of the seven climes belonging to traditional geography. However, there is another clime represented by a world possessing extension and dimension, figures and colours; but these features cannot be perceived by the senses in the same manner as if they were the properties of physical bodies. No, these dimensions, figures, and colours are the object of imaginative perception, or of the "psycho-spiritual senses." This fully objective and real world with equivalents for everything existing in the sensible world without being

[5] For what follows, cf. Henry Corbin, *Terre celeste et corps de résurrection: de l'Iran mazdéen a l'Iran shî'ite*, (Paris: Buchet-Chastel-Correa, 1961), 130, 133, 142*ff.*, 199*ff.*

perceptible by the senses is designated as the eighth clime. The term speaks for itself, since it signifies a clime outside all climes, a place outside all places, outside of where (*Nâ-Kojâ-Abâd*).

The *terminus technicus* in Arabic, *'âlam al-mithâl*, might also be translated by *mundus archetypus*, provided one is careful to avoid confusion with another expression. For the same word (*'âlam al-mithâl*) is used in Arabic to render the concept of the Platonic Ideas (interpreted by Sohrawardî in terms of Zoroastrian angelology), with the only difference that when it is used to denote Platonic Ideas it is almost always accompanied by the very precise qualification *mothol* (plural of *mithâl*), *aflâtûnîya nûrânîya*, "the Platonic archetypes of light." Whenever the term is used to describe the world of the eighth clime it refers, on the one hand, to the archetypal images of individual and singular things; in this case it refers to the oriental region of the eighth clime, the city of Jâbalqâ, where these Images subsist pre-existent and pre-ordained in relation to the sensible world. On the other hand, the term also refers to the Occidental region, the city of Jâbarsâ. It is the world or intermediary world where the spirits dwell after their sojourn in the natural terrestrial world, and the world in which the forms of our thoughts and desires, of our presentiments and of our behaviour and of all works accomplished on earth subsist.[6] The *'âlam al-mithâl*, the *mundus imaginalis*, is made up of all these manifestations.

To use once more the technical language of our thinkers, the *'âlam al-mithâl* is also designated as the world of "Images in suspense" (*mothol mo'allaqa*). Sohrawardî and his school understand by this a mode of being corresponding to the realities of this intermediary world, and which we shall designate as Imaginalia.[7] This well-defined ontological status is based on visionary spiritual experiences which Sohrawardî holds to be as fully relevant as the observations of Hipparchus or Ptolemy are considered to be relevant for astronomy. Of course, the forms and figures of the *mundus imaginalis* do not subsist in the same manner as the empirical realities of the physical world, otherwise anyone would have the right to perceive them. The authors also noticed that these forms and figures could not subsist in the purely intelligible world, that they had indeed extension and dimension, an "immaterial" materiality compared to the sensible world,

[6] *Ibid.*, 202*ff.*, 251*ff.*
[7] *Ibid.*, 142*ff.*, 199*ff.*

but that they also had a corporality and spaciality of their own. (In this context, I wish to recall the expression *spissitudo spiritualis* coined by Henry More, the Platonist of Cambridge; it has its exact equivalent in the writings of Sadrâ Shîrâzî, the Persian Platonist.) For the same reason, they considered it impossible for one mind to be the sole substratum for these forms and figures; and the possibility that they must be unreal, sheer nothingness, was also discarded, as otherwise we would not be able to discern, to grade or to evaluate them. The existence of this intermediary world, the *mundus imaginalis*, therefore, became a metaphysical necessity. Imagination is the cognitive function of this world. Ontologically, it ranks higher than the world of the senses and lower than the purely intelligible world; it is more immaterial than the former and less immaterial than the latter.[8] This approach to imagination, which had always been of prime importance for our mystical theosophers, provided them with a basis for demonstrating the validity of dreams and of the visionary reports describing and relating "events in Heaven" as well as the validity of symbolic rites. It offered proof of the reality of the places that occur during intense meditation, the validity of inspired imaginative visions, of cosmogonies and theogonies and above all of the veracity of the spiritual meaning perceived in the imaginative information supplied by prophetic revelations.[9]

In short, this is the world of "subtle bodies," of which it is indispensable to have some notion in order to understand that there is a link between pure spirit and material body. Their mode of being is therefore described as "being in suspense." Like that of the Image or Form this mode of being constitutes its own "matter" and is independent of the substratum to which it is immanent as if by accident.[10] In other words, Form or Image does not subsist in the manner black color subsists through the black body to which it is immanent. The comparison regularly used by our authors is the mode in which Images "in suspense" appear and subsist in a mirror. The material substance of the mirror, whether metal or mineral, is not the substance of the Image; the Image could only accidentally be of the same substance as the mirror. The substance is simply the "place of its appearance."

[8] *Ibid.*, 201.
[9] *Ibid.*, 142.
[10] *Ibid.*, 143.

And thus we are led to a general theory about the epiphanic places and forms, *mazhar* (plural *mazâhir*), which are so characteristic of Sohrawardî's "oriental theosophy."

Active imagination is the mirror par excellence, the epiphanic place for the Images of the archetypal world. This is why the theory of the *mundus imaginalis* is closely bound up with a theory of imaginative cognition and of the imaginative function, which is a truly central, mediating function, owing both to the median and the mediating position of the *mundus imaginalis*. The imaginative function makes it possible for all the universes to symbolize with each other and, by way of experiment, it enables us to imagine that each substantial reality assumes forms that correspond to each respective universe (for example, *Jâbalqâ* and *Jâbarsâ* in the subtle world correspond to the Elements of the physical world, whereas *Hûrqalyâ* corresponds to the Heavens). The cognitive function of imagination provides the foundation for a rigorous analogical knowledge permitting us to evade the dilemma of current rationalism, which gives us only a choice between the two banal dualistic terms of either "matter" or "mind." Ultimately, the "socialization" of conscience is bound to replace the matter or mind dilemma by another no less fatal one, that of "history" or "myth."

Those accustomed to sojourning in the "eighth clime," the kingdom of "subtle bodies," the "spiritual bodies"—threshold of the *Malakût* or the world of the Soul—would never have fallen victim to this dilemma. They say that the world of *Hûrqalyâ* begins "at the convex surface of the supreme Sphere." This is obviously a symbolic way of pointing out that this world is at the limit where the relationship of inferiority expressed by the preposition "in," "inside of," is inverted. Spiritual bodies or entities are not in any world, nor in their world, in the same manner as a material body is in its place or may be contained in another body. On the contrary, their world is in them. Hence, the Theology attributed to Aristotle (that Arabic version of the three last Enneads by Plotinus which Avicenna annotated and which all our thinkers read and meditated in turn) explains that each spiritual entity is "in the entire sphere of its Heaven." Of course, all these entities subsist independently of each other. Nonetheless, all exist simultaneously and each is contained in the other. It would be completely wrong to imagine this other world as undifferentiated and formless.

There is indeed multiformity, but the relative positions in spiritual space differ as much from those in the space encompassed by the starry skies, as the circumstance of existing in a body differs from the fact of being "in the totality of one's Heaven." For this reason it can be said that "behind this world there is Heaven, an Earth, sea, animals, plants and celestial men; but every being in it is celestial; the spiritual entities that subsist there are equivalent to human beings, but this does not mean that they are terrestrial."

> The most exact formulation of all this in the theosophist tradition of the West can perhaps be found in Swedenborg. One can hardly avoid being struck by the extent to which the statements of the great Swedish theosophist and visionary coincide with those of Sohrawardî, Ibn 'Arabî or Sadrâ Shîrâzî. Thus, Swedenborg explains: Although all things in heaven appear in place and in space as they do in the world, still the angels have no notion or idea of place and space. [In fact,] all progressions in the spiritual world are effected by changes of the state of the interiors... Hence, those are near each other who are in a similar state, and those are far apart whose state is dissimilar; and spaces in heaven are nothing but external states corresponding to internal ones. This is the only case that the heavens are distinct from each other... When...anyone proceeds from one place to another...he arrives sooner when he desires it, and later when he does not. The way itself is lengthened or shortened according to the strength of the desire... This I have often witnessed, and have wondered at. From these faces it again is evident, that distances, and consequently spaces, exist with the angels altogether according to the states of their interiors; and such being the fact, that the notion and idea of space cannot enter their thoughts; although spaces exist with them equally as in the world.[11]

This description applies eminently well to the *Nâ-Kojâ-Abâd* and its mysterious Cities. In brief, it follows that there is a spiritual place and

[11] E. Swedenborg, *Heaven and Its Wonders, also Hell and the Intermediate State, from Things Heard and Seen,* trans. Swedenborg Society (London, 1875), 191-195. Swedenborg repeatedly insisted on this doctrine of space and time, e.g., in his little book, *De telluribus in mundo nostro solari.* If this doctrine is not taken into account, visionary experiences can be countered by arguments that are as facile as they are invalid, because they confuse spiritual visions of the spiritual world with the fantasies produced by science fiction. An abyss separates the two notions.

a corporal place. The transfer from one to the other is in a way accomplished according to the laws of our homogenous physical space. By comparison with corporal space, spiritual space is a nonwhere and for those who reach Nâ-Kojâ-Abâd everything happens contrary to the evidence of ordinary consciousness, which remains oriented within our space. For henceforth the where, the place, is located in the soul; the corporal substance resides in the spiritual substance; the soul surrounds and carries the body. As a result, one cannot say where the spiritual place is located. Rather than being situated, it situates, it is situating. Its *ubi* is an *ubique*. Topographical correspondences can, of course, exist between the sensible world and the *mundus imaginalis*, one symbolizing with the other. However, it is not possible to pass from one to the other without a break. This is pointed out by many reports. One starts out, but at some point there is a break-down of the geographical coordinates found on our maps. Only the "traveller" is not aware of it at that moment. He realizes it— either with dismay or amazement—only after the event. If he did notice it, he would be able to retrace his steps at will or indicate the way to others. However, he can only describe where he has been; he cannot show the road to anyone.

2. SPIRITUAL IMAGINATION

Here we touch on the decisive point for which everything that precedes has prepared us, i.e., the organ by means of which the penetration of the mundus imaginalis, the journey to the "eighth clime," is accomplished. What is this organ capable of producing a movement that constitutes a return *ab extra ad intra* (from the outside to the inside), a topographical inversion? It is not the senses or the faculties of the physical organism, much less is it pure intellect. Rather, it is the intermediary power which has a mediating role par excellence, i.e., active imagination. But let there be no misunderstanding here. What is involved is the organ that makes possible a transmutation of inner spiritual states into outer states, into vision-events symbolizing with these inner states. Any progression in spiritual space is accomplished by means of this transmutation, or better even, the transmutation itself is what spatializes the space. It gives rise to the space that is there, as well as to the "nearnesses," the "distances" and the "far-off" places.

The first postulate is that this Imagination must be a purely spiritual faculty, independent of the physical organism and therefore able to continue to exist after the latter has disappeared. Sadrâ Shîrâzî, among others, insisted on this point on several occasions.[12] Just as the soul is independent of the material, physical body, as to intellective capacity for the act of receiving the intelligibles, the soul is also independent as to its imaginative capacity and its imaginative activity. Moreover, when it is separated from this world it can continue to avail itself of active imagination. By means of its own essence and this faculty, the soul is therefore capable of perceiving concrete things whose existence, as actualized in knowledge (cognition) and in imagination, constitutes eo ipso the very concrete existential form of these things. In other words, consciousness and its object are ontologically inseparable here. After this separation all the soul's powers are assembled and concentrated in the sole faculty of active imagination. Because at that time imaginative perception ceases to be scattered across the various thresholds of the physical body's five senses, and because it is no longer required for the care of the physical body, which is exposed to the vicissitudes of the external world, imaginative perception can finally display its true superiority over sense perception.

> (Sadrâ Shîrâzî writes) All the faculties of the soul then become as if they were one single faculty, winch is the capacity to configurate and typify (*taswîr* and *tamthîl*). The imagination of the soul becomes just like a sensible perception of the super-sensible. The *imaginative insight* of the soul is like its sensible insight. Thus, its hearing, its sense of smell, its taste and touch [all these imaginative senses] are just like the corresponding sensible faculties, but these imaginative senses are attributed to the super-sensible. Whereas in the outer world there are five sensible faculties each with its specific organ in the body, in the *inner world* they are *synthesized* into one (*hiss moshtarak*).

Having equated imagination with the *currus subtilis* (in Greek *okhêma*, subtle vehicle or body) of the soul, Sadrâ Shîrâzî sets forth in these texts an entire physiology of the "subtle body" and thereby of the "body of resurrection." And for this reason he accused even Avicenna

[12] Cf. the author's book, *En Islam iranien* (cf. note 1), vol. IV, book V: "L'Ecole d'Ispahân;" Chapter II is entirely devoted to the writings of Mollâ Sadrâ Shîrâzî, cf. also the work cited in note 4.

of having identified these acts of otherworldly imaginative percep-
tion with what happens in dreams during life in the here-and-now.
For, Sadra Shirazi claims, even during sleep, the imaginative power is
affected by the organic activities taking place in the physical body. A
great deal more is therefore required for this power to benefit from a
maximum of perfection and activity, freedom and purity. Otherwise,
sleep would simply be an awakening in the otherworld. That is not
so, however, as suggested by a statement attributed at times to the
Prophet and at times to the First Imîm of the Shî'ites: "Human
beings are asleep. Only when they die, they awaken."

A second postulate results: spiritual imagination is indeed a cog-
nitive power, an organ of true knowledge. Imaginative perception
and imaginative consciousness have their function and their noetic
(cognitive) value within their own world, which is—as pointed out
earlier—the *'âlam al-mithâl*, the *mundus imaginalis*, the world of the
mystical cities such as Hûrqalyâ, where time is reversed and where
space, being only the outer aspect of an inner state, is created at will.

Imagination is thus solidly placed around the axis of two other
cognitive functions: its own world symbolizes with the worlds to which
the two other functions correspond (sensible cognition and intellec-
tive cognition). In other words, there is a type of control to protect
imagination from straying and from reckless wastage. Thus, it can
assume its rightful function and bring about the events related in the
visionary narratives of Sohrawardî and others. For the approach to
the eighth clime must be made via the imagination. This may be the
reason for the extraordinary soberness of language encountered in
Persian mystical epics (ranging from *'Attâr* to *Jâmî* and on to *Nûr 'Alî-
Shâh*), where the same archetypes are constantly amplified and
reamplified by new symbols. Whenever imagination strays and is
wasted recklessly, when it ceases to fulfill its function of perceiving
and producing the symbols that lead to inner intelligence, the *mundus
imaginalis* (which is the realm of the *Malakût*, the world of the soul)
may be considered to have disappeared. In the West, this decadence
may date back to the moment when Averroism rejected the Avicennian
cosmology with its intermediary angelic hierarchy of the *Animae* or
Angeli caelestes. These *Angeli caelestes* (on a lower rung of the hierarchy
than that of the *Angeli intellectuales*) had in fact the privilege of imagi-
native power in its purest form. Once the universe of these souls had

disappeared, the imaginative function itself was thrown out of joint and devalued. Thus one can understand the warning issued later by Paracelsus, who cautioned against any confusion of *Imaginatio vera*, as the Alchemists called it, with fantasy, that "madman's corner stone."[13]

And this is the very reason for which we can no longer avoid the problem of terminology. Why is it that in French (and in English) we have no current and entirely satisfactory expression for the idea of *'âlam al-mithâl?* I have proposed the Latin *mundus imaginalis*, because we must avoid any confusion between the object of imaginative or imagining perception, on the one hand, and what we commonly qualify as "imaginary," on the other. For the general tendency is to juxtapose the real and the imaginary as if the latter were unreal, utopian, just as it is customary to confuse the symbol with allegory, or the exegesis of spiritual meaning with allegorical interpretation. Allegory, being harmless, is a cover, or rather a travesty of something that is already known or at least knowable in some other way; whereas, the appearance of an Image that can be qualified as a symbol is a primordial phenomenon (*Urphaenomen*). Its appearance is both unconditional and irreducible and it is something that cannot manifest itself in any other way in this world.

Neither Sohrawardî's stories, nor those which in the Shî'ite tradition tell of attainment to the "country of the hidden Imâm," are in the realm of the imaginary, the unreal or allegory, precisely because the eighth clime or "country of nonwhere" is not what we commonly call a Utopia. As a world beyond the empirical control of our sciences it is a supersensible world. It is only perceptible by imaginative perception and the events taking place there can be lived only by imaginative or imagining consciousness. Let me again emphasize that what is involved is not imagination as we understand it in our present-day language, but a vision which is *Imaginatio vera*. And this *Imaginatio vera* must be recognized as possessing fully noetic or cognitive value. If we are no longer capable of talking about imagination in terms other than *la folle du logis* [This is the current French term for imagination, which literally translated means the "madwoman of the house."—*Trans.*], it is perhaps that we have forgotten the standards and the

[13] Cf. the author's *Creative Imagination in the Sufism of Ibn 'Arabi*, (Princeton, 1969), 179. On the theory of the *Angeli caelestes* cf. the author's *Avicenna and the Visionary Recital*, Bollingen Series LXVI (New York: Pantheon Books, 1960).

rules, the discipline and the "axial arrangement" that guarantee the cognitive function of imagination, which I have sometimes referred to as imaginatrice.

It must be stressed that the world into which these Oriental theosophers probed is perfectly real. Its reality is more irrefutable and more coherent than that of the empirical world, where reality is perceived by the senses. Upon returning, the beholders of this world are perfectly aware of having been "elsewhere;" they are not mere schizophrenics. This world is hidden behind the very act of sense perception and has to be sought underneath its apparent objective certainty. For this reason, we definitely cannot qualify it as being imaginary in the current sense of the word, i.e., as unreal, or non-existent. Just as the Latin word *origo* has provided us in French with the derivatives *originaire* (native of), *original, originel* (primary), the word *imago* can give us the term imaginal in addition to the regular derivative imaginary. We would thus have the imaginal world as an intermediary between the sensible world and the intelligible world. Whenever we come across the Arabic term *jism mithâlî* to denote the "subtle body" that reaches the eighth clime, or the "body of resurrection," we will thus be able to translate it literally by imaginal body, but, of course, not by imaginary body. Perhaps we will have less difficulty situating figures that are neither "mythological" nor "historical," and perhaps this translation will provide us with the password for the road leading to the "lost continent."

And to find the courage to travel this road, we would have to ask ourselves what our reality is, the reality for us, so that, when we leave it, we would attain to more than an imaginary world, or a utopia. Furthermore, we would have to ask: what is the reality of these traditional oriental thinkers that enables them to reach the eighth clime, *Nâ-Kojâ-Abâd.* How are they able to leave the sensible world without leaving reality; or, rather, how is it that only in so doing they attain true reality? This presupposes a scale of being with many more degrees than our own. Let us not make any mistake and simply state that our precursors in the West conceived imagination too rationalistically and too intellectualistically. Unless we have access to a cosmology structured similarly to that of the traditional oriental philosophers, with a plurality of universes arranged in ascending order, our imagination will remain out of focus, and its recurrent conjunctions with our will

to power will be a never-ending source of horrors. In that event, we would be confining ourselves to looking for a new discipline of the Imagination. It would, however, be difficult to find such a new discipline, as long as we continue to see in it no more than a way of getting a certain distance to what is called reality and a way of acting upon reality. Now, this reality we feel is arbitrarily limited as soon as we compare it to the reality described by our traditional theosophers, and this limitation degrades reality itself. Another expression that is always offered as an excuse for confining reality is reverie such as literary reverie, for example, or, to be more up-to-date, social fantasy.

However, one cannot help asking if it was not necessary for the *mundus imaginalis* to have been lost and to have given way to the imaginary; whether it was not necessary to secularize the imaginal in the form of the imaginary so that the fantastic, the horrible, the monstrous, the macabre, the miserable, and the absurd could come to the fore. In contrast, the art and imaginations of Islamic culture in its traditional form are characterized by the hieratic, by seriousness, gravity, stylization, and significance. Neither our utopias, nor our science fiction, nor even the sinister "omega point" succeed in getting outside this world, in reaching *Nâ-Kojâ-Abâd*. Those who have known the eighth clime, on the other hand, did not fabricate utopias, any more than the ultimate of Shî'ite thought is a social and political fantasy.

It is an eschatology because it is an expectation and as such implies, here and now, a real presence in another world and is evidence of this other world.

* * *

No doubt countless comments could be made on this topic both by traditionalist and non-traditionalist metaphysicians as well as psychologists. However, by way of a tentative conclusion, I should like to confine myself to raising three little questions:

1) We are no longer participants in a traditional culture. We are living in a scientific civilization, which is said to have gained mastery even over images. It is quite commonplace to refer to our present day civilization as the "civilization of the image" (to wit our magazines, motion pictures, and television). But one wonders whether—like all commonplaces—this one does not also harbor a radical misunderstanding, a complete misapprehension. For, instead of the image being

raised to the level of the world to which it belongs, instead of being invested with a symbolic function that would lead to inner meaning, the image tends to be reduced simply to the level of sensible perception and thus to be definitely degraded. Might one not have to say then that the greater the success of this reduction, the more people lose their sense of the imaginal and the more they are condemned to producing nothing but fiction?

2) Would all the imagery, the scenography of these oriental narrations be possible without the initial, objective, absolutely primary and irreducible fact (*Urphaenomen*) of archetypal images whose origin is irrational and whose irruption into our world is unforeseeable but whose postulate cannot be rejected?

3) Is it not precisely the postulate of the imaginal world's objectivity, which is suggested to us, or imposed on us, by certain figures and certain symbolic emblems (Hermetists, Cabalists or the mandalas) that have magic effect on the mental images so that they acquire objective reality? In order to hint at a possible answer to the question regarding the objective reality of supernatural Figures and encounters with them, I wish to refer to an extraordinary text, in which Villiers de l'Isle-Adam speaks of the face of the impenetrable Messenger with eyes of clay; his face "can only be perceived by the mind. Living creatures only experience the influence inherent in the archangelic entity." "The Angels," he writes,

> exist substantially only in the free sublimity of the absolute Heavens, where reality is one with the ideal... They externalize themselves only in the ecstasy to which they give rise and which is inherent in them.[14]

These last words—the ecstasy which is inherent in them—seem to me to be of prophetic lucidity, because they have the virtue of shattering even the rock of doubt, of paralyzing the "agnostic reflex" in the sense that they break through the mutual isolation of consciousness and its object, of thought and being; here phenomenology becomes ontology. Undoubtedly, this is the postulate implied in our authors' teaching on the imaginal. There is no external criterion for the manifestation of the Angel other than the manifestation itself. The Angel is the very *ekstasis*, the movement out of ourselves, which

[14] Villiers de l'Isle-Adam, *L'Annonciateur* (epilogue).

represents a change in our state of being. For this reason, these words also suggest what the secret of the supernatural being of the "hidden Imâm" is in the Shî'ite consciousness: the Imâm is the *ekstasis* of this consciousness. No one who is not in the same spiritual state can see him. This is what Sohrawardî alluded to in his narrative of the *Crimson Archangel*, what he meant by the sentence we quoted at the beginning: "If you are Khezr, you, too, can pass beyond Mount Qâf without difficulty."

Editor's Note

Archetypal psychology has consistently encouraged what Patricia Berry here calls "interpretative self-awareness." Using the dream as guide, Berry shows us that theory is what we actually practice, and that for archetypal psychology the crux of both practice and theory (and who knows the difference?) is becoming aware of our assumptions toward the imaginal. We cannot simply assume this or that about the image, she says, but must find ways to "interpret our own interpretations" lest we unknowingly slight the image or fail to follow its lead.

Berry notes that for the alchemists *theoria* included "praying, reading, and thinking in relation to what they were doing." Following this lead, how might we relate our psychological theories to the primary material of archetypal work, i.e. the image? This is Berry's theme—how to craft psychological theories according to the precise facticity of the image, taken here as dream. "Our basic premise," says Berry, "is that dream is something in and of itself...an imaginal product in its own right."

Berry shows how many of psychology's usual approaches to the image can quickly become departures, leaving the image behind as they move on to draw implications from the image and make suppositions about it. And she shows how these latter steps can distance psychological theory from a proper basis in the image.

How, then, do we proceed? How do we approach an image with the respect and propriety due something having its own integrity? How do we acknowledge in our theories, and thus in our practice, that the image is irreducible and infinitely more interesting than anything we might say about it? Berry suggests that one way might be a *via negativa*, a negative road leading back to the image through "a recognition of unsuitable moves." Here is a theory that tracks the archetypal motto first sounded by Raphael Lopez-Pedraza and echoed by archetypal theorists ever since: "We must stick to the image!" Berry's is a radical and well-mannered approach designed to defend the image against the narrowing moves of interpretation, many of which have become almost second nature to the analytic mind.

Read this essay carefully, and then read it again. Berry, a poet in addition to her work as a psychoanalyst, gives us a seamless presentation in which every word urges a tempering of theory such that we might give the imaginal its due.

AN APPROACH TO THE DREAM

PATRICIA BERRY
(*Spring 1974*)

> *But every psychic process, so far as it can be observed as such, is
> essentially theoria, that is to say, it is a presentation; and its recon-
> struction—or "representation"—is at best only a variant of the
> same presentation.* —CW 17, § 162

Once upon a time a Jungian analysand appeared for her hour
strangely distraught. It seems she had had occasion to show
someone else a dream she and her analyst had worked on in
a previous session, and then was so unsettled with the disparity of
interpretation that she had rushed off for a third and then a fourth
opinion. All differed essentially. Dream interpretation, she now
charged, was a pseudo-science and interpreters mere charlatans.

Although this parable can reflect a number of problems about
analysis, and this sort of analysand in particular, it also gives cause
for some theoretical reflection about dreams. Of course any dream
has a variety of possible interpretations; of course each analyst has
his particular biases, approaches, and assumptions. But still, aren't
some interpretations more to the point somehow than others? Let's
take a look at her dream:

> I was lying on a bed in a room, alone apparently, but with
> the feeling of turmoil around me. A middle-aged woman
> enters and hands me a key. Later a man enters, helps me
> out of bed and leads me upstairs to an unknown room.

We may imagine a variety of Jungian analysts and the sort of interpretation each might give for this dream:

1) *ego-active analyst:* The whole dream is characterized by your ego passivity. You are reclining, a rather unconscious position, which makes for the feeling of unconscious turmoil. Without effort of your own, you take what is handed to you. You are led away by the animus, therefore, up into yet another area of passive fantasy.

2) *relationship-feeling analyst:* You're alone in a room, isolated and cut off from your marriage, relationships, children. Never do you express feeling for or make any real contact with the other figures in the dream. Therefore, you are led into the upper regions with only your animus as companion, alone and remote, the princess in the tower.

3) *transference-oriented analyst:* You're in a half-conscious sexual position, in which the turmoil represents your unrecognized erotic projections. You fantasy various solutions: (a) the phallic mother, or (b) the man leading you upstairs to an unknown climax. One of these (depending upon sex) refers to your projection of me as your savior.

4) *animus-development analyst:* When you confront your turmoil, it becomes the middle-aged woman, your fear of growing old and un-fruitful. But in that older woman you find the creative key which becomes then the unknown animus who leads you to the, higher room, i.e., to the unknown part of your psyche in which creative work can now take place.

5) *introvert analyst:* There you are at last alone with yourself, in the vessel. You receive now inner help. Your inner femininity gives you the key, the key being seclusion and facing the internal turmoil hith-erto denied by your extraverted defenses and acting out. This leads you to the next step, the animus figure who helps you out of bed and leads you to another level.

6) *feminine earth-mother analyst:* You were lying passive, naturally, in touch with your real feelings (depressive position). Now you can re-ceive gifts from the feminine, the positive mother. Unfortunately, as soon as the animus appears, you lose this connection by following him up into the intellect.

7) *process-oriented analyst:* It's not so much the content of the dream as the way you have introduced it into our session (that you told it to me in such an aggressive voice, that you waited until the end of the hour, that you handed it to me neatly typed and then leaned back passively waiting for an interpretation).

As we read these seven statements, how glaring the analyst's assumptions seem in some of them and how true or accurate in others. Yet any one of these perspectives could be derived from Jung's writings on the dream and none of them is necessarily wrong. We are not here concerned with "right" or "wrong" in regard to the above responses—rather why it is that we prefer one over another. We can avoid the problem by saying it all depends upon the patient's reaction—which interpretation "clicks" for him. But however practical this approach, it conceals an essential difficulty having to do with what might be called theoretical sensitivity.

We know from the comparative studies that have been done on theoretical schools and styles of therapy that virtually every therapy "works:" every therapy shows evidence of accomplishing the aims it sets for itself, and all fail to the same extent. Though not in itself surprising, the relativism of therapy in terms of results can lead to frightening consequences. It opens the way to an aspect of psychotherapy little different from charlatanism, syntonic transference neurosis, hysterical suggestion, doctrinal compliance, religious conversion, and political brainwashing. For these too "click," and in these too the subject feels himself changed for the better on the basis of insights revealed. Without a sensitivity among theories, it no longer matters what theory we have; one idea is as good as another, providing it works—and everything works equally. If there are better and worse theories about dream interpretation, they cannot be based on what "clicks"—for when we lose sensitivity here, we lose it in practice as well.

Furthermore, since our main mode of reflecting about what we are doing is by means of dreams, it is here of all places that becoming aware of our assumptions is of fundamental importance. It is the crux of our practice. The alchemists did not only perform experiments, they spent their time equally in a kind of *theoria*—praying, reading, and thinking in relation to what they were doing. In fact, to make practicality our determinant criterion is a kind of immorality, the sort we also see in the psychopath who says what works is therefore good. But rather than get too carried away with this charge against the moral cop-out of pragmatism, perhaps it would be more advantageous to turn to its contrary, the psychological importance of theory.

Because theory so determines practice—after all what we practice is theory—in order to be aware of what we're doing with dreams, we

have to become aware of what we're thinking about dreams. We have to examine not only how we put our theory into practice but also what we are putting into practice. This means turning to our assumptions and becoming aware of our unconsciousness in this realm too.

So what we will be elaborating in this paper is a tool (one among many) for more precisely grasping our underlying ideas when we look at dreams. Our intention is to work out some means for interpretative self-awareness, a method by which we may examine our actual interpretative process, interpret our own interpretations.

As we have maintained, methods have underlying assumptions, so this method too implies a theoretical position. Our basic premise is that dream is something in and of itself. It is an imaginal product in its own right. Despite what we do or don't do with it—it is an image.

I. IMAGE

We must stick to the Image!
—Rafael Lopez-Pedraza

Following Jung, by image we "...do not mean the psychic reflection of an external object, but a concept derived from poetic usage, namely, a figure of fancy or fantasy image..." (*CW 6*, § 743). In his passage Jung gives ground for a distinction between imagination and perception. A fantasy-image is sensate though not perceptual: i.e., it has obvious sensual qualities—form, color, texture—but these are not derived from external objects. On the other hand, perception has to do with objective reals—what I see is real and there. And so, by claiming external reality, hallucinations (psychotic or psychedelic) pertain to perception, whereas dream images pertain to imagination. The two modes, imaginal and perceptual, rely upon distinctly different psychic functions. With imagination any question of objective referent is irrelevant. The imaginal is quite real in its own way, but never because it corresponds to something outer. Though dream figures and places frequently borrow the visage of perceptual reality, they need not be derived from perception. As we read from Jung, images in our dreams are not reflections of external objects but are "inner images."

But why then, it may be asked, do we sometimes dream of figures from our perceptual world and at other times of figures never perceived?

Certainly the familiar figure must be some sort of after-image or *Tagesrest.* The traditional manner in which we deal with images that correspond with perceptual figures is to call them products of the personal unconscious and then seek to sort out the projections they carry for us. So far so good, for it seems what we're really doing is attempting to redeem these images from their perceptual imprisonment and to reclaim them as psychic, thereby shifting our standpoint from perceptual to imaginal.

But this cannot take place, our exit from this perceptual world becomes blocked, our movement stuck, when we deal with these so called personal figures on a personal level, forgetting that they are fundamentally fantasy-images cloaked in after-images. Personal figures are precisely those most bound to our literal perspective. When my spouse, children, or friend appear in my dream, they have become to some extent removed from the "reality" of the perceptual world with which they are so closely associated. The dream offers the opportunity to make metaphorical these figures, and thus the psyche may be seen as working toward the imaginal, away from the perceptual—repetitively and insistently. This movement may be regarded as the psyche's opus contra naturam, a work away from the natural reality of the perceptual toward the psychic reality of the imaginal.

Now we must look more closely at the kind of reality an image has. We have to examine with more exactitude just what we mean here by an image, and one of these ways is to take it apart, performing a kind of analysis of the image.

Sensuality: One reason why images so easily merge with the after-images of sense perception is that images too are sensate; images too imply a body of sorts. But this body is no more a perceptual "natural" body than are images derived from perceptual natural objects. The body to which images refer is metaphorical, a psychic body in which the sensory combinations and all the sense qualities of the image that would for perception be outlandish, incomplete, overwhelming, or distorted in some respect or other, here make sense.

Texture: The word text is related to weave. So to be faithful to a text is to feel and follow its weave. When we speak of putting a dream in its context, meaning with the text of the dreamer's life, we tend to neglect that the dream is sensate, has texture, is woven with patterns offering a finished and full context. The life situation need

not be the only means by which to connect the dream with this textural aspect. Image in itself has texture.

Emotion: Also inseparable from both sensuality and texture is emotion. A dream image is or has a quality of emotion. Dream moments may be expansive, oppressive, empty, menacing, excited... These emotional qualities are not necessarily portrayed verbally by the dreamer in his report, by the dream ego in his reactions, or by other figures in the dream. They adhere or inhere to the image and may not be explicit at all. Even if unrecognized by the dreamer in the dream, they are crucial for connecting with the images. We cannot entertain any image in dreams, or poetry, or painting, without experiencing an emotional quality presented by the image itself.

Simultaneity: An image is simultaneous. No part precedes or causes another part, although all parts are involved with each other. So we view the image level of the dream as non-progressive; no part occurs before or leads to any other part. We might image the dream as a series of superimpositions, each event adding texture and thickening to the rest. In the dream above we might then say that the horizontal dream ego, the woman with the key, and the man leading upstairs are all expressions essential to the psychic state; no one of them carries a secondary meaning. They are all layers of each other and inseparable in time. Such relationship we might express as while, or when. While the dream ego is lying alone in turmoil, a middle-aged woman hands a key and a man leads to an unknown room. It does not matter which phrase comes "first" because there can be no priority in an image—all is given at once. Everything is occurring while everything else is occurring, in different ways, simultaneously. Jung's emphasis upon the "present situation" need not be identified with the literal life situation, which removes the dream from the presence of the image, but also might be read to mean that every part of the dream is concurrently present.

Intra-relations: All the elements (characters, settings, situations) within a dream are in some sense connected. They are each part of the overall dream image, so that no part can be selected out, or pitted against the other parts. By this complete intra-relation of the dream we mean to point out the full democracy of the image: that all parts have an equal right to be heard and belong to the body politic, and that there are no privileged positions within the image. (This is not to

deny the innate hierarchies within the image, which we shall come to below under *Value*.) Let's look at an example showing how intra-relatedness appears in a dream image. A woman dreamed:

> I am in bed when a funny little dwarf emerges from beneath the covers. He is shyly glancing at me as though he wants some sexual contact. Just at that moment my friend R. (a conservative, responsible, older man) appears at the door and urgently shouts, "Run!" as though I am in some great danger.

One way of viewing this dream would be to take the conservative friend R. and the tricky little dwarf as opposites between which the dreamer must choose. But this approach would be to fix them into opposition, to reinforce what is already the dream ego's experience. By taking into account the coincidence of the opposites (the *coincidentia oppositorum*), which is to say the total dream image in which all parts fit, however, we would see the panicked R. as actually constellated by the amorous dwarf, and vice versa. The two of them together are the image. In daily life, when the dreamer is connected to her dwarf creativity, trickiness, and so forth, her conservative, responsible animus panics and urges her to run, to cut herself off from the dwarf-like, lower aspects; and hence, the other way round, when the responsible animus is in a state of panic, somewhere, probably very unconsciously, an assignation with the dwarf is occurring. In daily life, she drops her purse, loses her keys, unconsciously creates misunderstanding... If we are to stick to this imagistic level of the dream, the point is to refrain from choosing between characters.

Frequently we must also hold a tension within settings. A man dreamed: "I walked into my mother's kitchen and saw an *Encyclopedia Britannica* on the counter." The image is his mother's kitchen within which is an encyclopedia. An immediate tendency would be to destroy this image by saying, for example, an encyclopedia doesn't belong in a kitchen, or that just shows his mother's animus. Whereas the former would be to betray the image altogether (for the most effective images do in fact conjoin the most unfitting opposites), the latter would be in itself an animus statement—a preconceived judgment. But by giving the image the recognition and dignity of a psychic product infinitely more profound than we, we may find ourselves stilled. Within his

mother's kitchen is an encyclopedia, or a toad, or a maimed old man. Already the psyche has done something, something is happening in his mother's kitchen. For him the point is to work on this image (and let this image work on him) in whatever imaginative/experiential ways he can—which requires putting into abeyance his judgment and interpretation.

Value: Some images seem more potent, more highly attractive than others. For example, the encyclopedia stands out strikingly in what appears an otherwise mundane scene. Often, as in this case, the attraction has to do with an unusualness of image and setting (a lion in the bathroom) or sometimes of the image itself (a winged snake). In both cases the images are "unnatural."

When the dream presents an image that goes against the way things are naturally, let's assume such images to be of high value because they are examples of the opus contra naturam. As I understand Jung's idea of symbols, they change the course of nature and upgrade its energy to a higher value. Hence the unnatural, unusual, peculiar image is the one being singled out and the one containing most value.

There is another way of recognizing the value in dream images. Ordinary images may be invested with feeling, e.g., the little brown dog of my childhood or the scarf my mother gave me for Christmas. Here one needs discrimination among feelings—sentiment, kitsch, longing, nostalgia, expectation. . . The dream discovers the image of the feeling, exposing the feeling for what it is. So one may read the feeling through the image, as well as the image through the feeling. The dog or the scarf is not only of high value because I feel so strongly about it in my dream, but my dream also tells me where my strong feelings of nostalgia are located. To deal with one's more embarrassing feelings in a dream from a sentimental viewpoint is to miss the embarrassment and therefore the discrimination of the feeling quality.

The case is similar in those situations where one feels the urge to choose between, say, city and country, sky and earth, family home or own apartment. A dream may show the city as nerve-racking, the country as idyllic, the sky as fearsome, the earth as nurturing, the family home as complicated and petty, an independent apartment as self-contained and fulfilling. Yet each of these is a fantasy from the

point of view of the other. The city looks threatening just because of my idyllic fantasy and vice versa. To choose between one or another of these smaller images is to lose the larger one, which is, after all, a wholeness! To identify with the dream's fantasy, with the terms in which it has presented itself, is to miss the significance of the fantasy.

Structure: Significant structural relationships exist within and among images. Accordingly, images to some extent depend upon each other for their meaning. But it is important here that we separate ourselves from those schools of thought which would see images as only structures, deriving their meaning entirely from the slots they fill. In some varieties of structural thinking, form and matter, structure and content, can be separated; in imagistic thinking these pairs are one. The wise old man is both an archetypal structure and a content, and even the number four, the *quaternio*, such an abstract structural idea, is an imagistic content appearing as the four persons of my family, or a four-passenger car, or a city block.

Because images with contents are always structurally positioned within a dream, we cannot speak of them apart from this context. A red bird in one dream and a red bird in another never carry exactly the same content, since neither their structural relation (positioning) within the dream nor the other dream images with which they are structurally related are identical.

And the reverse is also true. Because structures are made up of images with contents, we cannot speak of them apart from these contents. Identical dreams with only a single content different—a black bird rather than a red one—would make for different meanings. In other words, it is not the position alone which makes for a symbol's meaning, but both position and content. The red bird is not the result of structural determinants (laws of force, binary oppositions, grammar, linguistics, or whatever) but is itself one of the determinants shaping the dream. The image is itself an irreducible and complete union of form and content, and for us cannot be considered apart from either. Image is both the content of a structure and the structure of a content.

II. IMPLICATION

> ...*interpretation must guard against making use of any other viewpoints than those manifestly given by the content itself. If someone dreams of a lion, the correct interpretation can only lie in the direction of the lion; in other words, it will be essentially an*

> *amplification of this image. Anything else would be an inadequate*
> *and incorrect interpretation, since the image "lion" is a quite un-*
> *mistakable and sufficiently positive presentation.* —*CW 17*, § 162

Having set forth the initial aspect of our approach to the dream as image and explored what image is, let's move on to its elaboration, what image implies. This second means of approach has to do with the entire procedure of drawing implications from the original image. Of course the further we move from the actual dream text, the more open to question, to individual differences, biases, and particular areas of knowledge (and their accompanying lacunae) our interpretation becomes. When we speak of this movement from image to implication (and on to a third category which we shall come to later), we aren't speaking of a sequential progression in the act of interpreting. It isn't that we necessarily look first at image, and then draw implications, and so on, in that order. But these are all aspects of interpretation, which order is not sequential but ontological. Image is prior not in time, not because we need take it up first when considering a dream, but prior in the sense of most basic, that to which we return again and again, and that which is the primary ground and spring of our imaginal awareness.

Thus when regarding the dream in its implications, we realize the narrower selectivity within which we are operating. And this seems paradoxical for it feels (because of our greater conceptual development? because of our iconoclastic tradition?) as if the image were the more limited mode. The dream only says this or gives these particular images, while implications seem to extend in many directions. But by moving away from image and into implication we forego the depths of the image—its limitless ambiguities—which can only partly be grasped as implications. So to expand on the dream is also to narrow it—a further reason not to stray too far from the source.

Narrative: We have so far treated the dream in relative stasis, sensing the various events of the dream as its levels or weaves. But now we begin to hear and watch the dream in its narrative or dramatic sense. It was to this aspect of the dream that Jung referred when he spoke of its dramatic structure: setting, development, *peripeteia*, *lysis* (*CW 8*, 561*ff*.).

Since most dreams appear in this story form, we might follow Jung here and use narrative rather than image as the primary category.

But this brings us into new entanglements, the first of which is the verbal nature of narrative. Even though words contain images, words cannot altogether contain them: words and images are not identical. Since for us images are primary, then any form into which the image is cast is a transposition of it, perhaps a step away from it. Of course, putting an image into words can vivify and enhance it; yet at the same time this move burdens and informs images with all the problems of language. Language has now become the context, a context which demands its kind of coherence. We have all had the experience of struggling to write down in coherent form what seems an essentially incoherent dream. But I am beginning to question our idea of coherence. Is it truly the dream that is incoherent or does our verbal approach make it so? Images do not require words to disclose their inherent sense, but as soon as we are involved with language, then what would inhere in the image is transposed into verbal coherence. So we find that some dreams cannot be written down. They resist the transposition, and then we find them "incoherent." We can't put the images together into a story.

So the second difficulty with narrative is that its verbal nature requires a coherence of a special sort: story or a sense of sequence. One thing occurs before another and leads to another. But the sequence of dream fragments is often ambiguous—and from the point of view of the image this must be so, for the image has no before and after. Through our telling, dream fragments whose sequence is ambiguous tend to become one thing rather than another. Our narrating gives an irreversible direction and forms the dream into a definite pattern.

Noting narrative's limitations is not to question the power of the word, the logos, in therapy—indeed the way we tell our story is the way we form our therapy—but merely to keep narrative distinct from the more primary imaginal layering and to note their sometimes discrepant phenomenology. When verbal or narrative lapses occur in our dream-telling, we fill in, we elaborate with what would make sense for narrative meaning but not necessarily for imagistic meaning. Images are entirely reversible; they have no fixed order or sequence. In some cases these narrative interpolations distort or even betray the image, since they tend to collapse it into the narrative, into the story we tell about it. And if dreams are primarily images—the Greek word for dream, *oneiros*, meant image not story—then putting these

images into a narrative is like looking at a painting and making a story of it. This sense of narration is also reinforced by therapy. As we tell our dreams, so we narrate our life stories. Not only the content of our dreams is influenced by analysis but also the very style of our remembering. Analysis tends to emphasize the narrative rather than the imagistic, even if Jung's emphasis on painting and sculpting has helped restore primacy to the image. But our real concern here is not whether imagistic or narrative report is the more basic. Rather our thought is that since the narrative style of description is inextricably bound with a sense of continuity—what in psychotherapy we call the ego—misuse of continuity because of the ego is also close at hand.

This brings us to the third and most important difficulty of narrative: it tends to become the ego's trip. The hero has a way of finding himself in the midst of any story. He can turn anything into a parable of a way to make it and stay on top. The continuity in a story becomes his ongoing heroic movement. Hence when we read a dream as narrative there is nothing more ego-natural than to take the sequence of movement as a progression culminating in the dreamer's just reward or defeat. The way story encapsulates one into it as protagonist corrupts the dream into a mirror in which the ego sees only its concerns. And since its main concern is progress in terms of whatever value system it has, dream interpretation soon becomes part of the heroic progress. Dreamer and interpreter chop their way through the unconscious—deciding here, refusing there—because the sequence of events has fallen prey to the idea of progressive betterment. Before and after have come also to mean worse and better.

The problem is compounded, since both the dreamer as he appears in the dream and the interpreter's heroic tendencies may appear in more subtle guises than the obvious one of heroic competence. Both may be heroic in function even though they be feeling and submissive. As Hercules dressed in feminine attire at one point, so too may heroic consciousness. But under this submissiveness, ego remains the center of the dream or therapeutic story. The dream is about him, his individuation.

Perhaps what we're really speaking of as heroic ego consciousness is less one or another mythological figure and more that mode which severs the inherent continuity and intraconnection of the dream image as a whole. This mode continuously makes divisions between

good and bad, friends and enemies, positive and negative, in accord with how well these figures and events comply with our notions of progression. Then to interpret as "negative" or "positive" these same characters is to take the narrative at face value, thereby getting caught in the dream ego's idea of movement.

As the failing is a rather obvious one, analytical sophistication has taught us to make one of two contrary moves. We may, for instance, side with the bad guys, taking the viewpoint of the "unconscious" (the forces opposed to the dream ego). Or we may attempt to distance ourselves from the narrative altogether by judging it. We show how the dream situation might have been more adroitly handled, where the ego took a false turn or set up a self-destructive situation. We become coaches, judging performance. But by so judging, we are perhaps even more trapped by the narrative and its ego-emphasis, since this trap is more subtle. Our interpretive remarks about better ways of handling are statements of one heroic and more experienced consciousness (ours) against another (that of the dreamer, who has now been identified with his performance in the dream). We are simply urging him to swap his heroic myth for ours or polish it in terms of ours.

Because the ego bind occasioned by narrative is on some level perhaps inevitable, before going any further we had best pay narrative some of the respect due it. We cannot hear a story without being caught; we cannot tell a tale without feeling ourselves into some part. Narrative, a most profound mode of archetypal experience, catches us up emotionally and imaginatively. Whether or not we would go so far as to maintain, as some do (vide Stephen Crites), that without narrative there would be no experience at all, we can at least agree that tales change experience and enrich daily patterns with archetypal significance. Personal events, moods, jealousies, and even symptoms, when reflected through a story, gain weight and yet distance. Single-sighted life patterns become multidimensional, and the variations brought by the narrative all become part of experience.

But just the reverse is also true when I take, as some part of me always does, the narrative too egoistically, too personally. In this case I become inflated with the archetypal nature of the material, and the material diminishes to fit my ego needs. There is indeed a regressive aspect to poesis, a means by which I may merely reinforce my own myopia, may fail to see the fantasy in its far-ranging, autonomous

aspect, as not just "mine." When I see it in its archetypal magnitude, judgments fall away. There is no way I can say this character is a good person, this a bad one, this figure made the wrong move, or see how unconscious he was. Characters are unconscious. Given the arrangement, they all do what they have to do, and given the characters the situation has to be as it is.

Finally, the way we treat narrative is the way we treat our own psyches. To hear the dream story as a moral allegory with a message for right and wrong behavior (progressive, regressive) is to sit in judgment on our souls. When we view the tale as archetypal, however, the characters all become valuable subjective entities, both lesser (only a piece of, not an identity) and greater (with more archetypal resonance) than any of our particular, narrow, and ego-concerned viewpoints.

Amplification: One way we draw upon narrative in analysis is through amplification. Amplifying a dream means an attempt through cultural analogues to make it louder and larger. At first glance it may seem this process mainly calls for a general background of cultural knowledge and some bit of intuition and luck. On closer examination, however, we find the process to be more selective and coherent.

When we ask ourselves what we have done in an amplification, we find first of all similarities. A dream figure or theme is in some essential way similar to a mythical figure or theme. The comparison we have made moves us from a personal image to one that is collective and cultural; we have moved from a lesser to a greater, from something fairly known (in the sense of close at hand) to something rather unknown (far-reaching). The key seems to be this quality of essential similarity. Whereas a similarity that is merely coincidental would take us very far astray—*viz.* the reams of amplification sometimes used to the detriment of the actual dream—a similarity of essence would of necessity remain in touch with the dream image, which relationship would be expressed in simile ("like" or "as") in order to parallel rather than replace the actual dream image.

Elaboration: Dreams are like knots of condensed implications, which we elaborate by taking key words whose connotations we explicate by treating the words as images. Going westward in a dream becomes going toward freedom, the new, death, sunset, natura, clockwise, extroversion... When the dreamer elaborates, or gives associations, there is always the danger of overvaluing them, of

letting them be determinate. We tend to forget that his remarks are probably from the conscious point of view; i.e., they are ego-syntonic, which does not mean they are invalid but that they are limited.

In most cases, the dreamer's elaboration tells us more about the dreamer than it does about the dream. We learn from this elaboration the ego's positioning and the constructs through which it views itself. Let say friend John appears in the text, for whom the dreamer gives the associative attributes of laziness, trickiness, and lack of determination. From this we may assume that the ego's ideal is non-lazy, non-tricky, and determined. But far more importantly, we learn that the dreamer sees in terms of these constructs. They say little about the dream, since they are after all conscious elaborations, but tell us a great deal about the ego's relation to the content "friend-John."

An over-solicitousness to the associative material may lead us to an additional difficulty in that we may lose to the conscious viewpoint the subtleties of a dream figure. Then we lose the chance to dissolve a conscious fixity, expressed by the association, and instead further rigidify it. The ego and "friend-John" become all the more firmly entrenched in the positions they have determined for themselves and each other.

Repetition: This is another characteristic which draws our attention when hearing or reading a dream and from which we draw implications. By repetitions I mean similarities of all and any sort. In the same dream we may find repetitions of adjectives—several things called "great" or "green"; or of verbs—running, rushing, hurrying; or of similarities in shape—a round tire, a round clock face; and so forth. Or the dream may show the recurrence of a theme, e.g., lower to higher. Let's say in the dream we find the secretary has no time and one must speak to the boss, a pain in the knee has become now a headache, someone is promoted in school. The collection of these repetitions shows a theme (movement upward) within the dream. This movement cannot be questioned—we can't say it should not appear—without betraying the image level of the dream. The most we can do, and it is a great deal, is to point up the repetition and its coordinates: boss, headache, academic promotion. All have to do with an archetypal idea of higher, and each carries the benefits and detriments of the others.

Restatement: The surest way of keeping implications close to the image is by restating the dream and its phrases, giving them a new inflection. By restatement I mean a metaphorical nuance, echoing or reflecting the text beyond its literal statement. This might be done in two ways: first, by replacing the actual word with synonyms and equivalents. (*Cf.* above under *Elaboration* where the movement westward becomes the movement toward freedom, death, etc.) Second, by simply restating in the same words but emphasizing the metaphorical quality within the words themselves. "I'm driving" in the literal sense becomes "I'm driving" or "I'm driving," depending on which metaphorical sense we stress. Without restatement we tend to get caught in the dream at its face value and draw easy conclusions from it, never truly entering into the psyche or the dream. When we are completely stumped with a dream, there might be nothing better to do than to replay it, let it sound again, listening until it breaks through into a new key.

III. SUPPOSITION

Nowhere do prejudices, misinterpretations, value judgments, idiosyncrasies, and projections trot themselves out more glibly and unashamedly than in this particular field of research, regardless of whether one is observing oneself or one's neighbour. Nowhere does the observer interfere more drastically with the experiment than in psychology. —*CW 17,* § 160

So far we have spoken of our interpretation in terms of the actual dream text (Image) and the Implications that can be drawn from it. Now we consider a third category, Supposition, which is most removed from the actual dream text and consequently most open to the personal predilections, opinions, and intuitions of the individual analyst. Under Supposition we might place any statement of causality, any because of this-that interpretive move; likewise any generalization made on the basis of the dream, any evaluation, prognosis, any use of past or future tense (this will be or this was), as well as any literal advice concerning the analysand's life situation.

Just as in the image all descriptive attributes are interwoven and form a single context, and as our discussion of implication centered in viewing the dream as narrative—so suppositions stem from and involve a single attitude. This attitude feels itself most obliged to

have an effect upon the analysand, to give him something, anything at this point, to take home with him. And curiously enough, it seems that the more the other two methods have failed, i.e., the more we have failed in our imaginative response to the dream—the more insistent our sense that now we must really make the connection. Unfortunately our failure with image and implication has probably been due to our own lapses of psyche, our own loss of imaginal reality and sense of soul. And when this occurs, as it seems to so inevitably, our first move toward reclaiming soul is to project it everywhere else and then to demand its reality. When the delicate movement of metaphor is lost, we tend to call in stronger, more literal replacements.

Now it seems as though the dream can be made actually relevant only by connecting it with a more simplistic notion of reality, a move made at the cost of the image, whose imaginal reality we can no longer sense. We have lost our touchstone of image as psyche and psyche as image and our premise that nothing can be more relevant or real than the dream image itself. Desperately we attempt to connect the dream to the collective fantasy of a reality we call life, relationships, the workaday world. But curiously enough this move often becomes a move into magic. For by losing the true power of the image, we borrow power instead from a magical connection with the ego-construed world of *materia*. By magic I here mean: reading the impersonal aspects of the world in terms of my personal intentions and interests (employing dreams for prognosis, diagnosis, foretellings, secret connections...). One modern form of magical thinking is causal thinking.

Causality: The dream as Image makes no causal statements. Events occur in relation to each other but these events are connective, as in painting or sculpture, without being causal. When we make causal statements in our interpretations, as useful as this may be at times, we are no longer talking about the imagination from the imagination but rather from a set of physical suppositions. How we do this makes a difference in our interpretation. In the dream fragment "I'm in a room with Mr. X and suddenly the lights go out" we might say:

a) Mr. X causes the lights to go out. (In rough analytic terms this would be to say that my shadow X—and all the qualities he carries—

causes unconsciousness. So saying, we would then proceed to focus mainly on the agent, shadow X.)

b) Or, X is the result of the lights having gone out. (In this case unconsciousness is a precondition for the appearance of X, and thus we will direct our attention to the unconscious state as agent.)

Let's take another example: "My fiancé and I are riding in the mountains in a horse-drawn sleigh. We pull up in front of my mother's house. She sees us and then slams the door so that the horses panic and drag us down a hill at a terrifying pace." The most apparent causal statement here is the one given by the dream ego—the mother's door-slamming causes the horses to panic. But to take this as the basis for the dream's interpretation is to ignore the total image. My fiancé and I sleighing over the mountain snow could just as well be seen as the cause of my mother's doorslamming or the cause of the horses' panic and downward pull. If we give equal recognition to each aspect of the dream, we realize that all events affect and simultaneously constellate each other. So analytically it is the total situation we must insight, not one or another aspect which taken causally would tend to exclude the rest. Perhaps this is the real danger of causal thinking, and why Jung warned of it. When anything is given priority as mover, all others become subsidiary, mere aspects with no more intentionality of their own than billiard balls. Purpose then is imputed only to the initial cause (or causes), and the rest falls into a state without anima, without movement or intentionality.

Evaluation: This refers to any negative/positive statement, any value judgment, applied to a dream or to any part of it. On the image level evaluations cannot apply, for the image simply is. My mother sticking needles in me is neither positive nor negative; it simply is. In Implication, however, with its narrative emphasis, characters take on some quality of—if not good or bad—at least helping or hindering. My mother is hindering me, the protagonist. But this is only because I have the idea of myself as protagonist and therefore require others to position themselves as helping or hindering. Any evaluative idea about my mother's needling behavior—she is a negative character or it is all for my own good—is pure supposition. In our initial dream with the seven interpretive examples, we might likewise suppose that it is good that the dreamer lies down, or it is mere passivity, or that the unknown man is like an intellectualization leading her up and

astray, or like a positive animus leading her into the unknown regions of her psyche. Which of these we suppose reflects our specific projections upon the dream or our ideas about such things in general.

Generalization: A dream is a specific statement of a particular constellation of characters and settings, so that any attempt to generalize from it is to suppose. Much of what we do in psychology has to do with generalization. We see a specific occurrence or fact and immediately try to give it a general significance, fit it into some larger framework. On the basis of a single dream we tend to say that the dreamer is this or that kind of person or has this or that problem. We make a "working" identity. Generalizations are extremely useful as long as we see that they are merely more or less clever suppositions. But much of what we gain through them we can also accomplish by means of amplification. By amplifying we call up parallels, patterns of significance. In amplification, however, the particular is not lost sight of, is not swallowed by the general, but played alongside, as a second melody in the same key. Particular dream motifs may easily parallel mythic ones without being subsumed by them. Specification: Rather connected to generalization is what would seem an opposite. Instead of broadening the dream context, specification refers to its narrowing for specific application. The dream is focused on one or another concern of the dreamer. We say "this dream has to do with the analysis, or your relation to your father, job, marriage..."—the innuendo being what the dreamer should do in regard to these matters and that the dream is giving indications. Indeed we talk about the dream as though it were a theological entity: knowing like an omniscient God, caring like a New Testament God, creating like an Old Testament God, and yet thinking just like you and me. The dream is concerned with all the petty things we are concerned with—where to go, what to do—and then corrects us when we have done the wrong things or made the wrong decisions. Specifying the dream into a message both anthropomorphizes the dream and divinizes it. Whether this be seen as a secularization of the religious instinct, a displacement, or a new wellspring of meaning is entirely up to our theological biases. But whatever stand we take to this theological issue, one thing remains psychologically certain: all specific conclusions we make are in the realm of supposition. The dream doesn't give specific advice; we do, leaning upon the dream for support.

* * *

When we look back over these suppositions we find most of what
we actually do in therapy falls within this category. We might
suppose therefore that dream analysis is highly personal, so much so
that interpretations tell more about the interpreter than about the
material under scrutiny. And indeed this is so, as we know from the
seven different interpretations with which we started. If dream inter-
pretation is so subjective, we might wonder how it works at all.

Just here is the catch—because it does work. What makes it work
must be based on something other than the dream image and its
implications. Since the relationship between the dream image and
our suppositions is so tenuous, we're no longer in a position to claim
our interpretations are based on the dream. Their validity must derive
from another source, which I suppose we can call therapeutic skill.

Does this mean we have made full circle from our starting point,
only to return to the pragmatism with which we began and from which
we have tried to escape? If our interpretations are mainly supposi-
tions, and these are successful by virtue of therapeutic skill, then
perhaps we must back up our practical ability with a theory of therapy
distinct from, i.e., no longer disguised as, a theory of dreams. We
have made a start in that direction by attempting to recognize and
distinguish among our moves in regard to dreams.

When we look back we may also wonder why so much of what
we do with dreams is supposition. Despite the internal richness of
the dream image, or perhaps just because of it, we seem to give least
attention to this category. Could it be we suppose because we cannot
imagine? The dream confounds us with the power of its images, and
we are mostly at a loss to respond with an equivalent power. Our
imaginations are untrained, and we have no adequate epistemology
of the imagination with which to meet the dream image on its own level.

Analytical training teaches us primarily how to suppose about
dreams and how to work out their implications. We learn by imitating
the suppositions of our analysts about our own dreams. What we
don't learn is a psychology of the image, comparable to what students
of archeology, iconography, aesthetics, or textual criticism would learn
about the image in their fields. But we can't even begin to discover
what would be a psychology of the image so long as we in psychology

are exploiting the image for what we take to be our therapeutic aims. Perhaps the other way round would be more appropriate: discover what the image wants and from that determine our therapy.

But training the imagination and developing an epistemology of it are full of hazards. On the one hand, we have to recognize our historical stuntedness in regard to the imagination, so that when we begin imagining in response to images of dream, literature, or elsewhere, we are not surprised at the impoverishment and the subjectivity of our responses. On the other hand, as if to compensate the iconoclasm of our tradition, there is an undifferentiated glorification of images, which leads neither to precisio n nor to a psychological connection. Perhaps the only way through these two limiting alternatives is a via negativa, a psychology of the image proceeding from a recognition of unsuitable moves. In this paper we have attempted such an approach. Our aim has been to work out a method for interpretive self-awareness, thus to clear some of the confusion from the primary images of the psyche—those that come in dreams. By reflecting upon our interpretive moves *vis-à-vis* dreams, we may gain some differentiation by realizing when we are not giving due to the imaginal.

Editor's Note

If I had to name one essay that expresses the extraordinary claims of archetypal psychology, it would be this one. The great mistake and confusion of the modern mind, says James Hillman, is the neglect of soul, the traditional third place existing between body and spirit. This collapse of the old tripartite worlds of body-soul-spirit into the simple dualism of body and spirit is catastrophic for all involved, especially soul, which is left without a place. Hillman here lays the groundwork necessary to reestablish soul's territory.

The way was cleared by Jung, who says, "Every psychic process is an image and an imagining." Here is one of archetypal psychology's essential insights, that the world of soul is the world of image, where "image" does not mean the reflection of an object or a perception, but rather is derived "from poetic usage, namely, a figure of fancy or fantasy image." This view of image and soul, says Hillman, requires a psychology based on similar grounds and proceeding along similar lines. For archetypal psychology, "All things are determined by psychic images, including our formulations of the spirit. All things present themselves to consciousness in the shapings of one or another divine perspective. Our vision is mimetic to one or another of the Gods."

Because our modern dualism has left spirit the only alternative to body, soul tends to be readily confused with spirit. The most common mistake is to sublimate soul into spirit, thereby enacting positivism's bias that all non-corporeal realities must necessarily be of a piece. But Hillman makes clear that spirit (*pneuma*) and soul (*psyche*) denote different realities. His articulation of these realities is a thing of power and beauty.

Of special note is how Hillman distinguishes soul and spirit without placing them into antagonism. This is not yet another tired opposition. Soul does not disavow spirit, far, far from it, but rather seeks to find ways to live with spirit, each dedicated to one another's unique gifts and foibles. "When we realize that our psychic malaise points to a spiritual hunger beyond what psychology offers and that our spiritual dryness points to a need for psychic waters beyond what spiritual discipline offers, then we begin to move both therapy and discipline."

This essay rings throughout with Hillman's recurring claim that the work of soul is a work of and on culture. Let it be clear, says this essay, that if we moderns are ignorant of soul, and desperately in search of it, this is largely because our culture has left behind soul in a headlong rush for the peaks.

PEAKS AND VALES

The Soul/Spirit Distinction as Basis for the Differences between Psychotherapy and Spiritual Discipline

JAMES HILLMAN
(Puer Papers, 1976)

> *The way through the world*
> *Is more difficult to find than the way beyond it.*
> "Reply to Papini" —Wallace Stevens

I. IN SEARCH OF SOUL

Long ago and far away from California and its action, its concern, its engagement, there took place in Byzantium, in the city of Constantinople, in the year 869 [C.E.], a Council of the Principals of the Holy Catholic Church,[1] and because of their session then and another one of their sessions a hundred years prior (Nicaea, 787 [C.E.]), we are all in this room tonight.

Because at that Council in Constantinople the soul lost its dominion. Our anthropology, our idea of human nature, devolved from a tripartite cosmos of spirit, soul, and body (or matter), to a dualism of spirit (or mind) and body (or matter). And this because at that other Council, the one in Nicaea in 787 [C.E.], images were deprived of their inherent authenticity.

[1] C. J. Hefele, *Conciliengeschichte* (Freiburg i/Breisgau: Herder, 1860), IV: 320, 404 (Canon 11).

We are in this room this evening because we are moderns in search
of a soul, as Jung once put it. We are still in search of reconstituting
that third place, that intermediate realm of psyche—which is also the
realm of images and the power of imagination—from which we were
exiled by theological, spiritual men more than a thousand years ago:
long before Descartes and the dichotomies attributed to him, long
before the Enlightenment and modern positivism and scientism. These
ancient historical events are responsible for the malnourished root
of our Western psychological culture and of the culture of each
of our souls.

What the Constantinople Council did to soul only culminated a
long process beginning with Paul, the Saint, of substituting and
disguising, and forever after confusing, soul with spirit. Paul uses
psyche only four times in his Epistles. *Psyche* appears in the entire
New Testament only fifty-seven times compared with two hundred
seventy-four occurrences of *pneuma*.[2] (Quite a score! Of these fifty-
seven occurrences of the word *psyche,* more than half are in the Gospels
and *Acts.* The *Epistles*, the presentation of doctrine, the teachings of
the school, could expose its theology and psychology without too
much need for the word soul. For Paul four times was enough.

Much the same is true in regard to dreams and myths.[3] The word
to dream does not appear in the New Testament; dream (*onar*) occurs
only in three chapters of *Matthew* (1, 2, and 27). *Mythos* occurs only
five times, pejoratively. Instead, there is stress on spirit phenomena:
miracles, speaking in tongues, visions, revelations, ecstasy, prophecy,
truth, faith.

Because our tradition has systematically turned against soul, we
are each unaware of the distinctions between soul and spirit—therefore
confusing psychotherapy with spiritual disciplines, obfuscating where
they conflate and where they differ. This traditional denial of soul
continues within the attitudes of each of us, whether Christian or
not, for we are each unconsciously affected by our culture's tradition,

[2] D. L. Miller, "Achelous and the Butterfly," *Spring 1973* (New York/Zürich:
Spring Publications), 14.

[3] Cf. M. T. Kelsey, *God, Dreams, and Revelation* (Minneapolis: Augsburg Publish-
ing House, 1974), 80-84; A. N. Wilder, "Myth and Dream in Christian Scripture," in
Myths, Dreams and Religion, ed. J. Campbell (New York: Dutton, 1970), 68-75; H.
Schar, "Bemerkungen zu Traumen der Bibel," in *Traum und Symbol* (Zürich: Rascher,
1963), 171-79.

the unconscious aspect of our collective life. Ever since Tertullian declared that the soul (anima) is naturally Christian, there has been a latent Christianity, an antisoul spirituality, in our Western soul. This has led eventually to a psychological disorientation, and we have had to turn to the Orient. We place, displace, or project into the Orient our Occidental disorientation. And my task in this lecture is to do what I can for soul. Part of this task, because it is ritualistically appropriate, is to point out C. G. Jung's part in prying loose the dead fingers of those dignitaries in old Turkey, both by restoring the soul as a primary experience and field of work and by showing us ways— particularly through images—of realizing that soul.

II. PSYCHE AND IMAGE

The three hundred bishops assembled at Nicaea in 787 [C.E.] up- held the importance of images against the enemies of images, mainly the Imperial Byzantine army. Images were venerated and adored all through the antique world—statues, icons, paintings, and clay fig- ures formed part of the local cults and were the focus of the conflict between Christianity and the old polytheistic religions. At the time of the Nicaean Council there had been another of those long battles between spirit and soul, between abstractions and images, between iconoclasts and idolaters, such as occur in the Bible and in the life of Mohammed, and such as those which took place in the Renaissance and in the Reformation when Cromwell's men broke the statues of Christ and Mary in the churches in England because they were the Devil's work and not Christian.

The hatred of the image, the fear of its power, and of the imagination, is very old and very deep in our culture.

Now, at Nicaea a subtle and devastating differentiation was made. Neither the imagists nor the iconoclasts got their way entirely. A distinction was drawn between the adoration of images and the free formulation of them on the one hand, and the veneration of images and the authorized control over them on the other.[4] Church Councils split hairs, but the roots of these hairs are in our heads, and the split goes deep indeed. At Nicaea a distinction was made between the image as such, its power, its full divine or archetypal reality, and what the image represents, points to, means. Thus, images became allegories.

[4] C. G. Hefele, *A History of the Councils of the Church*, trans. W. R. Clark (Edinburgh: Clark, 1896), V: 260-400, esp. 377-85.

When images become allegories the iconoclasts have won. The image itself has become subtly depotentiated. Yes, images are allowed, but only if they are officially approved images illustrative of theological doctrine.[5] One's spontaneous imagery is spurious, demonic, devilish, pagan, heathen. Yes, the image is allowed, but only to be venerated for what it represents: the abstract ideas, configurations, transcendences behind the image. Images became ways of perceiving doctrine, helps in focusing fantasy. They become representations, no longer presentations, no longer presences of the divine power.

The year 787 marks another victory in our tradition of spirit over soul. Jung's resuscitation of images was a return to soul and what he calls its spontaneous symbol formation, its life of fantasy (which, as he notes, is inherently tied with polytheism).[6] By turning to the image, Jung returned to the soul, reversing the historical process that in 787 [C.E.] had depotentiated images and in 869 [C.E.] had reduced soul to the rational intellectual spirit.

This is history, yet not only history. For each time you or I treat images as representations of something else—Penis, or Great Mother, or Power Drive, or Instinct, or whatever general, abstract concept we prefer—we have smashed the image in favor of the idea behind it. To give to imagination interpretative meanings is to think allegorically and to depotentiate the power of the imagination.

Here I want to remind you of Jung's position, from which I have developed mine. Jung's psychology is based on soul. It is a tripartite psychology. It is based neither on matter and the brain nor on the mind, intellect, spirit, mathematics, logic, metaphysics. He uses neither the methods of natural science and the psychology of perception nor the methods of metaphysical science and the logic of mentation. He says his base is in a third place between: *esse in anima*, "being in soul."[7] And he found this position by turning directly to the images in his insane patients and in himself during his breakdown years.

The soul and its images, having been alienated so long from our conscious culture, could be recognized only by the alienist. (Or by the artist, for whom imagination and madness have always been kissin' cousins in our culture's anthropology.) So, Jung said, if you are in

[5] Hefele, *Conciliengeschichte*, IV: 402 (Canon 3).
[6] C. G. Jung, *CW 8* (Princeton: Princeton UP, Bollingen Series), § 92.
[7] C. G. Jung, *CW 6*, § 66, 77.

search of soul, go first to your fantasy images, for that is how the psyche presents itself directly.[8] All consciousness depends upon fantasy images. All we know about the world, about the mind, the body, about anything whatsoever, including the spirit and the nature of the divine, comes through images and is organized by fantasies into one pattern or another. This holds true also for such spiritual states as pure light, or the void, or absence, or merging bliss, each of which is captured or structured in soul according to one or another archetypal fantasy pattern.[9] Because these patterns are archetypal, we are always in one or another archetypal configuration, one or another fantasy, including the fantasy of soul and the fantasy of spirit. The "collective unconscious," which embraces the archetypes, means our unconsciousness of the collective fantasy that is dominating our view-points, ideas, behaviors, by means of the archetypes.

Let me continue for just a moment with Jung—though we are almost through the abstract, thinky part of this lecture—who says, "Every psychic process is an image and an imagining."[10] The only knowledge we have that is immediate and direct is knowledge of these psychic images. And further, when Jung uses the word image, he does not mean the reflection of an object or a perception; that is, he does not mean a memory or after-image. Instead he says his term is de-rived "from poetic usage, namely, a figure of fancy or fantasy image."[11]

I have spelled all this out because I want you to know what I am doing. I am showing how soul looks at spirit, how peaks look from the vale, from within the fantasy world that is the shifting structure of our consciousness and its formulations, which are always shaped by archetypal images. We are always in one or another root-metaphor, archetypal fantasy, mythic perspective. From the soul's point of view we can never get out of the vale of our psychic reality.

III. SOUL AND SPIRIT

I have called this talk "Peaks and Vales," and I have been aiming to draw apart these images in order to contrast them as vividly as I can. Part of separating and drawing apart is the emotion of hatred. So I shall be speaking with hatred and urging strife, or *eris*, or *polemos*,

[8] C. G. Jung, *CW 8*, § 618, 623; *CW 11*, § 769.

[9] C. G. Jung, *CW 8*, § 746.

[10] C. G. Jung, *CW 11*, § 889.

[11] C. G. Jung, *CW 6*, § 743.

which Heraclitus, the first ancestor of psychology, has said is the father of all.

The contemporary meaning of "peak" was developed by Abraham Maslow, who in turn was resonating an archetypal image, for peaks have belonged to the spirit ever since Mount Sinai and Mount Olympus, Mount Patmos and the Mount of Olives, and Mount Moriah of the first patriarchal Abraham. And you will easily name a dozen other mountains of the spirit. It does not require much explication to realize that the peak experience is a way of describing pneumatic experience, and that the clamber up the peaks is in search of spirit or is the drive of the spirit in search of itself. The language Maslow uses about the peak experience—"self-validating, self-justifying and carries its own intrinsic value with it," the God-likeness and God-nearness, the absolutism and intensity—is a traditional way of describing spiritual experiences. Maslow deserves our gratitude for having reintroduced pneuma into psychology, even if his move has been compounded by the old confusion of *pneuma* with psyche. But what about the psyche of psychology?

Vales do indeed need more exposition, just as everything to do with soul needs to be carefully imagined as accurately as we can. Vale comes from the Romantics: Keats uses the term in a letter, and I have taken this passage from Keats as a psychological motto: "Call the world, if you please, the vale of soul-making. Then you will find out the use of the world."

Vale in the usual religious language of our culture is a depressed emotional place—the vale of tears; Jesus walked this lonesome valley, the valley of the shadow of death. The very first definition of valley in the Oxford English Dictionary is a "long depression or hollow." The meanings of vale and valley include entire subcategories referring to such sad things as the decline of years and old age, the world regarded as a place of troubles, sorrow, and weeping, and the world regarded as the scene of the mortal, the earthly, the lowly.

There is also a feminine association with vales (unlike peaks). We find this in the *Tao Te Ching*, 6; in Freudian morphological metaphors, where the wooded river valley teeming with animal life is an equivalent for the vagina; and also we find a feminine connotation of the valley in mythology. For valleys are the places of the nymphs. One of the etymological explanations of the word nymph takes these figures

to be personifications of the wisps and clouds of mist clinging to valleys, mountain sides, and water sources.[12] Nymphs veil our vision, keep us shortsighted, myopic, caught—no long-range distancing, no projections or prophecies as from the peak.

This peak/vale pairing is also used by the fourteenth Dalai Lama of Tibet. In a letter (to Peter Goullart) he writes:

> The relation of height to spirituality is not merely metaphorical. It is physical reality. The most spiritual people on this planet live in the highest places. So do the most spiritual flowers. . . I call the high and light aspects of my being spirit and the dark and heavy aspect soul.
>
> Soul is at home in the deep, shaded valleys. Heavy torpid flowers saturated with black grow there. The rivers flow like warm syrup. They empty into huge oceans of soul.
>
> Spirit is a land of high, white peaks and glittering jewel-like lakes and flowers. Life is sparse and sounds travel great distances.
>
> There is soul music, soul food, soul dancing, and soul love...
>
> When the soul triumphed, the herdsmen came to the lamaseries, for soul is communal and loves humming in unison. But the creative soul craves spirit. Out of the jungles of the lamasery, the most beautiful monks one day bid farewell to their comrades and go to make their solitary journey toward the peaks, there to mate with the cosmos...
>
> No spirit broods over lofty desolation; for desolation is of the depths, as is brooding. At these heights, spirit leaves soul far behind...
>
> People need to climb the mountain not simply because it is there but because the soulful divinity needs to be mated with the spirit...[abbreviated]

May I point out one or two little curiosities in this letter. They may help us to see further the contrast between soul and spirit. First, did you notice how important it is to be literal and not "merely metaphorical" when one takes the spiritual viewpoint? Also, this viewpoint requires the physical sensation of height, of "highs." Then, did you see that it is the most beautiful monks who leave their brothers, and

[12] W. H. Roscher, *Ausfuhrliches Lexikon der griechischen und romischen Mythologie* (Leipzig/Stuttgart: Teubner; Hildesheim: Olms, 1965), "Pan," 1392*ff.*

that their mating is with the cosmos, a mating that is compared with snow? (Once in our witch-hunting Western tradition, a time obsessively concerned with protecting soul from wrong spirits—and vice versa—the devil was identified by his icy penis and cold sperm.) And finally, have you noticed the two sorts of anima symbolism: the dark, heavy, torpid flowers by the rivers of warm syrup and the virginal petaled flowers of the glaciers?

I am trying to let the images of language draw our distinction. This is the soul's way of proceeding, for it is the way of dreams, reflections, fantasies, reveries, and paintings. We can recognize what is spiritual by its style of imagery and language; so with soul. To give definitions of spirit and soul—the one abstract, unified, concentrated; the other concrete, multiple, immanent—puts the distinction and the problem into the language of spirit. We would already have left the valley; we would be making differences like a surveyor, laying out what belongs to whom according to logic and law rather than according to imagination. Let us turn to another culture a little closer to home even if far away in time: the early desert saints in Egypt, whom we might call the founders of our Western ascetic tradition, our discipline of the spirit.

We must first recall that these men were Egyptians, and as Violet MacDermott has shown,[13] their spiritual moves need to be understood against their Egyptian religious background. As the inheritor of an enduring polytheistic religion, the desert saint attempted to "reverse the psychological effects of the ancient religion." His discipline aimed to separate the monk from his human community and also from nature, both of which were of vital importance to the polytheistic religion in which divine and human interpenetrated everywhere (that is, in the valley, not only at the peak or the desert). By living in a cave—the burial place of the old religion—the desert saint performed a mimesis of death: the rigors of his spiritual discipline, its peculiar postures, fasting, insomnia, darkness, etc. These rigors helped him withstand the assault of the demons, or ancestral influences of the dead, as well as his personal and cultural history.

[13] V. MacDermott, *The Cult of the Seer in the Ancient Middle East* (Berkeley/Los Angeles: University of California Press, 1971). Cf. H. Frankfort, *Ancient Egyptian Religion* (New York: Harper Torchbook, 1961), Chapter 1, for an excellent summary of Egyptian polytheistic psychology.

> The world of the Gods was, in Egypt, also the world of
> the dead. Through dreams, the dead communicated with
> the living . . . therefore sleep represented a time when his
> soul was subject to his body and to those influences which
> derived from his old religion...his ideal was to sleep as
> little as possible.[14]

Again you will have noticed the turn away from sleep and dreams,
away from nature and community, away from personal and ancestral
history and polytheistic complexity. These factors from which the
spiritual discipline works to be free give specific indications about
the nature of the soul.

 We find another contrast between soul and spirit, couched in
different terms from the spiritual ones we have been examining, in
E. M. Forster's little volume, *Aspects of the Novel*, in which he lays out
the basic components of the art of the novel. He makes a distinction
between fantasy and prophecy. He says that both involve mythology,
Gods. Then he calls up fantasy with these words:

> ...let us now invoke all beings who inhabit the lower air,
> the shallow water, and the smaller hills, all Fauns and
> Dryads and slips of the memory, all verbal coincidences,
> Pans and puns, all that is medieval this side of the grave
> [by which I guess him to mean the coarse, common, and
> humorous, the daily, the grotesque and freakish, even bes-
> tial, but also festive].[15]

When Forster comes to prophecy we gain yet more images of spirit,
for prophecy in the novel pertains to:

> whatever transcends our abilities, even when it is human
> passion that transcends them, to the deities of India,
> Greece, Scandinavia, and Judea, to all that is medieval
> beyond the grave and to Lucifer son of the morning [by
> which last I take him to mean the "problem of good and
> evil"]. By their mythologies we shall distinguish these two
> sorts of novels.[16]

By their mythologies we shall also distinguish our therapies.

 Forster goes on with the comparison, but we shall break off, taking
only a few scattered observations. Spirit (or the prophetic style) is

[14] MacDermott, 46.

[15] E. M. Forster, *Aspects of the Novel* (Harmondsworth: Pelican, 1927, rpt. 1971), 115.

[16] Forster, 115.

humble but humorless. "I may imply any of the faiths that have haunted humanity—Christianity, Buddhism, dualism, Satanism, or the mere raising of human love and hatred to such a power that their normal receptacles no longer contain them."[17] (You recall the lama mating with the cosmos, the desert saint alone.) Prophecy (or spirit) is mainly a tone of voice, an accent, such as we find in the novels of D. H. Lawrence and Dostoevsky. Fantasy (or soul, in my terms) is a wondrous quality in daily life. "The power of fantasy penetrates into every corner of the universe, but not into the forces that govern it— the stars that are the brain of heaven, the army of unalterable law, remain untouched—and novels of this type have an improvised air…"[18] Here I think of the free associations of Freud as a method in psychology, or of Jung's mode of writing where no paragraph logically follows the one preceding, or of Levi-Strauss's figure, the "*bricoleur,*" the handyman and his ragtag putting together of collages, and how different this psychological style is from that of intensely focused transcendental meditation, the turning away, the emptying out.

And finally for our purposes Forster says about fantasy novels, or soul-writing, "If one god must be invoked specially, let us call upon Hermes—messenger, thief, and conductor of souls…"[19]

Forster points to something else about soul (by means of his notion of fantasy), and this something else is history. The soul involves us in history—our individual case history, the history of our therapy, our culture as history. (We have seen the Coptic ascetics attempting to overcome ancestral history through spiritual practices.) Here, I too am speaking soul language in going back all the time to historical examples, such as old E. M. Forster, little fussy man in his room in Cambridge, now dead, and dead Freud and Jung, back to old myths and their scholarship, to etymologies and the history in words, and down to specific geographical localities, the actual vales of the world. For this is the way the soul proceeds. This is psychological method, and psychological method remains within this valley world, through which history passes and leaves its traces, our "ancestors."

The peaks wipe out history. History is to be overcome. History is bunk, said Henry Ford, prophetic manufacturer of obsolescence, and the past is a bucket of ashes, said Carl Sandburg, prophetic singer. So

[17] Forster, 129.

[18] *Ibid.*, 116.

[19] *Ibid.*

the spirit workers and spirit seekers first of all must climb over the debris of history, or prophesy its end or its unreality, time as illusion, as well as the history of their individual and particular localities, their particular ethnic and religious roots (Jung's ill-favored earlier term "racial unconscious"). Thus, from the spirit point of view, it can make no difference if our teacher be a Zaddik from a Polish *shtetl*, an Indian from under a Mexican cactus, or a Japanese master in a garden of stones; these differences are but conditionings of history, personalistic hangups. The spirit is impersonal, rooted not in local soul, but timeless.

I shall ride this horse of history until it drops, for I submit that history has become the Great Repressed. If in Freud's time sexuality was the Great Repressed and the creator of the internal ferment of the psychoneuroses, today the one thing we will not tolerate is history. No; we are each Promethean with a bag of possibilities, Pandoran hopes, open, unencumbered, the future before us, so various, so beautiful, so new—new and liberated men and women living forward into a science fiction. So history rumbles below, continuing to work in our psychic complexes.

Our complexes are history at work in the soul: father's socialism, his father's fundamentalism, and my reaction against them like Hefner to Methodism, Kinsey to Boy-Scoutism, Nixon to Quakerism. It is so much easier to transcend history by climbing the mountain and let come what may than it is to work on history within us, our reactions, habits, moralities, opinions, symptoms that prevent true psychic change. Change in the valley requires recognition of history, an archaeology of the soul, a digging in the ruins, a re-collecting. And— a planting in specific geographical and historical soil with its own smell and savor, in connection with the spirits of the dead, the *po-*soul sunk in the ground below.

From the viewpoint of soul and life in the vale, going up the mountain feels like a desertion. The lamas and saints "bid farewell to their comrades." As I'm here as an advocate of soul, I have to present its viewpoint. Its viewpoint appears in the long hollow depression of the valley, the inner and closed dejection that accompanies the exaltation of ascension. The soul feels left behind, and we see this soul reacting with anima resentments. Spiritual teachings warn the initiate so often about introspective broodings, about jealousy, spite, and pettiness,

about attachments to sensations and memories. These cautions present an accurate phenomenology of how the soul feels when the spirit bids farewell.

If a person is concurrently in therapy and in a spiritual discipline—Vedanta, breathing exercises, transcendental meditation, etc.—the spiritual teacher may well regard the analysis as a waste of time with trivia and illusions. The analyst may regard the spiritual exercises as a leak in the psychic vessel, or an escape into either physicality (somatizing, a sort of sophisticated hysterical conversion) or into metaphysicality. These are conditions that grow in the same hedgerow, for both physicalize, substantiate, hypostatize, taking their concepts as things. They both lose the "as if," the metaphorical Hermes approach, forgetting that metaphysics too is a fantasy system, even if one that must unfortunately take itself as literally real.

Besides these mutual accusations of triviality, there is a more essential question that we in our analytical armchairs ask: Who is making the trip? Here it is not a discussion about the relative value of doctrines or goals; nor is it an analysis of the visions seen and experiences felt. The essential issue is not the analysis of content of spiritual experiences, for we have seen similar experiences in the county hospital, in dreams, in drug trips. Having visions is easy. The mind never stops oozing and spurting the sap and juice of fantasy, and then congealing this play into paranoid monuments of eternal truth. And then are not these seemingly mind-blowing events of light, of synchronicity, of spiritual sight in an LSD trip often trivial—seeing the universe revealed in a buttonhole stitch or linoleum pattern—at least as trivial as what takes place in a usual therapy session that picks apart the tangles of the daily domestic scene?

The question of what is trivial and what is meaningful depends on the archetype that gives meaning, and this, says Jung, is the self. Once the self is constellated, meaning comes with it. But as with any archetypal event, it has its undifferentiated foolish side. So one can be overwhelmed by displaced, inferior, paranoid meaningfulness, just as one can be overwhelmed by eros and one's soul (anima) put through the throes of desperate, ridiculous love. The disproportion between the trivial content of a synchronistic event on the one hand, and on the other, the giant sense of meaning that comes with it, shows what I mean. Like a person who has fallen into love, so a person who has

fallen into meaning begins that process of self-validation and self-justification of trivia which belong to the experience of the archetype within any complex and form part of its defense. It therefore makes little difference, psychodynamically, whether we fall into the shadow and justify our disorders of morality, or the anima and our disorders of beauty, or the self and our disorders of meaning. Paranoia has been defined as a disorder of meaning—that is, it can be referred to the influence of an undifferentiated self archetype. Part of this disorder is the very systematization that would, by defensive means of the doctrine of synchronicity, give profound meaningful order to a trivial coincidence.

Here we return to Mr. Forster, who reminded us that the spirit's voice is humble and the soul's humorful.[20] Humility is awed and wowed by meaning; the soul takes the same events more as the puns and pranks of Pan.[21] Humility and humor are two ways of coming down to *humus*, to the human condition. Humility would have us bow down to the world and pay our due to its reality. Render unto Caesar. Humor brings us down with a pratfall. Heavy meaningful reality becomes suspect, seen through, the world laughable—paranoia dissolved, as synchronicity becomes spontaneity.

Thus the relation of the soul analyst to the spiritual event is not in terms of the doctrines or of the contents. Our concern is with the person, the Who, going up the mountain. Also we ask, Who is already up there, calling?

This question is not so different from one put in spiritual disciplines, and it is crucial. For it is not the trip and its stations and path, not the rate of ascent and the rung of the ladder, or the peak and its experience, nor even the return—it is the person in the person prompting the whole endeavor. And here we fall back into history, the historical ego, our Western-Northern willpower, the very willpower that brought the missionaries and trappers, the cattlemen and ranchers and planters, the Okies and Arkies, the orange-growers, wine-growers, and sectarians, and the gold-rushers and railroaders to California to begin with. Can this be left at the door like a dusty pair of outworn shoes when one goes into the sweet-smelling pad of the

[20] On the relation of humor and psyche, see Miller, 1-23.

[21] On synchronicity and Pan, see my "An Essay on Pan" in *Pan and the Nightmare* (with W. H. Roscher) (New York/Zürich: Spring Publications, 1972), lvi-lix.

meditation room? Can one close the door on the person who brought
one to the threshold in the first place?

The movement from one side of the brain to the other, from
tedious daily life in the supermarket to supraconsciousness, from trash
to transcendence, the "altered state of consciousness" approach—to
put it all in a nutshell—denies this historical ego. It is an approach
going back to Saul who became Paul, conversion into the opposite,
knocked off one's ass in a flash.

So you see the archetypal question is neither how does the soul/
spirit conflict happen, nor why, but who among the variety of figures of
which we are each composed which archetypal figure or person, is in this
happening? What God is at work in calling us up the mountain or in
holding us to the vales? For archetypal psychology, there is a God in
every perspective, in every position. All things are determined by psychic
images, including our formulations of the spirit. All things present them-
selves to consciousness in the shapings of one or another divine
perspective. Our vision is mimetic to one or another of the Gods.

Who is going up the mountain: is it the unconscious do-gooder
Christian in us, he who has lost his historical Christianity and is an
unconscious crusader, knight, missionary, savior? (I tend to see the
latent "Christian Soldier" of our unconscious Christianity as more
of a social danger than so-called latent psychosis, or latent homo-
sexuality, or masked, latent depression.)

Who is going up the mountain: is it the Climber, a man who
would become the mountain himself; I on Mount Rushmore—humble
now, but you just wait and see... Is it the heroic ego? Is it Hercules,
still at the same labors: cleaning up the stables of pollution, killing
the swamp creatures, clubbing his animals, refusing the call of women,
progressing through twelve stages (all in the end to go mad and marry
Hebe, who is Hera, Mom, in her younger, sweeter, smilingly hebe-
phrenic form)?

Or is the one ascending the spiritual impetus of the *puer aeternus*,[22]
the winged godlike imago in us each, the beautiful boy of the spirit—
Icarus on the way to the sun, then plummeting with waxen wings;
Phaethon driving the sun's chariot out of control, burning up the

[22] Cf. M.-L. von Franz, *The Problem of the Puer Aeternus* (New York/Zürich:
Spring Publications, 1970), and my several papers on the theme—e.g., "Pothos—
The Nostalgia of the Puer Aeternus" in *Loose Ends: Primary Papers in Archetypal
Psychology* (New York/Zürich: Spring Publications, 1974), 49-62.

world; Bellerophon, ascending on his white winged horse, then falling onto the plains of wandering, limping ever after? These are the puer high climbers, the heaven stormers, whose eros reflects the torch and ladder of Eros and his searching arrow, a longing for higher and further and more and purer and better. Without this archetypal component affecting our lives, there would be no spiritual drive, no new sparks, no going beyond the given, no grandeur and sense of personal destiny.

So, psychologically, and perhaps spiritually as well, the issue is one of finding connections between the puer's drive upward and the soul's clouded, encumbering embrace. My notion of this connection would avoid two side tracks. The first would take the soul up too, "liberate it" from its vale—the transcendentalist's demand. The second would reduce the spirit to a complex and would thus deny the puer's legitimate ambition and art of flying—the psychoanalyst's demand. Let's remember here that he who cannot fly cannot imagine, as Gaston Bachelard said, and also Muhammad Ali. To imagine in a true high-flying, free-falling way, to walk on air and put on airs, to experience pneumatic reality and its concomitant inflation, one must imagine out of the valley, above the grainfields and the daily bread. Sometimes this is too much for professional analysts, and by not recognizing the archetypal claims of the puer, they thwart imagination.

Let us now turn to the puer-psyche connection without forcing the claims of either figure upon the other.

IV. THE PUER-PSYCHE MARRIAGE

The accommodation between the high-driving spirit on the one hand and the nymph, the valley, or the soul on the other can be imagined as the puer-psyche marriage. It has been recounted in many ways—for instance, in Jung's *Mysterium Coniunctionis* as an alchemical conjunction of personified substances, or in Apuleius's tale of Eros and Psyche.[23] In the same manner as these models, let us imagine in a personified style. Then we can feel the different needs within us as volitions of distinct persons, where puer is the Who in our spirit flight, and anima (or psyche) is the Who in our soul.

[23] There are many Jungian interpretative attempts on this tale. Cf. M.-L. von Franz, *A Psychological Interpretation of the Golden Ass of Apuleius* (New York/Zürich, 1970); E. Neumann, *Amor and Psyche* (New York: Pantheon, 1956); and my own *The Myth of Analysis* (Evanston: Northwestern UP, 1972), 55*ff.*

Now the main thing about the anima[24] is just what has always been said about the psyche: it is unfathomable, ungraspable. For the anima, "the archetype of life," as Jung has called her, is that function of the psyche which is its actual life, the present mess it is in, its discontent, dishonesties, and thrilling illusions, together with the whitewashing hopes for a better outcome. The issues she presents are as endless as the soul is deep, and perhaps these very endless labyrinthine "problems" are its depth. The anima embroils and twists and screws us to the breaking point, performing the "function of relationship," another of Jung's definitions, a definition that becomes convincing only when we realize that relationship means perplexity.

This mess of psyche is what puer consciousness needs to marry so as to undertake "the battle of the sexes." The opponents of the spirit are first of all the hassles under its own skin: the morning moods, the symptoms, the prevarications in which it gets entangled, and the vanity. The puer needs to battle the irritability of this inner "woman," her passive laziness, her fancies for sweets and flatteries—all that which analysis calls "autoeroticism." This fighting is a fighting with, rather than a fighting off or fighting against, the anima, a close, tense, devoted embracing in many positions of intercourse, where puer madness is met with psychic confusion and deviation, and where this madness is reflected in that distorted mirror. It is not straight and not clear. We do not even know what weapons to use or where the enemy is, since the enemy seems to be my own soul and heart and most dear passions. The puer is left only with his craziness, which, through the battle, he has resort to so often that he learns to care for it as precious, as the one thing that he truly is, his uniqueness and limitation. Reflection in the mirror of the soul lets one see the madness of one's spiritual drive, and the importance of this madness.

Precisely this is what the struggle with the anima, and what psychotherapy as the place of this struggle, is all about: to discover one's madness, one's unique spirit, and to see the relationship between one's spirit and one's madness, that there is madness in one's spirit, and there is spirit in one's madness.

The spirit needs witness to this madness. Or to put it another way, the puer takes its drive and goal literally unless there is reflection,

[24] For a full exploration of anima, relevant literature, and citations from Jung, see my two papers "Anima" in *Spring 1973*, 97-132, and *1974*, 113-46.

which makes possible a metaphorical understanding of its drive and goal. By bearing witness as the receptive experiencer and imager of the spirit's actions, the soul can contain, nourish, and elaborate in fantasy the puer impulse, bring it sensuousness and depth, involve it in life's delusions, care for it for better or for worse. Then the individual in whom these two components are marrying begins to carry with him his own reflective mirror and echo. He becomes aware of what his spiritual actions mean in terms of psyche. The spirit turned toward psyche, rather than deserting it for high places and cosmic love, finds ever further possibilities of seeing through the opacities and obfuscations in the valley. Sunlight enters the vale. The Word participates in gossip and chatter.

The spirit asks that the psyche help it, not break it or yoke it or put it away as a peculiarity or insanity. And it asks the analysts who act in psyche's name not to turn the soul against the puer adventure but rather to prepare the desire of both for each other.

Unfortunately a good deal of the psychotherapeutic cosmos is dominated by the perspective of Hera's social adaptation (and her favorite minion, the strong ego of coping Hercules). Hera is out to get the renegade puer spirit and "do" something sensible with it. The puer spirit is not seen for its authentic archetypal value. Hera's priests and priestesses of psychological counseling attempt to make problems clearer, give therapeutic support, by trying to understand what upsets a person. Psychological counseling then literalizes problems and, by killing the possibility of seeing through to their madness, kills the spirit.

Psychologists who do not attend enough to spirit forget that it is one of the essential components of the conjunction and cannot be dismissed as a head trip, as intellect, as just theology or metaphysics or a puer flight. Spirit neglected comes into psychology through the back door, disguised as synchronicity, magic, oracles, science fiction, self-symbolism, mandalas, tarot, astrology, and other indiscriminations, equally prophetic, ahistorical, and humorless. For it requires spirit to discern among the spirits.

Diakrisis itself is a gift of the spirit, and psychologists who refuse the puer chug along empowered by doctrinal mechanisms of dead masters, their own imaginative sails decayed or never even hoisted, circling in the doldrums of low-profile, low-horizon humility: the practice of psychotherapy.

Once the spirit has turned toward the soul, the soul can regard its own needs in a new way. Then these needs are no longer attempts to adapt to Hera's civilizational requirements, or to Venus's insistence that love is God, or to Apollo's medical cures, or even Psyche's work of soul-making. Not for the sake of learning love only, or for community, or for better marriages and better families, or for independence does the psyche present its symptoms and neurotic claims. Rather these demands are asking also for inspiration, for long-distance vision, for ascending eros, for vivification and intensification (not relaxation), for radicality, transcendence, and meaning—in short, the psyche has spiritual needs, which the puer part of us can fulfill. Soul asks that its preoccupations be not dismissed as trivia but seen through in terms of higher and deeper perspectives, the verticalities of the spirit. When we realize that our psychic malaise points to a spiritual hunger beyond what psychology offers and that our spiritual dryness points to a need for psychic waters beyond what spiritual discipline offers, then we are beginning to move both therapy and discipline.

The puer-psyche marriage results first of all in increased interiority. It constructs a walled space, the thalamus or bridal chamber, neither peak nor vale, but rather a place where both can be looked at through glass windows or be closed off with doors. This increased interiority means that each new puer inspiration, each hot idea, at whatever time of life in whomever, be given psychization. It will first be drawn through the labyrinthine ways of the soul, which wind it and slow it and nourish it from many sides (the "many" nurses and "many" maenads), developing the spirit from a one way mania for "ups" to *polytropos*, the many-sidedness of the Hermetic old hero, Ulysses. The soul performs the service of indirection to the puer arrow, bringing to the sulphuric compulsions of the spirit the lasting salt of soul.

Likewise, for soul: the bridal chamber intensifies the brooding, gives it heat and pressure, building soul from amorphous clouds into driving needs. And these, by benefit of puer, become formulated into language. There is a sense of process, direction, continuity within one's interior life of dreams and wishes. Suffering begins to make sense. Instead of the repetitious and usual youth-nymph pairings of virginal innocence coupled with seed spilled everywhere foolishly, psychic conception takes place and the opus of one's life begins to form.

The puer-psyche marriage finally implies taking our complexes both out of the world and out of the realm of spiritual systems. It means that the search and questing go through a psychological search and questing, an exploration of soul by spirit for psychic fecundation. The messianic, liberating, transcending movement connects first with soul and is concerned first with its movement: not "what does this mean?"—the question asked of spirit by spirit—but "what does this move in my soul?"—the interiorization of the question. This alone puts psychic body into the puer message and trip, adding to it psychic values, so that the puer message can touch soul and redden it into life. For it is especially in this realm of soul—so lost, emptied, and ignorant—that the gifts of the puer spirit are first needed. It is soul, psyche, and psychology that need the spirit's attention. Come down from the mountain, monks, and like beautiful John Keats, come into the vale of soul-making.

V. FOUR POINTS OF DIFFERENCE

At this point I am leaving the puer's enthusiastic perspective to return again to soul. I want to suggest now three fundamental qualities of soul-making in distinction to spirit disciplines. These three are: (1) *Pathologizing*[25]—an interest in the psychopathologies of our lives—that is, an attentive concern to the logos of the pathos of the psyche. By keeping an ear tuned to the soul's pathologizings, we maintain the close link of soul with mortality, limitation and death. (2) *Anima*—a loyalty to the clouded moods of the water sources to the seductive twists and turns of the interior feminine figures who personify the labyrinthine path of psychic life, those nymphs, dark witches, lost Cinderellas, and Persephones of destruction, and the elusive, illusional fantasies that anima creates, the images of soul in the soul. (3) *Polytheism*—single-minded commitment to discord and cacophony, to variety and not getting it all together, to falling apart, the multiplicity of the ten thousand things, to the peripheries and their tangents (rather than centers), to the episodic, occasional, wandering movement of the soul (like this lecture) and its compulsion

[25] By pathologizing I mean the psyche's autonomous ability to create illness, morbidity, disorder, abnormality, and suffering in any aspect of its behavior and to experience and imagine life through this deformed and afflicted perspective; cf. "Pathologizing," part two of my *Re-Visioning Psychology* (New York: Harper & Row, 1975).

to repeat in the valleys of its errors, and the necessity of errancy and error for discovering the many ways of many Gods.

I am aware that these lectures have been organized in order to relate East and West, religious disciplines and psychotherapy, and so I must make a contribution to an issue that I believe is not the main one (the East-West pair). For I believe the true passion is between North and South, between the upper and lower regions, whether they be the repressive Northern Protestantism of Europe and America on the one hand, and on the other, Southland, the oppressed Mediterranean, the Latin darkness below the borders, across the rivers, under the alps; whether this division be the manic industrial North and the depressive ritualistic South, or between San Francisco and Los Angeles.

But Professor Needleman says the line is blurred between the therapist and the spiritual guide, and he would draw that line spiritually—that is, vertically—creating East and West across the mountain tops, perhaps like the Continental Divide, whereas I would draw the line horizontally, as rivers flow, downward. The three qualifications I have just made—pathologizing, anima, polytheism—are my way of drawing the line more heavily and bluntly, thick with shadow.

Anyone who is engaged with these three factors, regarding them as important, as religious even, seems to me to be engaged in therapy and psychology. Anyone who tends to dismiss pathologizing for growth, or anima confusions for ego strength or spiritual illumination, or who neglects the differentiation of multiplicity and variety for the sake of unity is engaged in spiritual discipline.

The lines between the two labors I would draw in this way. But I would also suggest that they are drawn not by what a person preaches but according to the weight of importance he lays upon trivia, the little things in daily practice. There are, for instance, many who are called psychotherapists and pretend its practice, but who, according to these criteria, are actually daily engaged in spirit. In the emphasis they give and in the values they select, their main concern is with ascension (growing up), strengthening, unity, and wholeness. Whereas I believe, though I am less familiar with the spiritual side of things (coming from Switzerland, where our main words are complex, schizophrenia, introvert-extrovert, Rorschach and Bleuler, and the spectrum of drugs from Ciba-Geigy, Sandoz, and Hoffmann-La Roche; that is, our fantasy is more psychiatric, more psychopathological

than yours, which is more spiritually determined by your history and geography, this Golden State, its founding missions, its holy spiritual names—Eureka, Sacramento, Berkeley (the Bishop), Los Angeles, San Diego, Santa Cruz, Carmel, Santa Barbara) I believe that the spiritual masters may, despite their doctrine, very often be engaged in psychotherapy when they follow the female inner figure as guide, the *paredros* or angel, when they allow vision and fantasy to flourish, when they let the multiple voices in the symptoms speak and turn the pathologizings into inner teachers, when they move from all generalities and abstractions to concrete immediacy and the multivalence of events.

In other words, the lines between therapy and discipline, between soul and spirit, do not depend on the kind of patient, or the kind of teacher, or whether the patient or teacher was born in the Cascades or the Himalayas, but rather depend upon which archetypal dominant is working through one's viewpoint. The issue always returns to "Who" in an individual's subjectivity is asking the questions and giving the answers.

Pathologizing, anima, and polytheism are, moreover intimately connected with one another. It would take us too far in this talk to attempt to show the internal logic of this connection, and I am not up to doing it swiftly and succinctly. Besides, this interconnection has been a main theme of many of my writings, because one soon discovers in work with oneself and others that each of these criteria of soul-making tends to imply the other. The varied anima figures, elfin inspirations, and moods that move a person, men and women alike (for it is nonsense to hold that women can have only animuses, no souls, as if an archetype or a goddess could be limited to the personal psychology of sexual gender), give a peculiar double feeling. There is a sense of me-ness, personal importance, soul sense, that is not an ego inflation, and at the same time there is an awareness of one's subjectivity being fluid, airy, fiery, earthy, made of many components, shifting, ungraspable, now close and intimate and helpful as Athene giving wise counsel, then wily and disappearing, naively pulling one into hopeless holes like Persephone, and at the next moment fantasizing Aphroditic whisperings in the inner ear, sea foam, pink vulvar bivalves, and then proud and tall Artemis, keeping everything at bay, oneself at a distance, at one only with nature, a virgin soul among brothers and sisters, only.

Anima makes us feel many parts.

Anima, as Jung said, is an equivalent of and a personification of the polytheistic aspect of the psyche.[26] "Polytheism" is a theological or anthropological concept for the experience of a many-souled world.

This same experience of multiplicity can reach us as well through symptoms. They too make us aware that the soul has other voices and intentions than the one of the ego. Pathologizing bears witness to both the soul's inherent composite nature and to the many Gods reflected in this composition. Here I take my cue from two passing remarks of Jung. "The divine thing in us functions as neuroses of the stomach, or the colon, or the bladder, simply disturbances of the underworld. Our Gods have gone to sleep, and they only stir in the bowels of the earth."[27] And again: "The gods have become diseases; Zeus no longer rules Olympus but rather the solar plexus, and produces curious specimens for the doctor's consulting room..."[28]

Sometimes going up the mountain one seeks escape from this underworld, and so the Gods appear from below bringing all sorts of physiological disorders. They will be heard, if only through intestinal rumblings and their fire burning in the bladder.

Like going up the mountain, but in the disguise of psychology, are the behavior therapies and release-relax therapies. Cure the symptom and lose the God. Had Jacob not grappled with the Daemon he would indeed have not been hurt, and he would not have been Jacob either. Lose the symptom and return the world back to the ego.

Here my point is that soul-making does not deny Gods and the search for them. But it looks closer to hand, finding them more in the manner of the Greeks and Egyptians, for whom the Gods take part in all things. All existence is filled with them, and human beings are always involved with them. This involvement is what myths are all about—the traditional stories of human and divine interactions. There is no place one can be, no act one can do, no thought one can think without it being mimetic to a God. Thus we study mythology to understand personality structure, psychodynamics, pathologizing. The Gods are within, as Heinrich Zimmer used to say, and they are within

[26] C. G. Jung, *CW 9ii*, § 427 and my discussion of this theme in "Psychology: Monotheistic or Polytheistic?," *Spring 1971*, 193-208.

[27] C. G. Jung, "Psychological Commentary on Kundalini Yoga" (from the notes of Mary Foote, 1932), *Spring 1975*, 22.

[28] C. G. Jung, *CW 13*, § 54.

our acts, thoughts, and feelings. We do not have to trek across the starry spaces, the brain of heaven, or blast them loose from concealment with mind-blowing chemicals. They are there in the very ways you feel and think and experience your moods and symptoms. Here is Apollo, right here, making us distant and wanting to form artful, clear, and distinct ideas; here is old Saturn, imprisoned in paranoid systems of judgment, defensive maneuvers, melancholic conclusions; here is Mars, having to turn red in the face and kill in order to make a point; and here too is the wood nymph Daphne-Diana, retreating into foliage, the camouflage of innocence, suicide through naturalness.

Finally, I would point to one more, a fourth, difference between peaks and vales, the difference that has to do with death.

If spirit would transcend death in any of several ways—unification so that one is not subject to dissolution; union with self, where self is God; building the immortal body, or the jade-body; the moves toward timelessness and spacelessness and imagelessness and mind-lessness; dying to the world as place of attachments—soul-making would instead hew and bevel the ship of death, the vessel of death, a container for holding the dying that goes on in the soul. It imagines that psychic life refers most fundamentally to the life of the *po*-soul, that which slips into the ground—not just at the moment of physical death but is always slipping into the ground, always descending, always going deeper into concrete realities and animating them.

So I cannot conclude with ultimates, positions, final words, wise statements from masters. There is no end to a wandering discourse, no summation, summit, for to make an end is to come to a stop. I'd rather leave unconcluded and cloudy, no abstracted spiritual message—not even a particular image. You have your own. The soul generates them ceaselessly.

Editor's Note

In the following essay, Wolfgang Giegerich grapples with some of psychology's most persistent demons. Struggling to maintain psychology as the soul's discipline, Giegerich argues that much psychological theory has little to do with soul, and thus falls into many of the ego's traps. Giegerich maintains that psychology is neurotic, recalling Jung's words that the "baleful work that is going on in every neurotic...[is] the destruction of the bond between men and the gods." But how can psychology offer a proper response to this ontological dysfunction, asks Giegerich, when psychology suffers the selfsame malaise?

We are in this predicament, says Giegerich, because "psychotherapy is fixated on the patient." In this one sentence he encapsulates his argument. The fact of fixation alone points to the single-minded and literalizing ego, and the concomitant lack of psychological movement. The fact that psychology is fixated not on soul and things psychological but on the person and his or her complaints points to psychology's dissociated personalism. And the fact that the person has become a "patient" points to psychology's medical delusions and inflations, complete with the medical model's denigration of pathology and its decrees as to what constitutes healing and cure.

Psychology's neurosis is reflected nowhere more strongly than in our psychological theories, says Giegerich. Note psychology's fascination with interpersonal relationships that have the effect of introspecting the soul right out of the world. Note psychology's lip-service to the importance of pathology, while its theories covertly insist that pathology must be a precursor to heroic growth. And note psychology's seeming inability to turn a therapeutic and theoretic eye on itself, a move that Giegerich claims would enable psychology to no longer "restrict therapy to the consulting-room and theorizing to books." Giegerich's call is clear: "[I]nstead of locating psyche in persons we must learn to see psychologically."

To accomplish this task, psychology must first reestablish soul as the missing third that makes possible psychological experience. "What is this factor, who is the third person of psychotherapy?" asks Giegerich. "It is, of course, the soul, which is no longer to be imagined as the individual property of [the person], but must be given independent reality." Giegerich's concern is how to articulate this reality in our psychological theories such that psychology might come home to its proper place in soul.

ON THE NEUROSIS
OF PSYCHOLOGY
OR THE THIRD OF THE TWO

WOLFGANG GIEGERICH
(Spring 1977)

1. THE THIRD PERSON IN THERAPY

In contrast to "group therapy," we speak of "individual therapy," *"Einzeltherapie."* A strange formulation, for does it not imply a one-person affair? This formulation evokes reminiscences of the early "talking cure," the monologue of the patient, in which the therapist functioned only as an observing audience, an outsider. Through this term a conventional medical thought pattern seems to intrude into our psychological thinking, or rather cling to it, although we believe to have overcome it long ago. Surely, we know and accept that psychotherapy is a two-person affair, a dialogue; that the analyst is inevitably drawn in, and that Jung even went far beyond the acknowledgment of a duality based on transference by demanding that the doctor step out of his role altogether and fully enter into the process on an equal footing with the patient. Just as the patient is to lift his mask in analysis, so is the analyst supposed to give up his anonymity. Mutuality takes the place of asymmetry. We know and affirm this— but the term "individual therapy" (let alone our practice) shows what a powerful hold conventional thinking has over us. We obviously still

think of psychotherapy as a one-way process in which everything revolves about the patient. He has to be cured. Psychotherapy is fixated on the patient.

Jung even went beyond the dialogue-idea to a dialectic understanding of psychotherapy. Whereas a dialogue is an interaction or communication between two persons, dialectics involves a Third. A dialectic understanding of therapy thus implies that doctor and patient are not alone. There always is a third factor, a third "person" present. This idea of the Third characterizes Jung's view of psychotherapy throughout. We read e.g. in "Psychology of Transference" (*CW 16*, § 399), "Psychological induction inevitably causes the two parties to get involved in the transformation of the third and to be themselves transformed in the process." It is this third "person" on which the therapy ultimately depends. The psychological induction is here not thought of as running from the patient to the analyst or vice versa, but rather as an embeddedness of both persons in the Third, in "mutual unconsciousness" (*CW 16*, § 364). Instead of asymmetrically concentrating on the patient, both persons now focus their attention on this objective third factor. What is this factor, who is the third person of psychotherapy? It is, of course, the soul, which is no longer to be imagined as the individual property of each of the two other persons, but must be given independent reality. It is the world of complexes and archetypal images, of views and styles of consciousness, and thus it is also psychology itself, in the widest sense of the word, including all our ideas about the soul, its pathology and therapy, as well as our *Weltanschauung*. "As the most complex of psychic structures," writes Jung (*CW 16*, § 180), "a man's philosophy of life forms the counterpole to the physiologically conditioned psyche, and, as the highest psychic dominant, it ultimately determines the latter's fate. It guides the life of the therapist and shapes the spirit of his therapy." The third person unfolds into two aspects or counterparts, which can be distinguished, but ultimately belong together: the soul itself and the theory about it (psychology), and, if we follow Jung, it is the latter on which the fate of the former depends.

Our psychological theories are thus of highest importance to the outcome of therapy (cf. *CW 10*, § 340). They are present from the beginning, and they guide and shape the spirit of therapy. If psychology is in this sense the third autonomous person with a living and decisive

presence in psychotherapy, it may also be suspected of having its own unconsciousness—and possibly even its own neurosis.

2. THE NEUROSIS OF PSYCHOLOGY

It was again Jung who formulated this suspicion and elaborated on it. In a paper of 1934 he comes to the conclusion that "Psychology today, it seems to me, still has a vast amount to unlearn and relearn... But first it must cease thinking neurotically..." (*CW* 10, § 369). To begin with, psychology itself thinks in a neurotic fashion, according to Jung. In the same paper we find a number of different formulations for this idea, mainly in reference to Freud's psychoanalysis. Thus Jung argues that precisely that which happens to the neurotic has been dignified with the name of a "theory" by the psychoanalyst, so that patient and doctor ride "the same hobby-horse" (*CW* 10, § 362). "It is positively grotesque that the doctor should himself fall into a way of thinking which in others he rightly censures and wants to cure..." (*CW* 10, § 356). Or: "Freud, it seems, took the neurotic conjectures quite seriously and thus fell into the same trap as the neurotic..." (*CW* 10, § 365).

These sentences contain a scandalous thesis. Neurosis is not what the patient has and for what psychology provides the remedy, but is already inherent in therapeutic psychology itself. Patient and doctor—a case of *folie à deux*! Instead of being the healing answer to neurosis, instead of overcoming it and bringing an end to it, therapeutic psychology is the continuation of neurosis by other means. Or in the words of the cynical joke attributed to Karl Kraus: psychoanalysis is that illness whose cure it thinks to be.

Because Jung exemplified this thesis mainly by psychoanalysis, it was usually taken as an expression of his alleged anti-Freudian resentment and thus it was not felt necessary to take it seriously. We do not want to follow this train of thought and place Jung's idea within a fantasy of the battle among the schools of depth psychology. We rather take it seriously as containing an important principle, a critical tool with which to examine our own psychological assumptions. Our critical question is: where do we, in and with our theories, ride the same hobby-horse as the patient?

The question is not directed at us as persons. Our purpose here is not to analyze the neurotic features of the therapist as a private individual, but rather those of psychology itself, which we are here

regarding as an autonomous "person." We want to find out whether our psychological theory has taken over neurotic thought patterns and mechanisms into the structure of its own "consciousness" and whether it tries to fight or cure those very same mechanisms in the patient in order to defend itself against becoming aware of its own neurosis. Of course, it is impossible to review the sum total of our psychological ideas in this paper. We must content ourselves with a number of characteristic examples that show the principle indicated by Jung at work in central areas of our psychology.

3. THE "NEGATION OF THE NEGATIVE"

I take this phrase and idea from E. Neumann's *Depth Psychology and a New Ethic*, where it is revealed as being at the core of the scapegoat mentality of old ethics, whereas depth psychology in its entirety has meant the confrontation of modern man with all those factors that he wanted to close his eyes to. This was true from the very beginning of psychoanalysis with Freud, who brought about the recognition of sexuality within a Victorian world, to Jung's emphasis on the shadow and his attempt to integrate the idea of evil even into the image of God. The principle of depth psychology is the lifting of the repressions, and there can be no doubt that this principle guides the practice of analytical psychotherapists, who do not want to talk the patient out of his symptoms, but allow him (or her) to "regress," that is, to follow the path of his pathology. So much for analytical practice. But how about psychological theory?

It seems to me, what our theory thinks about regression can be summarized in the oft-quoted saying *"reculer pour mieux sauter."* regression for the purpose of an even better progression. We affirm pathology and regression, but only because a reward is in the offing. Psychological theory holds out a carrot, much as in Christian theology the promise of Heaven makes the vale of tears palatable. It is only a token acceptance, necessitated by the circumstances, but not a whole-hearted affirmation. Just as the neurotic, if it turns out that his fantasy cannot be realized, is ready to put up with all kinds of disagreeable symptoms and to accept all sorts of concessions—so long as he does not have to give up his fantasy altogether—so is psychology willing to make concessions to the id, the infantile fantasies and pathology, if it can thereby avoid having to change its innermost attitude of

hostility towards the pathological. Even if in analytical practice the symptoms and the regressive tendencies are accepted, our thinking retains the habitual attitude that we call negation of the negative. *Reculer pour mieux sauter* means a return, not of the repressed, but of repression! The repression that we fight in the consulting-room returns as a repressive spirit in our very own theory. Here our psychological ideas clearly follow the neurotic mind.

Likewise, when psychotherapy as a whole is conceived after the model of medicine and thinks of itself mainly as a healing and curing profession, it inherits the hostile position that medicine holds towards illness. A standpoint which continues the hostility of the patient toward his disturbance is of course not in accordance with the principle of depth psychology. Both Freud and Jung were aware of this. Freud clearly stated that psychoanalysis was not a department of medicine, not a chapter in a psychiatry textbook, not even medical psychology, but psychology purely and simply.[1] And Jung went so far as to reject altogether the will to heal and change, or at least to query it. "But when a patient realizes that cure through change would mean too great a sacrifice, then the doctor can, indeed he should, give up any wish to change or cure" (*CW 16*, § 11), for what we call healing actually amounts to an amputation (*CW 10*, § 355). Instead of the usual hostile attitude Jung envisions a gratefulness toward the neurotic symptoms (*CW 16*, § 11) and demands, "We should even learn to be thankful for it [the neurosis], otherwise we pass it by and miss the opportunity..." (*CW 10*, § 361). "In the neurosis is hidden one's worst enemy and best friend. One cannot rate him too highly[!]..." (*CW 10*, § 359). "We should not try to 'get rid' of a neurosis, but rather to experience what it means, what it has to teach, what its purpose is... A neurosis is truly removed only when it has removed the false attitude of the ego. We do not cure it—it cures us" (*ibid.* 361). Here Jung's thinking has fully given up the *reculer pour mieux sauter* attitude. This is true depth psychology, because the negative is no longer negated, not even secretly, but unconditionally "*erinnert*" and affirmed—without leaving open an escape hatch.

Jungian theory distinguishes a positive from a negative aspect of the archetypes, and when we find the negative aspect at work in a

[1] S. Freud, "Nachwort zur 'Frage der Laienanalyse,'" *Studienausgabe*, Erg. bd. (Frankfurt, 1975), 343*ff*.

patient, we think it necessary to "constellate" the corresponding positive one. Here our "panic fear" (*CW 10*, § 530) of psychopathology expresses itself, as well as does our attempt to combat it through apotropaic measures. We use the good mother to drive out the bad mother. The negative must not be. But we do not simply fight it through activities (constellating the positive aspect), but also theoretically through the "neurotic trick of euphemistic disparagement" (*CW 10*, § 365): we conceive all "negative" images as merely temporary, as an expression of an intermediate stage that hopefully will be followed by "positive," "prospective" images. Thus we devaluate the negative. Darkness is "nothing but" a night-sea-journey upon which there will be a new sunrise, and it is for the sunrise that we are willing to go into the dark. Even worse—"death" becomes the road to rebirth. If this is how we see death, as a mere passage, it does not have a full reality of its own. It is degraded to a means to an end.

Thus psychology takes sides for life and for light and against darkness and death, it belittles the negative, and through such thinking tries to overcome it, to leave it behind or below. Here we have in our own theory what Jung terms the denial of the left hand. The acceptance of darkness is, so to speak, acted out. We want the patient (or ourselves as persons) to accept it; we project the task of accepting it onto persons and into the consulting-room, and thereby save our theory from having to admit darkness and death into its innermost structure. By the same token we like to use the formula "not yet," this variety of the "nothing but" and thus to place the negative or imperfect into an eschatological fantasy of development or growth. The patient is "still" in the oral or uroboric phase, he has "not yet" reached the genital level or the solar-rational stage. With such formulations we implicitly cast out the condition in which he is now; the present condition is not accepted as what it is, but only for what may come out of it. Inherent in the positive hope for a better future is a condemnation of the present. We only seem to accept the shadow, in actuality we still repress it, only in a more subtle and less obvious way. The very distinction between the positive and the negative means a dissociation. Moreover, as a moralistic value judgment, it necessarily involves a devaluation and repudiation. Speaking about symbols Jung takes a stand against such thinking. "The moralistic and hygienic temper of our days must always know whether such and such a thing is

harmful or useful, right or wrong. A real psychology cannot concern itself with such queries; to recognize how things are in themselves is enough" (*CW 6*, § 203). Positive (prospective) and negative are not psychological categories but instruments of moralistic repression.

Our theory is full of ego; ego-psychology, ego-functions, ego-development and stages of the ego, ego-consciousness and ego-strengthening. What does this mean if not that our theory is dominated by, or fixated upon, the very same ego that ought to be "removed" by the neurosis, as we heard from Jung? Psychology has again incorporated a neurotic aberration in its very theory. The archetype of the hero, who in some ways can be considered a paramount model of neurotic behavior, has even been made the quasi-official prototype of "healthy development." When such a heroic ego is confronted with the consequences of its violence and tires of its show of strength, it may long to abandon itself to the "Great Experience," the *Urerfahrung* (Neumann), the "Peak Experience" (Mallow), or the "Creative Moment," something quite out of the ordinary that therefore can also not be attained within ordinary life. This ego will wait for an oversize numinous experience, for the very special Archetypal dream, or practice all sorts of meditative techniques, or even make use of drugs to go on its special trip. A term like Great Experience implies a betrayal of the small events of everyday life and the hero's impotence to experience them. The thinking behind such terms alienates us even more from ourselves and from simple things by depreciating them and inflating us.

Another type of negation of the negative can be found in the attitude that characterizes conventional depth psychology. Whereas therapy aims for flexibility, spontaneity, free association and active imagination and wants to provide a *temenos* of warmth and understanding, psychology as theory is interested in hard facts, in a systematic body of experientially based knowledge about the psyche in well-defined concepts, and tries to give itself a scientific air by using a technical jargon, typology, clinical expressions, even "cases," by designing tests and employing various other methods for the validation of its findings. In our practice we take heed of Jung's advice to steer clear of any rigid technique and to be open to the individuality of the patient and to the requirements of the moment. But our theoretical thinking is dominated by practical and technical

questions: group therapy or not? Is one allowed to touch the patient? What to do if the patient...? How to deal with transference reactions? Could "other" techniques, such as gestalt or primal scream enrich our repertoire? Such are the questions that really interest us, which shows that the technological mind is firmly rooted in the thought of psychology itself. The attitude prevailing in psychological theory is one of control, of "directed thinking," of grasping. Obviously our theory uses the very same defense mechanisms of rationalization and intellectualization that it fights in the patient; imaginative theorizing, so-called speculation, is banned from theoretical psychology as is a feeling-toned personal involvement and mode of rhetoric. Symbolic thinking is something that the patient (or modern man in general) is supposed to develop, but our theory balks at it as at "inferior thinking."

Even our idea of wholeness partakes of neurotic thinking. For we expect to achieve completeness through adding previously neglected functions to the number of well-developed ones or by compensating a one-sidedness through supplying the lacking side. In this manner we will only get an aggregate of functions, which in themselves are one sided and split-off, but we will never get wholeness. Jung ridiculed this mistaken idea of completeness in a letter of 9. I. 1960, discussing the topic of "Socrates and his flute." He states that "The story starts with his *daimonion*, whispering into his ear: 'Thou shouldst make more music, Socrates!' Whereupon dear old well-meaning Socrates went to buy a flute and began lamentable exercises. He obviously misunderstood the advice, but in a characteristic way," by taking the inner voice "literally and technically as if he were a modern man"—or, I would add, as if he were a modern Jungian psychotherapist. What was his misunderstanding? That he thought he could achieve wholeness through compensating his one-sided philosophical activities (thinking) with the "opposite" activity (music). The equation "philosophy + flute = wholeness" is obviously wrong according to Jung. Compensation does not mean a behavior (in the widest sense of this word: all directly or indirectly observable actions of the organism) that is added to the one sided activity, but it means a change of attitude. Instead of thinking on the level of behavior (=literalizing), Socrates should have understood the counsel psychologically. Then he would not have played the flute by way of

counterbalance; he would and could have stayed with philosophy—but he would then have philosophized in a less rationalistic, more "musical" fashion. The one-sidedness was not one of behavior (his specialization in philosophy), but one of the attitude with which he practiced this true and only profession of his (*cf.* Berry, "On Reduction" on this[2]). Thus Socrates acted out the compensation on the level of behavior when he should have accomplished it on the level of psychology, that is in the *Erinnerung*, recollection, by an inner change of mind.

Now, returning to ourselves and to psychology, we can say that we too try to act out the idea of wholeness by projecting it on the patient as a task to be accomplished and by understanding it on the level of behavior in terms of balancing the various functions or activities. But for Jung, wholeness is a matter of the *Blick fürs Ganze*, the view of the psyche as a whole (*CW 10*, § 370), not of becoming a psychological Jack-of-all-trades. It is not our specialization that has to change, but the narrow-mindedness with which we see. The place where wholeness has to be achieved, where the inferior function has to be developed and where the shortcomings that we call "shadow" have to be integrated is not mortal man as person—to think so would be hubris—but it is psychology, the psychology of each of us, as it was the place for Jung himself when he wrote his book on types. With these comments we are already touching upon the topic of the following section.

4. PERSONALISM AND REDUCTIONISM

In the same paper that gave us our touchstone with which to examine psychology for a possible neurosis, Jung describes "the prime evil of neurosis" as the loss of the "great relationship." He "who denies the great must blame the petty." Thus did Freud want to "put an end once and for all to the larger aspect of the psychic phenomenon," says Jung with reference to *The Future of an Illusion*, "and in the attempt he continues the baleful work that is going on in every neurotic: destruction of the bond between men and the gods..." (*CW 10*, § 367). Psychology again perpetuates the very principle behind the patient's neurosis.

What Jung attacks here could be called the empiricism of psychology, that view which, because it denies "the great," looks for the

[2] P. Berry, "On Reduction," *Spring 1973*, 80*ff.* and *passim*.

causes in "the petty," i.e., tries to "explain" the neurosis causally from all kinds of "empirical" factors: sexuality or any biological instinct, the bad mother, family structure, social conditions, an organic deficiency, experiences during infancy, the trauma of birth, etc., etc. In all such theories the defense mechanisms of displacement and projection are at work; not only is our interest then directed outside our own field and psychology rooted heteronomously in other branches of knowledge (biology, sociology, behaviorism, medicine, and so on), but the neurosis itself is displaced far away from ourselves, from the soul, into some extrinsic factor. The neuroses must under no circumstances—such theories proclaim—be located within the soul. The external source of the neurosis may of course have to be sought relatively close to us, such as in our body (sexuality) or in some "inferior function"—it will be acceptable as long as it can be experienced (imagined) as something external and objective, in other words, as long as it does not involve our innermost subjectivity, the soul.

Jung by contrast advocated the idea that the neurosis originates, not from any empirical factor, but "from the mind [*Seele*] of the sufferer. Nor does it come from some obscure corner of the unconscious, as many psychotherapists still struggle to believe..." (*CW 10,* § 337). Scientific psychology, which aims for knowledge of objective facts, avoids the use of the word "soul" in favor of "behavior"—and this for no small reason. It is not a matter of "mere words," but one of intensest reality: scientific objectivity helps us to "get out of it," it helps us to defend ourselves against the neurosis and to keep it at bay, outside. We are wrong to believe that word-magic occurs only in the primitive and in some patients; it happens now and on our home ground of psychology. The avoidance of the word soul and the "euphemistic disparagement" of the word behavior is an all-too-anxious attempt to seal off our most intimate subjectivity against any "evil" influences. Little wonder that such an isolated (autistic) psychology acts out the idea of relationship to excess.

Paradoxically the carefully avoided subjectivity unwittingly returns within the objective scientific world of facts, in more than one way. I do not here want to go into the topic of the "subjective conjectures" (*CW 10,* § 356) that underlie the allegedly objective "explanations" and "laws" of scientific psychology, but will restrict myself to the discussion of personalism. Empirical psychology knows only of

psychological phenomena that belong to persons, that is, it can only conceive of them in terms of personal property, of "mine" or "his" or "yours" (cf. *CW 12*, § 562). The root metaphor of psychology is atomism. First come all the individual persons and only then the soul (each person's soul, instincts, feelings, and thoughts). If the soul exists for psychology as countless individual, separated souls, how can there be wholeness? Likewise, the psyche itself is thought to be made up of self-identical units (called agencies, functions, and the like), units, that is, which are originally and primarily conceived as separated and which make a whole only on account of their being combined within one system (aggregate). We already talked about the fact that the very structure of our theoretical thought establishes the isolation and sepa-rateness that it wants to overcome through striving for wholeness. We also know that addition (combination) cannot create a whole out of what is defined as split off, but that a change of our *theoria* in the direction of a *Blick fürs Ganze* is indispensable.

Now we add that psychology must start from the "whole," from "the great," from the "bond between men and the gods," if it wants to arrive at wholeness and heal the neurotic splits. This is why Jung thought very little of basing our insights on case studies, on clinical observation within the consulting-room. "The scope must be widened to reveal...the meaningful whole" (*CW 10*, § 354). For this reason Jung turned to such seemingly remote and odd fields as mythology, gnosticism and alchemy when it was a question of seeing "the full range of the human psyche" (*CW 10*, § 369) at work. And instead of explaining the "larger aspect of the psychic phenomenon" from the consulting-room experience, he conversely tried to see the patient and personal behavior in the light of the insights gained from such eccentric studies.

Why Jung turned to such odd fields and what is meant by "the great" and "the petty" can become clearer from an analogy that Edgar Wind uses in a similar connection. He talks about an iconographer who on account of his reductive approach discovered that "the symbolic creations of geniuses are unfortunately harder to nail down to a definite subject than the allegorical inventions of minor artists" and adds:

> If this be so, there is something wrong with the manner
> of nailing down. A method that fits the small work but
> not the great has obviously started at the wrong end. In
> geometry, if I may use a remote comparison, it is possible
> to arrive at Euclidean parallels by reducing the curvature
> of a non-Euclidean space to zero, but it is impossible to
> arrive at a non Euclidean space by starting out with
> Euclidean parallels. In the same way, it seems to be a
> lesson of history that the commonplace may be under-
> stood as a reduction of the exceptional, but that the
> exceptional cannot be understood by amplifying the
> commonplace. Both logically and causally the exceptional
> is crucial, because it introduces...the more comprehen-
> sive category.[3]

But are we Jungians not making use of the more comprehensive
category, are not we too starting with the "whole" and the "great?"
For after all, the concepts of the collective unconscious and of the
archetypes are in the center of Analytical Psychology. Yet, when we
look at what we actually do, then I think it is an illusion to assume
that Analytical Psychology is any less personalistic than, say, psycho-
analysis. The difference is merely that the latter openly admits its
personalistic and reductive approach whereas our theory disguises it.

 We talk of the concrete mother and the other women in the family
and entitle this "the matriarchal sphere"! We describe a mother as
negative and then say she evoked the negative aspect of the mother
archetype through her nature. What are we doing here? If a bad mother
evokes the bad aspect of the mother archetype and a good mother
the good aspect, then this means that the concrete person is the
actual and decisive reality. The archetype is then no primordial image
any more at all, it is not originary, but a derived and dependent factor—
if not merely a big, inflated, but empty word behind which there is
no other reality but the personal mother. It is a mere duplication of
this mother, in the same way as Freud describes the imaginary parents in
the family romance of the neurotic:[4] these new and ennobled parents
show characteristics that derive from the recollection of the real parents,
so that the child actually does not remove the father, but only magnifies
him. This euhemeristic analysis fits perfectly to our personalistic use

[3] E. Wind, *Pagan Mysteries in the Renaissance* (New York: Norton), 1968, 238.

[4] "Der Familienroman der Neurotiker", in S. Freud, *Studienausgabe*, vol. 4, 226.

of the term archetype: even if we rightly frown at personalistic reduction where it is used to disparage archetypal fantasy material—there are things which legitimately can be, even ought to be, subjected to a reductive interpretation: our inflated concepts.

The origin and root of the archetypal images (the way Analytical Psychology comprehends them) are the empirical persons. It is for this reason too, that in Analytical Psychology we almost exclusively find the mother (+anima), father (+animus) and the self archetypes: the richness and multitude of archetypal figures that we find in mythology has dwindled to these three or five (showing that our "archetypes" derive from, and depict, the (aggrandized) real family. This means that the old sensationalist fallacy is still at work and is only disguised in Analytical Psychology. How honest and relieving is Freud's language. He means mother and he says mother. We mean the very same mother, but blow her up to an archetype. Thus we destroy what the term archetype actually and "originally" refers to, we cancel that imaginal "substance" from our thinking, but succeed in concealing this loss because with a kind of "immunization strategy" (H. Albert) we retain the word archetype as well as the numinous aura adhering to it. This aura, however, is now attributed to persons or to parts of the empirical personality. By thus undermining the concept of archetype from within and pressing the transpersonal into the narrow confines of the personal and empirical (understood personalistically) we even more definitely put an end to the larger aspect of the psychological phenomenon than Freud was able to do by denying it altogether. Our conventional use of archetypes therefore is the very opposite of "starting out with the more comprehensive category:" It amounts to nothing less than an apotheosis of the personal(istic) and thus absolutely and unquestionably moors the "prime evil of neurosis" in our theory because it provides divine authentication for it.

5. THE EFFECT OF PSYCHOLOGY

Psychology has fallen into the very mode of thinking that it objects to in the neurotic. But if psychology itself is neurotic, how can it have a healing effect (which it obviously does have)? This is a very curious dilemma, since we cannot rightly deny either the neurosis or the healing effect. There seems to be only one possible answer:

psychology does not heal despite its neurosis, but because of it. This would also fit in with the insight that "healing" is itself a neurotic concept. Could it not be that the patient is freed of his (personal) neurosis because in therapy it is transferred to psychology, so that the latter carries it for him? In Freud's view, the neurosis changes into a transference neurosis. But what happens to this new neurosis, where does it go when the transference is "dissolved?" Are we to think that the transpersonal objective realities called "transference" merely dissolve into thin air?

I would say, they are again transferred, but this time not onto a person, but onto an objective structure. Psychology receives the neurosis into itself, as into a container, and thus relieves the patient. The instrument of this transference is the endless number of inter-pretations ("working through") during analysis, by which the neurosis is deepened and widened ("amplified") and the patient's mentality raised to the objective level of psychology. What is sometimes called the "objectivation of the neurosis" could mean precisely this process. The patient is cured through his new connection with the impersonal theory which claims universal validity (e.g., overcoming of the Oedipus complex; individuation). Thus he gains a more objective, transpersonal attitude towards himself. What cures is the impersonal character of theory that appears in psychology as it does in any body of herme-neutic, in science, philosophy, or religion. This is the reason why any psychology works in therapeutic practice. That our psychology happens to be personalistic in its content does not alter the fact that as a system of meaning it remains objective and transpersonal. Indeed, from an archetypal view, it is itself of archetypal substance, although it is the very point of this psychology to deny anything archetypal (Freud) or to abuse the archetypal concepts reductively (Analytical Psychology). (In other words: personalistic reductivism is itself an archetypal mode).

If this be so, the principle of *epistrophé* (the reversion or return of our personal idiosyncrasies to the appropriate archetypal dominants)[5] would be confirmed once more; it would be the principle even behind conventional, often anti-archetypal psychotherapy, and analysis would work with theory as an autonomous factor even while denying it to be such. Inasmuch as such a revision is not a matter of intellectual comprehension, but requires, in order to have psychic reality, a ritual,

[5] On *"epistrophé"* see J. Hillman, *Loose Ends*, Zürich, 1975, 50.

we can understand why the tedious process of therapy has to be repeated with every patient anew. Therapy does not overcome, but on the contrary fully initiates into, that (archetypal) world that is called neurosis (and which is embodied in psychology). It is this initiation that relieves the individual person. Our psychology serves the same purpose that e.g., the Mithraic cult or its successor, Christianity, had for the man of late antiquity. As redemptive religions they proclaimed the victory of light over darkness (what we would now call The Successful Repression) and thereby enabled the individual to reflect his personal neurosis against a transpersonal background and to give it a home there. Psychology with its eschatology of development is not merely a parallel to, and successor of, Christianity, but it is a true redemptive religion with a very severe cult—only in disguise.

Our psychology can be successful in therapy. But of course, the neurosis as such remains, and each successful analysis helps to neuroticize psychology once again or, at least, to keep it neurotic. Psychology as a whole does not heal the split, it rather perpetuates the neurosis and firmly moors it. And the cure of the patient is only one part of the effect of our therapeutic psychology. The other side is that over 80 years of psychotherapy have by no means been able to reduce the number of psychic disorders on a collective level. Psychology at large is abortive, it miscarries. Neurosis and medical psychology are fruits off the same tree. Together they seem to be one of the "games people play" such as cops and robbers.

The displacement or transference from the personal level to objective psychology means that this psychology, as a cultural phenomenon and as a general way of looking (neurotically) at oneself and the psyche carries the seeds of ever new neuroses in itself; what disturbances it takes from the patient, it somehow returns to the population at large (*Zeitgeist*). Our psychology has built repetition-compulsion into therapy; for every patient who completed his analysis there are several others waiting to begin one. With these findings we add a further aspect to Freud's pessimistic idea of the intermixability of analysis. He discussed the unending duration of the analysis of the individual patient and the possibility that an analysis may be terminated with momentary but not with definitive (prophylactic) success. Our different point of view additionally takes into account the effect

of analysis for the unanalyzed population at large, i.e., the epidemic character of the disease called analysis. Our result confirms the conclusions of Hillman who approached this same topic, also with reference to Freud, from his chosen perspective of hysteria and mysogyny.[6]

6. THE THERAPY OF PSYCHOLOGY

In the past, we have been able to practice psychotherapy in the knowledge that even if we personally have our share in the neurosis we at least served a cause that was above board; the shortcomings and failures in therapy were due to (all-too-) human frailty, not to the very method of psychotherapy. Now we have, in addition to the humiliating insight of the possible neurosis of the therapist, to live with the much more hurtful discovery that even our cause, psychology, is thoroughly neurotic. Should we therefore abandon it? Of course not. For if we did so, we would once more react to neurosis with defenses and repression. No, as therapists we must also accept the neurosis of our own discipline. Jung says that one should be grateful to the neurosis and learn not how to get rid of it, but how to bear it. It is above all psychology which has to learn this lesson, not only the patient. The false ego-centeredness of our theory has to be disposed of. So psychology itself must be its own first patient. We now have to realize that the analysis of the persons involved (patient and analyst) will not suffice; theory needs analysis just as badly. Not all is done if I as analyst have subjected my personal neurotic mess to analysis; my impersonal mess, the neurosis of my psychology, remains untouched. (And yet, it is the impersonal neurosis that is closest and most intimate to us, since it is rooted in the transpersonal core of the personality.) This is why Jung spoke of the necessity for psychology to "unlearn and relearn," of the need for a "radical revision" (cf. Hillman's title: *Re-Visioning Psychology*) and for a "liberation from outworn ideas which have seriously restricted our view of the psyche as a whole" (*CW 10*, § 369*f.*). Above all, he demanded a critique of the premises and presuppositions underlying our thinking, indeed, a "critical psychology."

Freud, in his paper on "Analysis Terminable and Interminable," realized that the attempt to shorten the duration of analysis shows a remainder of medicine's impatient disdain for the neuroses and himself opted for "setting oneself the goal, not of abbreviating, but of

[6] J. Hillman, *The Myth of Analysis* (Evanston: Northwestern UP, 1972), 291*ff.*

deepening analysis."[7] This necessary deepening, however, must not
be understood in terms of duration or thoroughness in detail, nor as
penetration to ever "earlier" disorders (primary narcissism or prena-
tal traumas) or more basic causes (Freud's biological bedrock). These
are the wrong categories which needs make analysis interminable
(infinite) since one can always find something more basic or earlier.
This thinking amounts to the futile attempt to come to an end by
following the Euclidean parallels to infinity.

 The deepening of analysis must rather be taken as a progression
to a fundamentally new level, to E. Wind's "more comprehensive
category to the "curvature of non-Euclidean space." Psychology must
be curved (*intentio obliqua*), bend backwards, reflect on itself. The same
analytical principles with which it hitherto turned to the patient (with
the empiricist intentio recta) it may now apply to itself and thus
complete and fulfill the analysis by taking itself, as third person,
seriously. This is what "critical psychology" means.

 So far we psychotherapists acted (and researched!) just as uncon-
sciously in our profession as did Jung's Kenya natives when they
performed the ritual of greeting the rising sun. We have, of course, a
rich knowledge of what to do and to say and how to interpret, but if
we were asked (as the Africans were by Jung) why we behave and
think that way, we could, as those natives, put forward no other ground
than "because it is the truth, that's the way the facts are, just look at
all this case material" and would, with this dogmatism, betray our
unconsciousness. (That our facts are to some extent empirically
validated, whereas the Kenya ones were not, obviously makes no
difference as regards consciousness. Valid empirical evidence may
establish true knowledge, but does not make more conscious. Supersti-
tion and science, despite their fundamental difference, are thus on
the same level in this respect because they share the same blind(ing)
belief in facts. "The collaboration of the psyche—an indispensable
factor—remains invisible" (*CW 10*, § 498).)

 The principle of depth psychology is the lifting of the repres-
sions, and the psychoanalytic "fundamental rule" was established to
serve this principle. Freud states about the application of this rule,
"It is a most remarkable thing that the whole undertaking becomes

 [7] "*Die endliche und die unendliche Analyze*" in: S. Freud, *Studienausgabe*, Erg. bd.,
Frankfurt, 1975, 387 (my translation).

lost labour if a single concession is made to secrecy. If at any spot in
a town the right of sanctuary existed, one can well imagine that it
would not be long before all the riff-raff of the town would gather
there."[8] I think that our much neglected psychological theory is such
a sanctuary. There, as we have seen, all the neurotic ideas gather.
Psychology acts out its insights in its "behavior" (i.e. psychotherapy),
but the theory, as the "consciousness" and "attitude" of psychology,
is protected and defended against any such insight. I have given a
number of illustrations for this. By way of a reminder I want to point
out the effect or inherent purpose of the genetic approach: he
uroboros, primary narcissism, the *Einheitswirklichkeit*, magical
thinking and the like are (via projection) placed as far away as possible
from ourselves by our theory, either into what we are not (prehistoric
man, the infant, or the creative genius) or what we by no means want
to be (the neurotic patient), in order to avoid that our own thinking
and way of viewing—our innermost subjectivity—become affected
by these realities. We do not want to give up this last resort and refuge
and change fundamentally, without reserve (what Jung termed to radi-
cally "unlearn and relearn"). The last and most secret, most interior
stronghold of the old ego-centered attitude is psychological theory,
whose involvement in therapy and transference is not subjected to
analysis the way that of the other two persons is. Now we see why
analysis miscarries despite its tremendous effort: the entire undertaking
becomes lost labour because a concession has been made, even if
only at a single spot.

There is an iron curtain between therapy and theory. The practi-
tioner, stressing feeling-experiences, depreciates theory as an
intellectualism; for the psychological scientist theory is something
sacred that must be kept clean from emotions, imagination, and
neurosis. Through this dissociation we get both a neurotic practice
and a neurotic theory. That intellectualizing one's affects is a defense
mechanism is generally accepted, but that the reverse, ignoring theory
for personalistic introspection, etc., is also used as a defense, is not
seen. It would of course not help if theory were made more practi-
cally relevant and the practitioner occupied himself more with theory.
This would bring the two extremes closer, but no matter how close

[8]"Further Recommendations in the Technique of Psycho-analysis," in: S. Freud
CP vol. II (London 1953), 356n.

they come, the neurotic split of psychology would remain. What is needed is their oneness, "wholeness." This is what Freud was driving at when he spoke of the "junction of curing and research."[9] Therapy is theoretical and theory works therapy. We cannot actually restrict therapy to the consulting-room and theorizing to books. Jung writing his theoretical and psycho-historical studies did not merely provide theoretical tools for analysis. His written work is in itself therapy, full-fledged therapy, inasmuch as it aims at affecting our attitudes of consciousness. By thinking otherwise, we would split off theory.

Conversely, we are subject to a self-deception if we believe an ever deeper introspection or the abandonment to feeling experiences à la primal scream would bring a genuine initiation into the "inner world." Introspection means that we look into ourselves and thus obviously from outside. Initiation by contrast means to enter, but when this happens we are in "it" and part of it and therefore can no longer look into it. Abandonment to feeling experiences implies, to be sure, to enter. But as the term abandonment suggests, something was left out and behind which therefore does not participate in the transformation process and thus can serve as anchor and firm ground. The experiences may be as intensive as they come, nothing truly essential in the sense of initiation will have happened because of the *reservatio mentalis*, of the prior exclusion of our mind, which remains as rationalistic and egotistic as before. Only one half enters and feels. Or it is the whole ego that enters, but then the reservatio mentalis would mean that despite being whirled around as a unit by the emotions, the inside structure of the ego would stay intact. In the so-called feeling experience it is the old ego that experiences and feels. It remains the self-identical subject even when it "relates." It is true that psychology must be subjective. But its subjectivity cannot be the ego's, "my" personal property—it rather must be an impersonal and objective subjectivity, one that first gives me my sense of "my-ness."

As we said, psychotherapy is fixated on the patient or at best on patient and doctor (on their personal experiences and reactions), in short: on the personal. Thus personalistic psychotherapy is truly a *folie à deux*, a Buberian "I-Thou" encounter, because only two persons are accepted, *tertium non datur*. The "grammar" of psychology is faulty,

[9] "Nachwort zur 'Frage der Laienanalyse'", in: S. Freud, *Studienausgabe*, Erg. bd. (Frankfurt, 1975), 347 (my translation).

we cannot conjugate properly: I, thou—that is where we stop. But the proper "conjugation" (Greek: *syzyga!*) knows of a third person, of the objective and impersonal It (the objective psyche, the "great," *Psychologia*) which is present along with the two other persons because it is their impersonal and larger aspect. Freud came so close to it with his id, but unfortunately placed the id within the individual as a part of the personality. Where psychotherapy is seen in terms of the dialogue between two persons, an I and a Thou, there is no syzygy and no conjugation, but an absolute *disiunctio* (cf. *CW 16*, § 397); Jung's usual word is dissociation: doctor-patient, sane-neurotic, conscious-unconscious, thinking-feeling, etc. The eros of transference may then try as hard as possible to bind the two together, it will never get beyond a "transference neurosis." Where the framework of psychology is personalistic because the third of the two is not seen, there can be no *coniunctio*. The "soul's child," which according to Jung (*CW 16*, § 465) is the goal of transference (and of psychotherapy), will not be born: such a psychology must be abortive; it must miscarry; soul-making cannot take place. Psychotherapy will instead have to devote itself to "practical" purposes (curing, ego-strengthening, behavior modification, sensitivity training, emotional experiences, development of all functions, etc.) and turn technological, as Faust did after the coniunctio, which had almost been achieved, finally failed. In his case, too, it had to fail since the "objective process of the union" was disturbed by "Faust's personal intervention," his identification with the mythological (=transpersonal) figure Paris (*CW 12*, § 558*f.*).

Jung always insisted: the origin of the neurosis lies, not in the past, but in the present, that is, close to home. In this spirit we would need to concentrate on what is closest to home: our attitude of consciousness, our theories. In order to make psychology we must *erinnern*, to make soul, come home. Instead of looking for the archetypes out there and thus reifying them, we need develop an archetypal approach; instead of locating the psyche in persons we must learn to see psychologically; instead of talking about the uroboros in the child or in the patient, our psychology must advance to a uroboric consciousness. If psychology has become its own first patient and if its "space" is curved, so that all "straight" lines return into themselves as with the *draco caudam suam devorans* (the dragon devouring his tail), it will no longer be fixated on the patient, on behavior, and on the practical.

Both founders of depth psychology, Freud and Jung, looked at the analytical cure with a certain detachment, Freud confessing that he had never been a therapeutic enthusiast, no true physician and had never had a strong desire to help the suffering, Jung admitting to a rather meagre interest in people and the external facts of life. This does not mean that they encountered the patient with indifference, but it might throw a light on why they were destined to be psychologists. The interest of the psychologist is not directed to the factual person and his behavior, but to things psychological. The curved line which the psychological glance follows meets the patient and the facts—it does not avoid them and instead turn merely inwards (introspection)— but it goes on and returns to where it came from. Not the patient, but its own origin is its goal. Psychology does not speak about the patient, about the external object, but always about itself; and psychology proper only begins where it follows uroboros, the dragon of imagination,[10] that is to say, where it merges with the imaginal itself. But in this circular motion the patient is encompassed, not as a fixed point and an end in himself, but as something that is taken along and "seen through." The same, however, applies to the seeing subject (ego); it too ceases to be a fixed point and enters into the alchemical *rotatio*, so that there will be nothing fixed and "factual" left, no reserve, the circling motion of imagination itself now becoming the only fact (and factor!). And this dissolving of the two factual persons and their self-identical egos into the circular motion is the actual purpose of therapy. This is what the goal of "changing the patient" should be taken to mean, whereas the modificatio n of his behavior and what other practical purposes and factual problems classical psychology concerns itself with now appear not to be truly psychological at all, since only the entrance into the *circulatio* is an authentic initiation.

Jung tried very hard to communicate this idea. Already his typological approach of 1913 had the purpose of removing the dispute among the various schools (Freud-Adler-Jung) from the empirical level of fact to a psychological one of viewpoint: instead of empirically proving or disproving the various theories, he reflected on the entirely different question of what made Freud or Adler see things the way

[10] On the dragon as imagination see J. Hillman, "The Great Mother, her Son, her Hero, and the Puer", *Fathers and Mothers* (Zürich: Spring Publications, 1973), 112.

they did. His typology was certainly not sufficient for this task (for which reason Jung later let it lie in favor of the much more comprehensive and subtle archetypal theory), but already this early attempt left the scientific fixation on the object and on the factual behind, returning the psychological inquiry into itself and thus recognizing the autonomy of psychology.

With respect to therapy, Jung expressed the same ideas, e.g., by demanding a "counter-application to the doctor himself of whatever system is believed in" (*CW 16*, § 168). As a whole, Jung envisioned a psychology that goes beyond all empiricism and personalism, beyond the practical and the consulting-room[11] and viewed psychology (and the analytical session) from the perspective of *Vermittlung*, mediation. Anything that goes on in therapy, indeed anything that is in the world ("our" world) is psychologically mediated. Our psychological theories are larger than we and prior to ourselves. They surround and encompass both ourselves and what we perceive (e.g. the patient). This vision starts out with wholeness and "the great" and is therefore no longer confronted with the self-defeating task of trying to unite two individual souls that are separated by definition.

I would like to repeat: the place where psychotherapy has to happen and where alone it would not have to be abortive is the objective, impersonal and yet also most subjective, third person: psychology. Integrating, developing, compensating, healing, recollecting, imagining, introspection, initiation, analysis, expanding one's consciousness and what else psychotherapy aims for are tasks to be accomplished not by the person, but by psychology. Only on this level, on the "higher plane of psychological and philosophical dialectic" (*CW 10*, § 333) can psychology become psychological, because it alone opens the third alternative to the deadlock of opposites: the imaginal realm of the soul's child. Anything truly important cannot happen in us unless it happens in our psychology. For we are in it—even if we think it is in us. Instead of needing psychological methods for obtaining more intensive personal experiences, we might find out that psychology itself can be our richest and most personal experience: the experience of soul-making.

[11] With a "significant turn of events," "analytical psychology has burst the bonds which till then had bound it to the consulting-room of the doctor. It goes beyond itself...[and] can claim to serve the common weal [*Allgemeingut zu werden*]" (*CW 16*, § 174).

SPRING 1978

ARCHETYPAL PSYCHOLOGY
JUNGIAN THOUGHT

Cover of *Spring 1978*. The image is of the Allegory of Spring by Giuseppe
Arcimboldi (1527-1593), from the Academy of San Fernando, Madrid.

Editor's Note

Because so much of archetypal psychology rests on words for articulation, it is sometimes easy to forget that the word is only one way to proceed psychologically. In this essay, Thomas Moore introduces us to musical therapy, a style of imagining the soul that hears the soul musically as it hears the music in the soul. Here is an approach, says Moore, that "pictures soul in movement and describes it in metaphors other than visual."

Moore carefully distinguishes musical therapy from music therapy. The latter, he says, uses music to further certain therapeutic assumptions and aims; the former delights in the fact that the soul's "various elemental factors, its scales and tunings, melodies and harmonies…make a music." Although this music might be represented in performed and recorded music, says Moore, "in itself [it] is 'audible' only to an 'inner ear' that is tuned to the fundamentals and overtones of the soul."

Such claims reverberate with archetypal themes. Elsewhere in this anthology, we have seen Corbin maintain the *mundus imaginalis* as an intermediary place of ontological power, Hillman argue for soul as denoting a mediating perspective between body and spirit, and Giegerich claim psyche as the missing third of psychology. Now Moore tells us of *musica humana*, a third kind of music different from that which we hear with our ears (*musica instrumentalis*) or made by the movements of nature (*musica mundana*). "*Musica humana*" instead is "created from the counterpoint of virtues, moods, and feelings experienced within the person himself." We need not impose musicality on the soul, says Moore, but merely to listen to what is already there.

Appreciating the music in soul also gives soul back to music, providing psychological reflection to music in its own terms. Listen closely, for example, as Moore restores the many gods to harmony, which so often suffers from monotheistic hearing, by encouraging us to hear harmony as requiring careful tempering and tuning to scale, thereby reducing the infinite possible tones to their fitting values. Such harmonizing, says Moore, "takes place before the making of melodies…[where 'before'] is to be understood as both temporal and structural." Harmony, in other words, resounds archetypally.

Moore gives us a way of re-hearing the soul to accompany re-visioning in terms of insights. Enveloped and penetrated by the soul's silent sounds, life takes on resonance and tone, dissonance is restored to a place of value, and the fundamentals of a life reverberate with the overtones of soul. "Behind the tunes," says Moore, "sound the pre-compositional, archetypal modes and scales."

MUSICAL THERAPY

THOMAS MOORE
(*Spring 1978*)

Although the use of earphones, stereophonic sound systems, massive record collections, and peripatetic tape recorders may give the impression that music therapy is a recent phenomenon, that is not the case. The connection between music and the soul has been noticed and exploited for centuries. Plato warned against the use of certain musical modes or scales, medieval church authorities proscribed "pounding the organ" during certain ascetic seasons of the liturgical year, Congreve claimed that music could "soothe the savage breast," and an odd Platonist of the Italian Renaissance, Marsilio Ficino, practiced music therapy with instruments and voice. It is no secret that there is psychological value in music. What is less widely known, perhaps, is that there are musical values in psyche.

What I wish to propose is musical therapy as distinct from music therapy. The latter is a matter of recordings, instruments and sound. At its lowest level it is "Musak" in the service of psychotherapy. At its best it is a recognition of the value to soul of the art of music in all its variety. By musical therapy, on the other hand, I mean a music of the soul that may be altogether silent—no violins, no singing, no audible vibrations. The movements of the soul, its various elemental factors, its scales and tunings, melodies and harmonies—these make a music which is re-presented in performed and recorded music, but in itself is "audible" only to an "inner ear" that is tuned to the fundamentals and overtones of the soul.

This notion, too, is nothing new. During the period of the Middle Ages and Renaissance it was called *musica humana*. In the sixth century Boethius made a significant distinction among the kinds of music. He divided music into three parts: *musica instrumentalis*, the music we hear with our ears; *musica mundana*, music made by the movements of nature—the circlings of planets and the rhythms of seasons; and *musica humana*, the music created from the counterpoint of virtues, moods, and feelings experienced within the person himself. *Musica humana*, or musical therapy, is a way of imagining the soul, and its chief merit is that it pictures the soul in movement and describes it in metaphors other than visual. We will consider how a psychotherapist might develop a "good ear" as distinct from gaining in-sight into psyche, but first we must explore the musical fundamentals of the soul.

HARMONY

Harmony" as the word is commonly used is of little use to a polytheistic archetypal psychology. Harmony in the usual sense derives from a fantasy of wholeness. To harmonize one's life would be to bring all the bits and pieces together in the service of some overarching egoistic intent. Indeed, in ordinary music, harmony for the most part is a system of arranging all the tones of a composition as functions of a single tonic or "key" tone. Thus, in Mozart's G Minor Symphony each note in the first movement can be analyzed as a function of the note "G." "G" is the ego of the piece, setting it in motion, structuring its every moment, and making the final cadence final.

But there is an older meaning for the word "harmony" in music theory, one which reflects the polycentric nature of soul. In Pythagorean music theory, one creates harmony by constructing a scale, by tempering and tuning. Without temperament and without a scale music is impossible. Before the music can begin, the infinite possible tones within the reach of an octave have to be reduced to a definite number, to a few clearly distinguished tones. According to legend, when Pythagoras was measuring his single-stringed instrument or clanging some anvils, he discovered the remarkable phenomenon that the purest intervals of a scale correspond to the simplest mathematical proportions of the measured string. The ratio 2:1 produces an octave, a relationship in which the two tones sound almost

identical. The ratio 3:2 produces a fifth, the next purest sound, and 4:3 the fourth, the inversion of the fifth. With these simple propor- tions we have the foundation of Western music.[1] For Pythagoras the discovery was astounding. He believed that he had found the secret structure for the entire universe: all things built on number in simple proportion, demonstrated aurally in the inescapable "harmony" of the musical scale.

"All things" built on number included the cosmos and the soul, and it is from this Pythagorean fantasy that we get the idea of human and cosmic music. But what is especially significant for us is the fact that harmony in this context means multiplicity. To harmonize is to distinguish, divide, measure out. Music begins by making clear distinctions among the fundamental elements, the tones of the scale. It is also significant that this "harmonizing" takes place before the making of melodies. "Before" is to be understood as both temporal and structural. Before a composer writes he must know the charac- teristics of the distinct notes of the scale; before a performer plays he must tune his instrument so as to play the proper tones in their due proportions. In the music itself, all the melodies consist of imagi- native variations on scale-tones and on the peculiar properties of their interrelationships.

Here, then, we arrive at the first principle of musical therapy. It is essential to develop a theory and an ear for the fundamental elements which lie at the root of the flow of human experience. Once again, we do not have to devise new metaphors to maintain the basic musical analogy, for a centuries-old tradition points to the correspondence between the seven tones of the diatonic scale and the seven planets with their specific deities. As Robert Fludd's (1574-1637) marvelous charts and diagrams show,[2] the seven tones of the scale are to music what the seven planetary Gods and Goddesses are to the cosmos and

[1] For a thorough treatment of Pythagorean music theory, see Richard L. Crocker "Pythagorean Mathematics and Music," *Journal of Aesthetics and Art Criticism*, 22, ii (1963), 189-98; 22, iii (1964), 325-36. For a general historical view of Pythagorean musical imagery in literature and religion, see: John Hollander, *The Untuning of the Sky* (Princeton: Princeton UP, 1961) and Kathi Meyer-Baer, *Music of the Spheres and the Dance of Death* (Princeton: Princeton UP, 1970).

[2] Reproductions of Fludd's charts may be found in the following: Frances Yates, *Theatre of the World* (Chicago: Univ. of Chicago Press, 1969), Peter J. Ammann, "The Musical Theory and Philosophy of Robert Fludd," *Journal of the Warburg and Courtauld Institutes,* 30 (1967), 198-227; and in Hollander and Meyer-Baer.

to the soul. The psychotherapist as *musicus*, as musician, must have an ear for the temperament and harmony which resonate deep within the melodic (personal) events of life. To become familiar with the Gods of polytheistic mythology, to distinguish them carefully, is essentially to discover the scale or scale-tones out of which experience is composed.

TEMPERAMENT

These Pythagorean analogies were developed in a remarkable way by Marsilio Ficino (1433-1499). Ficino engaged in both music and musical therapy. Most of his work aimed at training the imagination and memory in various ways in order first to distinguish the elemental factors in experience and then to set about keeping as much variety in life as possible. A healthy soul, he said, is one which is most like the sky—filled with many distinct, moving forms.

One method Ficino developed for forming a musical imagination involved sorting out ordinary music according to character corresponding to the various planetary Gods. Certain kinds of music would be Venusian in character, others solar, lunar, and the rest. When a person knew himself to be lacking in the qualities or benefits of a particular deity, listening to appropriate music might bring to that person the peculiar power or spiritus of that God.[3] With Ficino we get a rather sophisticated picture. Certain music conveying the character of particular deities is used in order to constellate within the person qualities of all these deities, establishing a psychological scale or temperament. Indeed, one of Ficino's favorite words is "tempering." Health is achieved by tempering one's soul as the zodiac is tempered. *Musica instrumentalis* is a method for tempering, whereas the elements of the soul are themselves the tones tempered.

We run into a problem with Ficino's notion of tempering, however. Can we simply take a look at ourselves or someone else, diagnose a lunar deficiency, play a lunar tune, and get back into temperament? It sounds too easy, and it seems excessively ego-centered. A solution may be found in the subtleties and paradoxes of Ficino's argument.

In addition to music, Ficino recommends dozens of ways for keeping the imagination alert. He advises such things as properly colored clothing, taking walks in selected environments, using herbs and spices with care, painting astrological pictures on the bedroom

[3] For a more extensive discussion of Ficino's music theory, see D. P. Walker, "Ficino's Spiritus and Music," *Annales Musicologiques*, 1 (1953), 131-50.

ceiling, or making mechanical working models of the universe. He wants to make the entire environment a constant reminder (an art of memory) of the diversity and the strengths and weaknesses of the soul. Furthermore, his method is indirect. Listening to or playing lunar music will not automatically quicken lunar consciousness in the soul, but it will keep one's imagination awake so that when a lunar movement stirs, one can consciously recognize and cooperate with that movement. Ficino goes a little further, however, suggesting that our involvement with the world, when it is imaginative, actually graces our psychological life with a variety of spirit, or, to maintain the musical analogy, with resonance and tone.

Therefore, in the process of tempering, the ego works not as a senex king reigning with full control and purpose, but more in the manner of an artist. It is an aesthetic ego, at once attempting to create an expressive and deeply resonant life, and yet recognizing the necessity for cooperation and receptivity in the presence of transpersonal movements and factors beyond ego's resources. Ficino's own experience with Saturn makes the point. Saturn was prominent in his horoscope and in his life. He knew that he could not change this dominant, although he advised others suffering a similar problem to expose themselves to Venusian and Jovial objects as a partial antidote. Finally, the only way he could suggest to deal with Saturn was to get into his sphere without reserve. On the other hand, a favorite story Ficino liked to relate was the Judgment of Paris. He would point out the problems which arise when one consciously chooses one God above others. His universal rule: when faced with a choice, as was Paris, honor all the Gods.

DISSONANCE

Once we get away from the notions that harmony is vertical or concerned with uniting diverse elements, that it is functional or basically monocentric, and that it is consonant or a pleasing blend of sounds, then we have room for dissonance. In monotheistic contexts, *musica humana* often involves an attempt to eradicate discord. Clement of Alexandria, for example, describes God as the New Orpheus who with his song "composed the entire creations into melodious order, and tuned into concert the discord of the elements."[4] Ficino, on the

[4] Clement of Alexandria, *The Exhortation to the Greeks*, trans. G. W. Butterworth (Cambridge, Mass.: Loeb Classical Library, Harvard UP., 1919), 11.

other hand, pictures the world as an harmonic edifice where all parts are composed as a "lyre which produces concord complete with dissonances and consonances."[5] Dissonance has a place in this concord. Music without dissonance, if there is such a thing, is bland. Even the extremely cautious conservative music of the High Renaissance has some dissonance at almost every point.

Musical therapy, therefore, does not imply any harmonizing of life as avoidance of dissonance. Stability, evenness, calm, order, control, happiness and peace—these are not the goals of musical therapy. Dissonance has a place and even an energizing function. In music, sound dissonance creates climax and provides expressiveness, it gives bite and spice to an otherwise unsavory mixture of tones. For centuries one of the most dissonant intervals was the tritone or diminished fifth, sometimes called *diabolus in musica,* the devil in music. So in *musica humana* dissonance may be devilish and shadowy, but it also lends interest and motion. Just what is considered dissonant in music has changed over the centuries. In the Middle Ages the interval of the third was heard in many places as unstable and dissonant; today it is the epitome of consonance. So, too, for the music of the soul, dissonance is to an extent a matter of time and taste. What is shadow for some is sunlight for others. What is important, then, is not to define or exemplify psychological dissonance, but rather to sense its quality of instability and pungency, and to grant its place in the entire composition of the soul.

OVERTONES

Robert Fludd was another in the line of original and highly imaginative thinkers of the Renaissance, a line which included such image-minded people as Cusa, Ficino, Pico, and Bruno. Fludd illustrated his writings with many intricate charts, many of which include images of *musica humana.*[6] For example, his "Temple of Music" pictures Pythagorean scales, Pythagoras' anvils, and three sets of organ pipes symbolizing the three kinds of music. Another chart is of special interest: "On the Internal Numbers and Harmony of Man." This diagram shows explicitly that the soul consists of three octaves: the material octave, the mediating octave (Anima Media), and the spiritual octave. In the chart the human body lies at the base of the three

[5] Quoted in Andre Chastel, *Marsile Ficin et L'art* (Geneva: Droz, 1954), 57.
[6] See *Ammann.*

octaves, described as the vessels of all of them. Within the material octave Fludd places the four elements: earth, air, fire, and water. In the mediating octave are the seven planets, the fixed stars, and the prime mover. In the highest octave, the diapason of spirit, are the nine ranks of angels.

It is a phenomenon of acoustics that a tone, called the fundamental, produces overtones when it sounds. For example, when a string is struck or plucked it vibrates in its entire length, producing the fundamental tone. At the same time, it also vibrates in halves, thirds, quarters, and so on, producing the fainter sound of the upper partials or overtones. Usually one does not consciously hear these overtones as separate tones, but with a little training anyone can hear the first few. Add to this the fact that octaves sound as identical tones, only higher or lower, and we have an effective aural image for the psychological and spiritual depth or resonance contained in ordinary (body) events. Body is then the vessel of psyche and spirit as in Fludd's chart, as the fundamental and obvious "tone," while spirit and psyche are overtones.

Following Fludd (who, by the way, was well aware of Ficino's work), we arrive at an image of the musical therapist. This is a person who has an ear for the psychological overtones in events, represented especially by the planetary Gods, the archetypal images behind events; and he has an ear for the spiritual overtones, the angelic, connecting, analogical, rather subtle and volatile links between body and soul. Drawing on the other imagery we have discussed, we can describe the musical therapist as one who perceives the tuning of the soul, distinguishing its tonality—the basic spheres or tones which constitute its own deep-seated scale. He appreciates consonance and dissonance as desirable ingredients of the soul's music, and he has an aesthetic attitude toward the function of ego. He evaluates the patterns and movements of the soul as to whether they are "fitting"[7] and appropriate rather than natural, moral, or normal.

For the musical therapist a personal life is not a story but a melody, expressive and moving, or a composition of many melodies in harmony and counterpoint. Long or short, massively orchestrated or played with simplicity, behind the tunes sound the pre-compositional, archetypal modes and scales. This is the human music giving life tone and

[7] Stanley R. Hopper introduced the word "fitting" in an ethical and psychological context in his lectures on "aisthesis."

resonance. With *musica humana* in mind, Shakespeare's famous lines concerning music take on added significance:

> The man that hath no music in himself,
> Nor is not mov'd with concord of sweet sounds,
> Is fit for treasons, stratagems, and spoils;
> The motions of his spirit are dull as night.
> (*Merchant of Venice*, V.i. 83-86)

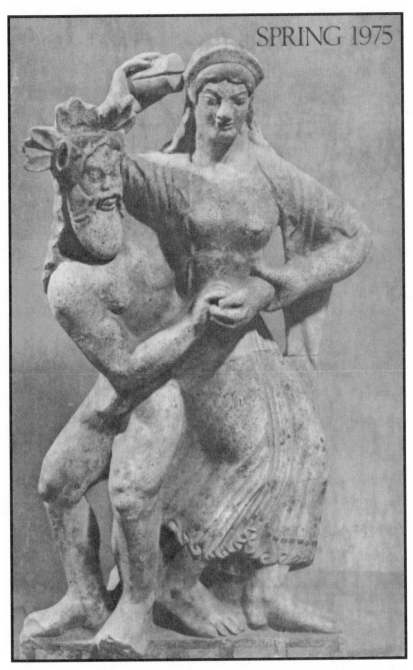

SPRING 1975

Cover of *Spring 1975*. The image is of an Etruscan satyr and maenad.

Editor's Note

This is the concluding essay in a three-part series that began in *Spring 1977* ("Inquiry into Image") and continued in *Spring 1978* ("Further Notes on Images"). In the first two essays, Hillman addresses many of the confusions that obscure the appreciation of images. Images are routinely mistaken as symbols, he says, confused with pictures, conceptualized, amplified beyond their proper bounds, implanted into developmental schemes, sexualized, pathologized, personalized, and idolized. In this concluding essay, Hillman turns from what we do with images to the question of how we sense them at all. Before any of the above operations can occur the image first presents itself and we...well, exactly what does happen?

We often talk about images and our relations to them through sensory language: we see an image, we say, or hear or listen to it. We use the same words when we refer to physical sensations, but they clearly refer to a different order of experience, just as the actual mother making pancakes in the kitchen is not the same mother that appears in the dream.

Hillman follows the logic of this situation where it leads. Our sensing of images seems to be given by images themselves as innately sensate, sensual, and sensible. The image is both what is sensed and how we sense; not only what we see but how we see. Hillman's task here is none other than to release sensation from its prison in a literal, objective world. Instead of an imaginal world stripped of body and sensation and left ephemeral and unformed, or a natural world gutted of soul and left to mindless boredom, Hillman reclaims sensation for the soul.

Image-sense suggests that without imagination there is no sense or sensibility: "The old dictum—nothing in the mind that is not first in the senses—can be affirmed as it is deliteralized. For it means that the mind is primarily aesthetic." Hillman here introduces one of the enduring tenets of archetypal psychology—that psychological life is aesthetic life: "What holds [the] conjunction of concrete sensation, psychic image, and spiritual meaning is *aisthesis*..." Hillman thereby establishes aesthetics as a primary modality for archetypal psychology. "[A]esthetics as the *via regia*," says Hillman, "if we would restore our life in images and work out the appropriate method for the poetic basis of mind, based in fantasy images."

IMAGE-SENSE

JAMES HILLMAN
(*Spring 1979*)

Our usual language for perceiving dreams is curiously imprecise. We listen to the dream to see what it is telling us, or we look at what it says. We see through it in order to hear its message.

The quick movements back and forth between seeing and hearing seem to prevent either from being the privileged sense for dream work. We cannot assume that understanding dreams is simply a matter of seeing by means of images or hearing by means of metaphors. It is as if the psyche mixes these two modalities to remind us of its complexity: that at least two senses are needed for grasping an image.

There is something more here: I think we are also being told that we can't get at an image at all by sense-perception taken in the usual Aristotelian or empirical view of it. For images are not the same as optical pictures, even if they are like pictures (*Spring 1978*, 158-162). Nor are they actual physical sounds (cf. Moore, *Spring 1978*; Kugler, *Spring 1978* and *1979*). We do not literally see images or hear metaphors; we perform an operation of insight which is a seeing-through or hearing-into. The sense-words see and hear themselves become metaphors because, at one and the same time, we are using our senses and also not using them as we may believe we are. By appearing together in the single psychological act of studying an image, seeing and hearing relativize each other. We see-through our hearing and listen-into our seeing.

By confusing our usual sense language, images and dreams are also retraining our senses themselves. They are being freed from the conceptual constraints which decide how they must perform and what their proper objects are. So, a dream is indeed a derangement of the senses as was said long ago by both rationalists and romantics.

Perhaps the key to the training of dream-workers is this retraining of the senses by the image. Perhaps, the reason for collecting our dreams so faithfully, amplifying them with symbols and studying cultural imageries, is not mainly to learn archetypal patterns of content, but to train our eye and ear out of their habitual modes of sense-perceiving, so that we can "read an image," as Lopez-Pedraza says, and "hear psyche speaking," as Robert Sardello says.

Unfortunately, so long as we go at our training in terms of knowing about images (symbolizing) rather than sensing images (imagining— cf. Spring 1977, pp. 62-69), we may never let the image derange us enough to retrain us. Much of what we learn to do with images in training institutes defends against the derangement of the senses.

I suppose that is why these places are called "training," rather than "retraining," institutes. The senses and the mode of consciousness based on them are taken for granted; they are given new kinds of content to work with, but the mode of perceiving the content is left unquestioned. It is as if one could read the dream of Blake with the mind of Locke. Whereas Blake's intention is precisely to break Locke's notion of consciousness based upon sensation. So, it seems to me, a primary purpose of the dream is not to redress the balance of consciousness but to re-train the senses, our simplistic belief in them, by means of the dream. Dreams, after all, are incursions of imagination into the usual world of sense which we pretentiously call "consciousness." In this world, dreams don't make sense because sense doesn't make dreams. Dreams are images, made of imagination.

Protestor: "Are you doubting our notion of consciousness—that it is a waking consciousness and implicates us in a sense-perceived world?"

I am doubting this notion of consciousness now only in regard to images, dreams. For this notion is not adequate to imagination— whether the images of dreams, insanities, or the arts. To go at imagination with straight-on sense-perception creates insanity. It forces the image into hallucination (experienced as perceptually "real"—

material, objective, true) or loses it as illusion (experienced as perceptually "unreal"—immaterial, subjective, false). We sense images and make some sense of them without having to sense them in the simple perceptual meaning of sensation.

There is probably something still more perplexing being said by this mixture of sense. It suggests that imagination has no sense language of its own. Maybe it has no language at all of its own. Even those words which are most appropriate for discussing imaginative products— tension, inhesion, vision, voice, expression, authenticity, surface, spontaneity, fecundity, structure, maturity, unit, integrity, creativity— are concepts that do not present themselves as images or have images as their first reference. They are equally valid for other sorts of events. The language of poetics (stylistics, rhetoric, aesthetics) and the technical terms of each art are only tenuously connected to the imagination as it presents itself in images. The dream comes in its own terms, images— just like life.

Now you may see better why I have been trying to use the actual words of the image for grasping its significances. I have been very literal about "sticking to the image," even sticking literally to its language, so that the image can tell us about itself in its own words (*Spring 1977*, 78-79, and *Spring 1978*, 153-57). I have been experiment-ing—probably too literally, obsessively—in hopes of showing that imagination can speak of itself without borrowed terms, that concepts are neither sufficient nor necessary for making sense of dreams.

It is not to be bemoaned that imagination has no conventional language of its own (except the word-play of the image), for imagi-nation seems to turn this weakness into an amazing grace. Its borrowings from the language of sense-perception are also transfor-mations of that language. When we speak of "hearing a metaphor" or "seeing an implication," we have twisted hearing and seeing from their common-sense meanings, for we do not hear a metaphor as we hear a bumble-bee buzz by. Seeing and hearing are deliteralized, having lost their sense sense. One of the major accomplishments of our dreaming is precisely this re-sensing and re-visioning usual scenes and events, forcing us not only to train our sense in a new way, but also our language of sense words.

I believe Gaston Bachelard saw this deforming-transforming capacity of imagination better than anyone. But then he came on the

heels of nineteenth-century French tradition that insisted upon shock-
ing the senses, deranging them thoroughly out of their accepted paths
in order to awaken the sensibility to images. We, however, come to
our dreams via Locke and Freud, the empirical tradition that starts
with sensation as the fundamental criterion of reality. Our public-
and-palpable ontology insists that what is ultimately real is what the
senses perceive. That is why the spontaneous confusion of the
senses when speaking of dreams is so very important: it shakes
our foundations.

Both aesthetics and psychology have tried to deal with the confu-
sion of the two senses in terms of "synesthesia" and the relation
between poetry and painting (*ut pictura poesis*). Synesthesia is not only
a puzzling quirk in certain sensitive persons for whom numbers are
colors, colors taste on the tongue, or musical tones present sculptural
forms. Synesthesia—confusion, interpenetration of one sense with
another—goes on all the time in our common speech when we talk
imaginatively, or of imagining. Evidently, synesthesia is how imagi-
nation imagines. What this does is transform the singleness of any
one sense out of its literalness. It brings us to a new sense of the
senses, making metaphor of sense perception itself. Consequently,
synesthesia plays a special role in the arts because it helps art's own
intention—metaphorical insight, awakening of sensibility—freeing
it from depiction and representation.

My point here is that when imagination does use usual language—
and that is about all it has to use—then it must twist this usual language
into second sense. "Running" is merely abstract until we can hear the
word visually, as a faucet running or a convict running. Or it is sheerly
conceptual until it becomes particularized into running toward, with,
from, for, etc., or adverbalized as desperately running, flatfootedly
running. A curb is but a curb until we can hear other senses in that
granite hard-edge, its further potentials. And any word, every word in
a dream can reveal a second sense, especially when we play with it as
we have shown in *Spring 1977* and *1978*.

Protestor: "If imagination has no language of its own, then how
can we claim it to be a faculty? Other faculties have their languages:
feeling, thinking, the moral faculty, and the will, each has a string of
terms describing its modes and concerns."

Grand—imagination not a faculty! The claim that it is a faculty has been precisely what has deceived us most about imagination. We have considered it one function among others; whereas it may be essentially different from thinking, willing, believing, etc. Rather than an independent operation or place, it is more likely an operation that works within the others and a piece which is found only through the others—(is it their ground?). So, we never seem to catch imagination operating on its own and we never can circumscribe its place because it works through, behind, within, upon, below our faculties. An overtone and undersense: is imagination prepositional?

We shall be looking more carefully into prepositions in another section of this inquiry. Here, I want to show only what I mean by the "preposition of images" as an essential factor in imagination. If, in a dream, "I am walking with my wife," this is an image not only of walking and of wife. The image is pre-positioned by with, and the components of the image, "wife" and "walking-I" are ligated by this with, so that the persons and the actions are pre-positioned, governed by, this "with-scene," a "with-walking" of the I who is in a compound or combine, or complex, with the wife. Does this further imply compliance, even complicity? And, may we read whatever else also occurs in this dream in terms of the relations specified by this preposition? You see, I could also have been walking behind, or across from, past, toward my wife: each preposition presents a different proposition. Or, the dream could have said, "My wife and I are walking"—no preposition at all; simply the conjuncted walking, a pair in tandem, no inference of unconscious complicity.

I said at the beginning of this inquiry (*Spring 1977*, 62) that an image is a specific mood, scene, and context. The factors which help determine the mood and scene and which definitively determine the context (mode of weave) are the prepositions. They specify the mode of relations, the structure of events. They are the subtle joints which articulate the internal positioning of the image, how it knits together. "Subtle," by the way, probably derives from "sub-toile," underlying canvas, weave, texture, the invisible network.

Symbols are held in the subtle net of an image. They can be discovered in substantial things (nouns like redbirds, hags, pearls) or in actions (verbs like fly, grow, sleep). But it is the prepositions which subtilize symbols by dissolving their substantial universality into a

specific pattern, an image. This shift of noticing—from what is seen and heard to the way in which it inheres—is sensing an image. Here, I am explicating Edward Casey's useful dictum: An image is not what you see but the way you see. Imagination might here be defined more closely as the subtle sensing of the prepositional relations among events. Of course, these prepositions don't have to be written out as words. They are also there in melodies, in sculptures, in a walk down the street ("up" the street, "through" the street…). So, we sense the subtlety of images by means of prepositions: their overtones and undersense; looking into behind; listening for and hearing through. The sense of images is a composite of the gross sensations of nouns and verbs, adjectives and adverbs, and the subtle sensations of their relations; the composition is performed by the prepositions.

Protestor. "I believe you are pulling a fast one on me. This subtle sensing of invisibles, these little prepositions which make for whole patterns—this is the intuitive function, the very opposite of sensation. Your second sense and subtle sense is nothing other than what Jung describes as intuition."

Jung's model cuts the double sense into two, sensation and intuition, opposing them to each other. In that system, sensation perceives consciously and intuition unconsciously. They are laid out across from each other and supposedly cross each other up. The problem that this model causes for sensation is much like what that cross does to thinking and feeling. They are forced into diametric opposition. However, common speech which betrays common experience employs terms like "thoughtfulness," "consideration" and "attentiveness" equally for thinking and feeling. Psychological functions are not inherently opposed; we make them so with our conceptual models. An image begins to make sense as we intuit its significance. Jung himself has indicated this, holding that the careful aesthetic elaboration of a psychic event is its meaning (*CW 8*, § 402). Only when we leave the actual image do the two ways divide into sensation and intuition, aesthetics and meanings (*CW 8*, § 172).

Listen to Jung: "Fantasy is just as much feeling as thinking; as much intuition as sensation. There is no psychic function that, through fantasy, is not inextricably bound up with the other psychic functions" (*CW 6*, § 78). "All the functions that are active in the psyche converge in fantasy" (*CW 7*, § 490). When we stay with the imagining mind in

its engagement with an image, then all functions take place together and throughout. The four functions are irrelevant to imagining, so that too much concern with the functions is anti-imaginal, even anti-psychological.

I am also trying to deliteralize the sensation function from its narrow definition based upon physiological sensations. I want to give sensation back its intuitive power, its second sensing of archetypal invisibles. I am also trying to return sensing to intuition, giving it back its precise appreciation of significant detail. And my way of doing this is by "sticking to the image" (a very sensation sort of idea). For an image offers a way off the cross of typological oppositions.

It follows that our usual talk about certain images, that they refer to the sensation function or that they are more concrete, sensuous, and gutsy than others, is not to be taken literally. Van Gogh's shoes, Zola's whores, and a dream of emptied bowels and rockdrills do not show more sensation than images of wee elves in leas forlorn or primary numbers and bare ideas, or images presenting highly qualified feelings. To consider some images sensate and others not, deprives some images of their sense and literalizes sense into the narrowed meaning of grossly earthy. Bachelard would hold that each and all these examples are images, but bespeaking different realms of imagination, one group presenting the poetics of earth, the other the poetics of air. It is all poetics. And all involves the senses—though a sense beyond sense, a second sense of sense, a sensibility of the sensuous, not the sensuous as such.

Protestor. "Now what in the world is that? Is it in the world at all, or have you left it for something mystical, like second sight, twice-born man, or third eyes and ears, subtle bodies?"

It has something to do with those mystical expressions, though they put second sense into a metaphysical mystery, while I am trying merely to show that imagination remains in the world of sense and takes this same world from a different angle. I think we can keep to our double understanding of the simple word "sense," which means both concrete, physical, directly tangible, and also, meaning, significance, direction, invisibly mental. When you "lose your senses" or get "some sense knocked into you," an undersense of the word begins to emerge.

Here, Protestor, I am really on your side. I am trying to deliteralize the high-powered language that generates a metaphysics of imagination—or leave this to the mystics. To speak about "subtle bodies" and "second sight," does not mean to posit such things, as things. Metaphorical insight does not require a para-world of its own, over, under and beyond. We do not have to take our prepositions as literal positions. Imagination takes place wherever we are, as we are. We do not need to substantiate the imaginative perspective by means of visionary witness; we do not need to measure auras and perceive astral bodies. The metaphysical mode again separates imagination into a faculty or a realm of reality, hypostasizing it and returning it to literal sense-perception, straight-on seeing and hearing, the witness of film and tape. I am trying, however, to keep imagination close at hand, prepositionally, as the way in which things appear, imagining it as a permeating ether that dissolves the very possibilities of separate faculties, functions and realms. Yet, curiously, whenever one tries to deliteralize the senses, one finds oneself using such words as "ether" and one is soon enmeshed in spiritism and spookiness, as if our habitual minds cannot stick with an imagination within the senses, but must phosporize it into an epiphanic marvel.

So, let us return to what we do. Let's examine more closely how this second sense works in one of the dreams that we have been using: the image of the swan in the cave (*Spring 1977*, 63).

The dream begins: "In some kind of a cave, a dark cavern. The whole place slopes backwards and downwards from where I'm standing..." This seems a simple presentation of optical vision. I can see myself standing, and behind me, as on a stage set or in a photograph, the ground and walls sloping back and down. Then, as I stay there looking at the image, I begin hearing "backwards" and "downwards" in a second sense. (Perhaps this re-sounding of the image is an effect of this image itself, its echoing cavernous resonance.) The scene is no longer a simple descriptive reproduction; now it has a second sense of implications. Metaphorical insight emerges through hearing while seeing.

Insight occurred largely because I slowed my reading of the image from narrational sequence (what happened next? and then, and then?) to poetic imagistic reading. In narrational reading, the sense emerges at the end, whereas in imagistic reading there is sense throughout.

Most poetry (not the heroic epic, of course) is printed on the page in a form that forces the eye to slow itself to the cadence of the images. Now, the second level of "backwards and downwards" is given with the first, and not added to it as an interpretation. The classical Gestalt psychology of Köhler and Koffka would consider the menacing pull of the dark cavern to be as important and primary as the speleo-logical description. For them, description is always physiognomy. We do not project the second sense onto the first, since the quality of depth is immediately presented to the senses by the scene itself, that it slopes back and down, that it is a cave, that it is dark.

Freud might have gone yet further, saying that the primary level of the dream scene is the latent meaning of "sloping backwards and downwards" (regression towards the mother) which the dream manifests in a speleological metaphor. I think a trained psychologi-cal mind works the way in which I am here imagining Freud. Such a person would not have to look at the scene first as a photograph; he would start right off hearing the image with metaphorical insight. He would see the sense in it even while sense-perceiving it—or even before. A second sense would be immediately intuited and felt as present whatever the situation. I wonder whether Freud's idea of latent meaning needs to be taken so literally. Perhaps, "latency" (in child-hood, in dream content, in psychosis) merely intends to remind us not to stay in a manifest position. It is a sign that says: "keep digging." Have I made myself clearer?

Protestor. "Clearer, but not less mystical. You have put the second sense first, as a sudden apprehension or intuition of significance 'what-ever the situation.' You have extended your claim beyond Gestalt and Freud, declaring that this world, like Prospero the magician said, is a dream, that everything is imagery, that the very geology of the earth and how we stand on it is the expression of hidden significance, meanings everywhere. You are giving us the old 'doctrine of signatures'— the handwriting of Gods everywhere, whatever the situation. It sounds paranoic to me; and the best protection against it is sound common sense, leaving some things as sense data, just as they present them-selves to the eyes, ears and nose, our animal sensing."

I admit to extending my claim to sensing images everywhere, not only in dreams, and I admit to an affinity with the old doctrine of signatures. I can go even further. I can agree with Plotinus who held

that the soul perceives only this second sense and cannot perceive what you call "sense data." Psychological perception is always of intelligibilities, forms—what we would nowadays speak of as pure intuition, or as the apperception of physiognomic gestalten. For Plotinus, the soul is affected by sense data only because the soul is located in a body. When you split sense data from meanings, you not only split sensation from intuition, you split soul and body. Only a soulless body, or a soulless psychology, can speak of sense data apart from the image in which the data is presented. You see, the Greeks too had trouble with the word "sense" (*aisthesis*) which meant both sensation and perception. Neoplatonic thought resolved the problem of two senses of sense much as we are doing: by radically distinguishing the two, yet maintaining them together in a single act. So, yes, there is a second sensing going on wherever, whenever, your simple "animal" sensing goes on. Both at once.

But let's examine your charge of paranoic. Certainly, this second sense calls out, as Murray Stein has reminded me, a "hermeneutic of suspicion." One may not impugn to things an only natural, or face, value; this has been condemned as the "naturalistic fallacy." So, inasmuch as everything manifest is suspect, our second-sensing is paranoic ("suspect" = "below-looking"). It is paranoic, too, in that the activity of sensing implications is basic to image-making: we can hardly point to something as an image unless we mean that something implies. Indeed we do build images out of naive events by paranoic means: suspecting, supposing, implying.

But in a far more essential way, the act of second-sensing or metaphorical insight is not paranoic. The act does not dissolve what is there, the image, into what is not there, a meaning. The cave is not transformed, but remains a cave, sloping backwards and downwards. We hear the implications of standing in this cavern, feeling its gravitation into depth and backwardness, sensing the inclination in the ground of our stance. This significance emerges without exchanging the image for a hermeneutic about "the ground of being," "regression," "the mother's womb," "the unconscious," or even into phenomenological "caveness." We are not putting the cave into any symbol system—for that is where the truly paranoic begins. In fact, by keeping the significance right within the "sense data" of the image, the second sense embedded in the first, we avoid the paranoic literalization of

meaning as a plan or plot at which the image hints. Our kind of sensing is a precautionary therapy against a more severe kind of paranoia: systematic interpretation. Like takes care of like.

Those literary critics who are "anti-metaphor" are probably worried by this same paranoic question that you have raised, Protestor. They too protest that since poems consist of images, why read them for metaphors. Why paraphrase a poem into meaning: paraphrasing = paranoiding, systematic fallacies of one sort or another. Poems don't mean; they are. However, the anti-metaphor campaign has taken metaphor too literally, as if a metaphor really does transfer images into meanings on another plane, whereas I understand metaphor as enhancing the image by hearing and seeing more sense in it. We can amplify an image from within itself, simply by attending to it more sensitively, tuning-in, focusing.

Your defense against paranoia, Protestor, was "sound common sense." You would leave some things as sheer sense data, just as they present themselves to the eyes, ears and nose, our animal perception.

The first move in this defense again splits the word "sense" into two meanings: psychic and natural. Whereas I am insisting that the two senses are co-temporaneous and even co-relative. We get more sense (significance) from an image the more we note its sense (data), and the more it signifies the more it affects us sensuously, sensately, sensitively.

Your second move connects the natural sense to animal perception, the nose. Yet, even smell makes a metaphor of itself, for we can stink from foul clothes and from moral turpitude; we can both smell a fish and something fishy. The modern way of handling this double sense is to explain that the second is transferred from the first. However, the alchemical way, like my way, holds them together: alchemical *putrefactio* is a rotting substance, both natural and psychic at once.

The sense of smell alone may be a better analogy for image-sensing than both seeing and hearing together, because smell is both more concrete, and less. Heraclitus, for instance, considered smell to be the mode of psychic perception (a proposition treated more fully in my *The Dream and the Underworld*). When Heraclitus further implies that the nostrils are the most discriminating of the sense organs, and that the Gods distinguish by means of aroma (D. K. Frgs. 7, 67, 98), he is referring to invisible perception or the perception of invisibles.

Like perceives like: the invisible, intangible, inaudible psyche perceives invisible, inaudible, intangible essences. Sensate intuition or intuitive sensation.

Even the word "essence" has a double sense: both a highly volatilized substance like a perfume and a primary principle, seed-idea, form. Smell involves us in what is most sensate and most subtle; primitive and primordial in one and the same sense. I do believe that the divine mode of the Gods or the underworld mode of souls is not so far apart from what you call "our animal sensing."

Protestor: "You mean to say that we smell images!"

I mean to say that smelling is the best sense analogy for imagining for these reasons: First, we commonly hold smell to be more gutsy than sight and sound. So the sense of smell gives a sense of body-depth to whatever is smelled. By smelling an image, I am implying the image has body.

Second, smell is commonly held to be the most parasitical sense, that is, it has hardly any language of its own—something we already discovered about imagination. Smells, like images, are "reflections," "effluvia:" the odor of a rose, the scent of burnt toast, the stench of a refinery. Odor, scent, and stench have no smell of their own, no content without a particular body. Smells cannot stand alone. They must be linked to an image: rose-odor, toast-scent, refinery-stench. On the analogy with smell, therefore, the sense of an image inherently "sticks to the image" and cannot leave the image without losing its sense.

It follows, third, that a smell refers to a particular image in which the smell inheres. It conjures a unique event and favors discrimination among unique events. If we want to understand an image for itself, we must smell it out. We need a good nose for differences, *diakrisis* of the spirits, that imaginative precision which is the main aim of the imaginal method.

Fourth, smelling images guards us against optical illusions about seeing images. If an image is not what you see but the way you see, then smell reminds us that we don't have to see an image to sense it. In fact, smell reminds us that we can't see them, keeps them deliteralized, like the old definition of archetype: non-presentable form. So, by "smelling" images, we keep the archetypal as an actual sensation in the image, without having to exaggerate this sensation by calling it numinous or tremendous.

Protestor. "All these sensation details. It's like Wundt's laboratory revisioned. Are you sure you're not a sensation type—or is this the compulsion of your inferior function?"

We are all sensation types as soon as we are seized by an image. Can anyone image without sensing? The moment you leave sensing out of imagining, it is imagining that becomes an inferior function: sheer fantasy, mere imaginings, only a dream. Let me go on.

Fifth, smells are all there at once, like images. There is no beginning, middle and end, like stories. We are less likely to read images narratively.

Sixth, unlike the words of our other senses (touch, see, etc.) smell has a "bad" connotation. Something negative, offensive, is carried along with the sense, so that smell reminds us of our native aversion to images. We don't altogether like them. Iconoclasm is inherent to the image itself. The cult and worship of images requires flowers and incense, as if to sweeten (as Adolf Guggenbühl says) what is also inherently obnoxious. There is an intolerable aspect to every image, as image. Its habitation in the undersense of things is their under-world and "death." An image as a simulacrum is but a shadow of life and the death of concretistic faith. Imagining implies the death of the natural, organic view of life and this repels our common sense. Hence, the underworld stinks; dung and corpses; brimstone. Images are demonic, of the very devil; keep a distance. Have a keen nose.

Seventh, the cognition of smell is like a recognition. Smells bring the remembrance of Platonic recollection together with an instinc-tual reaction. Lured by musk, swayed by damp honeysuckle, we respond to the Aphroditic evocation and recognize love arising without previous learning. Reflex and reflection together. The smelled image is both immediate and remembered, both animal and memorial.

Eighth, smells cannot be summoned. Though they may evoke remembrance of things past, we cannot wilfully recollect them as we can a room or a tune. We are subject to them, assailed by them, translated into their world: with one whiff of mixed lavender, cedar, and camphor, I become a little boy excitedly hiding in a chest—imagination utterly beyond control of will. The egoless spontaneity of smell is similar to that of imagining.

Ninth, this spontaneity beyond control of will, however, is not beyond limit. It does not imply imagination as flight into pure possibility, as if one could imagine anything. No, smell is always of

something, so imagining is always held within the bounds of a specific image—this image, right here, under your nose. This is what I mean by "the body of the image:" its particular limits which are its shape and its way of working. If, as Jung says, psychic reality is simply that which works in the psyche, then what does this working, and always in a specifically patterned way, is the body of the image. Images don't work for us when we cannot sense their body. And it is our nose that reminds us that images have bodies, are animals.

Protestor. "If I take you seriously, it would mean that images are actually perceived by an animal nose at an instinctual level, and that they must have, in some sense or other, an animal body. Aren't you merely elaborating what Jung always insisted upon: images and instincts are inseparable?"

Let's leave it right there: images as instincts, perceived instinctually; the image, a subtle animal; the imagination, a great beast, a subtle body, with ourselves inseparably lodged in its belly; imagination, an *animal mundi* and an *anima mundi*, both diaphanous and passionate, unerring in its patterns and in all ways necessary, the necessary angel that makes brute necessity angelic; imagination, a moving heaven of theriomorphic Gods in bestial constellations, stirring without external stimulation within our animal sense as it images its life in our world.

Protestor. "Preposterous! Must you go so far out?"

Not far out—here and now. Don't you see that I am protesting against all notions of "mere" sense, as if the senses were inferior, chaining us to a concrete, literal, mundane world, a physical world without spirit, a body without soul. Descartes. I am also trying to restore to us the animal of "sheer" sense who has been banned to the laboratory and jungle, leaving us without imagination. To restore our earth to a ground in creative imagination we must re-imagine the creation. To recover imagination we must first restore the preposterous sea-monsters and every winged fowl and every thing that creepeth. Only the animal can answer Descartes. Imagine—the subtle body is our brute awareness, and angelology, a logos of animals.

This chapter has been so difficult because we have been working within the region of the *opus major*, the grand conjunction of body, soul, and spirit. What holds that conjunction of concrete sensation, psychic image, and spiritual meaning is *aisthesis*, which denotes originally both breathing in (smelling) and perceiving. I am saying that when we

walk through the world aesthetically, then we experience images like breath through the nostrils, a reflex consciousness on which life depends. Instead of the search for meanings, the perceptive sensitive response which transforms events into images. This *via aesthetica* would be what is meant by "living psychologically:" the undersense returned from symbolism and from paranoic meanings to the significance of the senses. A significant life does not have to "find meaning" because significance is given directly with reality; all things as images make sense.

The old dictum—nothing in the mind that is not first in the senses—can be affirmed as it is deliteralized. For it means that the mind is primarily aesthetic. As well as Apollonic reflection (leaning back and away, distancing), there is another sort of attention, moving closer to sniff, discrimination with the eyes closed as in music and prayer and kissing, as in remembering. Close noticing.[1] This approach to living psychologically reconnects us to the ancient meaning of psyche as a breath-soul of the head whose passages were the nostrils.

Does this not rekindle your animal faith in the image? To our animal faith, the image is simply there, living, moving like the airs we breathe, whether we believe in it or not, whether it numinously nods or not, whether we understand it or not. Release from *pistis*—"I don't believe in these things; fantasies only; I make them up myself." Release from symbolic hermeneutics—"I must find out what the image means; interpretation, understanding." Instead, aesthetics; and rather like the "mythical realism" of Boer and Kugler (*Spring 1977*). It seems aesthetics is the *via regia*, if we would restore our life in images and work out the appropriate method for the poetic basis of mind, mind based in fantasy images.

[1] Persephone's reaching toward the fragrant flower when Hades suddenly irrupts can be read as her move into deepening the senses which brings him forth. It is her movement toward the under-world mode of perception, smell, a delight in the discrimination of essences. The aesthetic, too, opens into the underworld.

Editor's Note

In this wonderfully clear essay, Mary Watkins demonstrates that many of our usual approaches to the image (taken here in the context of art therapy) often negate and limit our relation to the imaginal. She also offers some extraordinary examples of how to relate to an image in terms dictated by the image. We can thus see in her work a beautiful blending of Berry's "*via negativa*, a psychology of the image proceeding from a recognition of unsuitable moves," and Hillman's *via aesthetica*, psychological life proceeding by and through image-sense. Watkin's task is the abiding task of archetypal psychology—how to do right by the image by taking our theoretical and practical leads from the image itself, just as it is.

Usually, says Watkins, it is we who get in the way of the image. We either use the image as a fulcrum for diagnosis, or view it as dangerous, or attempt to treat it according to preconceptions that "have not arisen freely from the dialogue between the image as it is and our theoretical framework." Another mistake, more subtle, has us laying ourselves bare before the image in an attempt to experience it in the raw, thereby foreclosing reflection and insight.

An alternative approach, says Watkins, "understands the particular image which arises as the best possible way of representing meanings as yet unknown and not fully grasped." Watkins would give priority to this image, seeing that "its specificity lends us the imaginal background to [every] experience, thus raising the dayworld onto the plane of metaphorical meanings." Echoing Hillman's "image-sense" and Corbin's "*mundus imaginalis*," Watkins concludes that "[a]s image and experience interpenetrate, the image is not discarded but becomes an eye through which one perceives and senses."

Watkins does her best, which is considerable, to proceed with the image according to its own dictates and desires. Pay close attention to the examples she gives and how carefully she works. From the outset, note how genuinely interested she is in the image just as it is. Note how she leaves it to the image to determine how, or even if, things proceed. And pay special attention to how she remains passionately engaged with the image while respectful of its irreducible mystery. The self-effacing quality of her interpretative self-awareness offers both theoretical precision and practical wisdom, a precision and wisdom nurtured by an unwavering trust in images.

SIX APPROACHES TO
THE IMAGE IN ART THERAPY

MARY WATKINS
(Spring 1981)

To my dismay, I have painfully discovered that there is no natural kinship among psychotherapists who depend on images for their theories or therapeutic technique. No number of annual meetings, foundings of new journals, societies or departments based on the image will create such a kinship. Use of the image does not form family ties among such diverse orientations as behavior therapy, Jungian therapy, guided daydream therapy, psychosynthesis, psychodrama, Freudian therapy, gestalt therapy. Nor does the explicit founding of a single kind of therapy (for instance, art therapy or sand play therapy) coalesce its group of practitioners. Within it there will be radical differences in the approach to the imaginal.

Let us look beneath the disguise of family resemblances, and list a number of theoretical allegiances one may serve in so-called "working with the image." Though these distinctions can be used whether we work with our own images or dream and fantasy images of patients, we will choose the images in art therapy as an illustration. Each of the six approaches to the image I shall describe has its own history (Watkins, 1976). Here, however, our concern will be with how these approaches negate, limit, or nurture one's relation to the imaginal. My allegiance is clearly with ways of relating to images that allow them to teach both

patient and therapist the depth of meanings—historical, existential, mythical, and poetic—lived by the patient.

ONE

We begin with what we shall call the diagnostic approach. Here the image is not evoked for the purpose of the patient's insight, or from any notion that the experience of an image is beneficial in a direct way. The image is evoked by the clinician for his own understanding and is elicited often before the beginning of treatment or when treatment has gone awry. But it is not felt to be part of treatment. The power of art to express psychodynamic issues and developmental level is so well accepted that using pictures to diagnose and form a treatment plan has been virtually co-opted by the psychological tester in her Draw-a-Person tests, Kinetic Family Drawings, tree drawings, etc. When art's contribution is narrowed to diagnosis, the art therapy room is drained of much of its vitality. There is little interaction with the patient around the drawings. The paintings are confiscated by the art therapist for analysis. Though the insights derived find their way into the psychologists' diagnostic reports, the images are discarded. The rhetoric of clinical reports has largely banished the language of images, for fear of fostering that culprit of pathology: so-called primary process, mythical or primitive thought. Roy Schafer (1976: 168, 175) is the border guard here, arguing that through our metaphors and images

> ...we introduce primary process modes of thought into systematic thinking, and so, as we do in the spooky theory of introjects, we contaminate the explanation with what is to be explained.

> A soulful language cannot help us understand all we wish to understand about "soul," "soulfulness," and, in Schreber's phrase, "soul-murder"...

As the language of image is "raised" to the level of abstract thought, the precision of the image is lost. The image of dry, wintry bleakness, of a tree without leaves in a barren landscape, and the image of a dark, rough sea with growing storm clouds of purple and gray are homogenized when "depression" is the insight digested from these startlingly different pictures. Unfortunately Jungians too betray the image through their own brand of diagnostic reductionism. Here radically different images are subsumed under a single category—whether "anima,"

"negative mother," "shadow," etc. Once adopted these terms too erase the particularity of the image artistic effort has been at pains to present.

Given the richness of her medium and the sensitivity of her eye, the art therapist may understand the patient more subtly than the psychologist or the psychiatrist. But as long as diagnosis is the aim, the possibility of working therapeutically through the medium of art is minimized. Where diagnosis is the prime concern, artistic productions fall prey as utterances and interactions to a point of view which assesses weaknesses and not strengths. The image merely expresses symptoms, deficits, and madness in one guise or another. The image can only be evidence to support one theoretical construct rather than another, one characterization of development over another. The particularity of the image is not allowed to create its own phenomenology of the patient's world, or to suggest a possible development inherent in its own structure. When this is the case (and I would argue that much of the art-therapy literature deals with this diagnostic concern), art therapy has betrayed itself by letting its diagnostic efficacy be the only avenue to respectability within the psychiatric hierarchy. When one focuses on how art can be used in diagnosis or to evaluate developmental phase, one obscures how art itself can aid development (not just assess it), how it can create conceptualizations (not be reduced to them), can form the substance of therapy (not only pave the way for it or be adjunct to it). Too often our intellectual curiosity sharpens our diagnostic skills and diverts us from therapy, so that as the patient passes through the hospital, special school or residence she is diagnosed by everyone and treated by no one. For all its value the focus on diagnosis can create a distance between art therapist and patient that precludes direct and prolonged involvement with the disturbing images that often arise during a period of crisis. The reasons such distance may be preferred (or unwittingly encouraged) are indeed complicated. But one contributor—an essentially negative view of images and of the "unconscious"—leads us to a second basic approach to the imaginal.

TWO

This second point of view envisions the unconscious and its products as dangerous. Asking patients to open themselves to the imaginal level of experience is tantamount to offering a system of delusions, encouraging a schizophrenic break, aligning therapy with

the worst and weakest in the patient rather than with ego strengths
and defenses. The lines in this war of theories are clearly drawn. In
some settings, a blatant feeling of the irrelevancy of a patient's images
disguises a deeper fear surrounding the imaginal. If the images can
be kept in the basement, so much the better. If medication is needed
to achieve this, it is given without question. If art is included at all in
places taking this attitude, it is merely occupational, like playing bridge
or shop work—something to keep the patients busy, to keep their
minds off the images which distress and disturb. Crafts or represen-
tational art may be emphasized, but not art that reaches toward fantasy.
More often it is not given a place. This position is easy for us to fight.
Most of us would deny any relation to it. But no sooner do we
congratulate ourselves, than its close relatives arrive at our door claiming
our kinship after all.

 Art-therapy books are full of cautions against the use of art
therapy for various kinds of people—usually those most disturbed
by their imagery. In these cases, art is given credit only for evoking
imagery in a person already overwhelmed with it, rather than credit
for the boundedness that expression of an image through a concrete
medium can give. Art demands an alertness, an activeness, an atten-
tion to materials and to aesthetic concerns.

 In the second view, images are conceived as positive in most cases,
but as negative when the boundaries between real and imaginary,
between conscious and unconscious are considered too permeable.
On that border are those clients who are often the ones struggling
hardest with images. It is quite a trick to practice therapy while
pretending you can steer persons away from the very images that
most preoccupy. With more disturbed patients we need to recognize
where our hesitations to work with images come from to gauge if we
believe involvement with their most disturbing images would be "over-
whelming" for them, or because we are not sure how to receive them,
and help patients work with them. "Being overwhelmed" is itself
an experience which comes in different images: being raped, tidal
waves, drowning, quicksand, dissolving. The one being overwhelmed,
while most often painted as an innocent victim of alien malevolence,
can also take many faces: denying fighter, passive limp surrenderer,
bitter vitriolic victim, etc. In image-work when a person enters into
the experience of "being overwhelmed," we want not to stop images

but to find the one which gives form even to this experience. Whom do they feel like? Who do they imagine me as: malevolent overwhelmer? withholder of salvation? anxious mother rushing to protect? What image precisely expresses the particularity of this psychological experience? (The fact of making the image precise can make it less overwhelming.) There are practical ways to help people feel safer working with images, but these should not replace an attempt to make imaginal whatever experience tends to disrupt the work.

You can remind the patient that she can always put the image-work aside for a while, suggest media that give expression to the image so that it is both externalized and communicable (painting, writing out dialogues with characters, etc.), or limit the time spent on such work at a sitting. For some people these bounds can make the experience feel safer, while still allowing the person access to her own experience. Again, though, one needs to work with the images around "unsafeness" and "safeness." We mustn't rush to reassure when we are not at all clear about the psychic landscape that has given rise to these terms.

THREE

Here the imaginal is recognized and encouraged to come into the clinic or special school for the sake of treatment. Notice that the image is beckoned in order that it may undergo therapy. The image does not heal; we heal the image. The art therapist suggests another color to the child than the black he has used for the last four pictures. One gives less attention to pictures with disturbing imagery and prefers to concentrate on ones that express so-called "ego-strength," or one emphasizes what is considered to be "positive" in the picture (the green bud, the emerging light, the centeredness, the balance of opposites, etc.). For instance, in Edith Kramer's classic book, *Art As Therapy With Children* (1971), a picture of a giant (which actually expressed more of the child's impotence and emptiness than his ego-strength) was placed rather quickly into a drawer until the child, Kenneth, could one day give the giant the strength usually expected from such beings.

Let us not turn aside from Kenneth's giant (see Picture 1).

> *Kenneth*: Kenneth, a six-year-old abandoned child who had knocked about in many foster homes, was much given to

grandiose fantasies that consoled him in his isolation and
helplessness. One day he wanted to paint a picture of a
giant "as tall as the art room." He climbed a high closet
from which he could reach the ceiling and measured out
a long strip of brown wrapping paper reaching from there
to the floor. While he was measuring, Kenneth declared
that he wanted all the colors because the giant would be
very beautiful... He chose black crayon and at the top of
the paper drew a life-sized head with faint features. Then
he drew two lines reaching from the head down to the
bottom of the paper, representing legs and body at once.
In the middle of this configuration he placed a small rect-
angle—the "penis"—above it a tiny circle—"the
bellybutton." That was all. I asked Kenneth if the giant
would have arms. Kenneth did not respond. I offered him
a tray full of "all the colors;" he did not take them. There
was a moment of sadness. Both Kenneth and I knew that
there was nothing we could do. To urge him on would
only have deepened his sense of defeat. We rolled the
paper up and put it away with Kenneth's other work.
Maybe a time would come when he would have the inner
strength to paint it. (Kramer, 1971, 29-30.)

Kramer realizes that this giant expresses much of what Kenneth
feels—a creature created to be powerful but who is unable to fulfill
this role. It shows how Kenneth may experience a split between whom
he is supposed or wants to be and how he feels inside.

Is there not a way in letting this story be told and showing empathy
for this predicament that Kenneth can leave the art room more
"developed?" How might we go about it? Young children are ready
to give a story to almost any set of lines or formless colors. For the
child the scene he paints is not a static snapshot of a single moment,
but contains the past and future of its characters. To test this, one
need only show interest in the child's picture; soon enough one finds
oneself confidante to an amazing session of story-telling.

I would help Kenneth say something about where the giant is,
how he feels, what he is thinking about and doing, how he spends his
day. I am interested in Kenneth's giant and I show it. If Kenneth's
conflicts are close to his awareness, I might empathize with how hard
it is when others want you to be a giant, or when you feel you must be
the one to take care of things, to be protected and safe. I would be

Picture 1

Picture 2

Picture 3

careful to choose my response from feelings I know Kenneth can have and from what the giant is sharing with us. Or if the conflict is further from awareness I would talk with him about giants' feelings when they are expected to be strong and to scare or care for everyone. I would restrict our talk to giants, focusing attention on the imaginal scenes and figures that preoccupy him. I want to keep the giant out of the drawer and let him have space with Kenneth and me. I might join Kenneth in speaking to the giant. When we play a game or talk about home, where is the giant? How does he feel? What does he think?

In fact, when an image like the giant is central you may encourage a series of pictures and stories about the life and times of this charac- ter. One four-year-old boy began unprompted to cut out pictures of characters he had drawn so they could interact with one another. He had me keep them during the week and at the next session would eagerly pull them out for yet another play. While such figures may arouse fear, sadness or anger, finding ways to relate to them inevitably arouses one's liveliness. Let us remember that this liveliness is not a Pollyanna gloss imposed by the therapist, with suggestions of super- ficial change in the image or the favoring of one over another. It evolves from a relation to the image as it is, as it presents itself.

In this third type of treatment attitudes toward the image, the tendency is to look for the positive in the picture, even if this means staring through what it presents. There are certain notions of what good and bad images are—light is good, dark is bad. The therapist treats the person by ridding him of the bad image and implanting or encouraging positive ones. This finds its most suspicious expression in techniques that do not allow the person to draw what comes spon- taneously, but ask for a particular family of images (like mandalas). Guggenbühl-Craig labels these as efforts to "sweeten the image" (1977).

This approach includes intervention toward making images correspond to naturalistic criteria. James Hillman has called this the "naturalistic fallacy" (1979: 157, 142). Edith Kramer presents an example of introducing such criteria to change the image from outside.

> *Clyde*: Eight-year-old Clyde, an intelligent, inhibited, and
> depressed child had grave doubts about the size, perma-
> nence, and intactness of his sexual organs, even though
> they were normally developed. Clyde was a good sculp-
> tor. One day he modeled a gorilla, standing upright with
> raised arms, about a foot high. He wanted to give it a

penis and asked me how big he should make it. When I
suggested that he show me what he thought, he shyly prof-
fered a clay sausage the size of an adult penis. I made
him hold the clay penis against his sculpture and pointed
out that it was as big as the gorilla's legs. I asked him
whether he had ever seen a person with a penis as large as
his leg. Clyde smiled, and shook his head. Looking down
on his lap he seemed to ponder the relative size of leg
and penis. Then without further hesitation he sculptured
a very life-size sexual organ in a state of erection, com-
plete with testicles. (Kramer, 1971: 34-5.)

Kramer claims that her response was helpful insofar as it led Clyde to
ponder the relative sizes of penises and "demonstrated to him the
absurdity of his first idea." She claims that had she "encouraged Clyde
to stick an outsized penis onto his gorilla, this would have aggra-
vated rather than allayed his anxieties" and he would have seen his
therapist as "seductress and a fool."

Is what Kramer imagines necessarily so? What if Clyde had been
encouraged to give the statue the penis he felt it required and to
express how this creature felt? You can give the child information
about reality without restructuring his fantasy. You can allow that
penises are relative to body size and still acknowledge that people
may feel their penis or a gorilla's to be enormous or tiny. We want the
child to understand what goes along with this feeling of having a
tremendous penis. What is the gorilla up to? How would he, Clyde,
feel with the gorilla? What would they do together? We should draw
back from assuming what an image is about. If we do not let the
gorilla and his penis remain as the image dictated, we end up with
understandings of persons that mirror only our "normalizing" pre-
conceptions, which have not arisen freely from the dialogue between
the image as it is and our theoretical framework. We too eagerly
impose our notion of what development of the image would be (i.e.,
an average penis) and fail to follow the line of development suggested
by the image.

One common mistake in dream interpretation and working with
waking dreams is the tendency of the therapist and the patient to side
together favoring one character over another. When the dream-ego
suffers the image of some awful figure, one thinks the solution lies
in ridding the dreams of that figure, by understanding it as some

concrete referent in the patient's history, or by training the dreamer to act differently in the dream. But let us slow down a moment and look at the dream or waking dream less as a narrative where this causes that, and more as an image—where all the parts co-determine each other. If we do this, we will agree with Patricia Berry (in "An approach to the dream," 1974: 99), that

> There is no way I can say this character is a good person, this is a bad one, this figure made the wrong move, or see how unconscious he was. Characters are unconscious. Given the arrangement they all do what they have to do, and given the characters the situation has to be as it is.

Our task is not to criticize one character and praise another. Through painting more pictures and engaging in active imagination we want to understand what the viewpoints of the various characters and landscapes are, and how indeed their modes of being are co-constellated. Hillman and Berry suggest the dream ego often mirrors the ego viewpoint, whereas more unconscious viewpoints are personified in the other characters, who consequently are particularly important to understand.

I argue against this third approach because though such therapy employs the image, its conceptualization of the unconscious stands squarely against an imaginal psychology. Rather than expressing the spontaneous and recurring issues in a person's life, an image is used to introduce a therapist's normalizing goals or the patient's collective ego values. The direction moves away from involvement in the unconscious via the art itself, which results in a basic disrespect for the form in which images spontaneously occur. There is no appreciation of the constructive, purposive or prospective functions of the unconscious. Implicitly fearing imaginal experience, the treatment approach hastens to substitute one image for another, suggesting small or gradual changes (improvements) in an image. Persons are steered away from the images that are their actual and immediate preoccupations.

FOUR

In the psychoanalytic interpretive approach, the latent meaning derived from interpretation is more valued than the manifest image. The image becomes a story to be deciphered into the elements of past life, to which images are believed to refer—particularly to traumatic

events and psychosexual issues. Like Freud's notion that analysis could terminate dreaming by emptying the contents of the unconscious, this approach deals with images as though intending to be rid of them. Imagination itself is placed only in relation to the inadequacies of reality and the strength of one's desires and wishes. The presumption is that were reality more adequate, or the distance between desire and actuality collapsed, imagination would cease to dream. Imagination is a way to master, to adapt to, to supplement reality. I don't debate these functions of imagining; they are obvious and important. But they do not exhaust the activity of imagining.

The fourth approach does not claim for art a privileged position among the therapeutic modalities, nor does it grant to art or expressive therapies that make use of the image what is distinctly valuable about them. For one can use behavior in a group, transference, or free association to derive the same psychoanalytic insights. The path, as I see it, proceeds from image to insight and interpretation, from image to actual event, not the other way around.

FIVE

Here the expression of the imaginal becomes curative in and of itself. It is not the interaction between patient and therapist, or the interpretation of the image that benefits the person, but simply his or her "experience" with the image. This view does not benefit from the globality at which its explanation usually stops. What actually is curative, what actually helps is left unclear. Supposedly, one need only allow the "conscious" to be open to the "unconscious," whatever these theoretical constructs point to, for healing to occur. When this is the case the art therapist has the responsibility of creating an atmosphere in which art can happen, particularly art that is expressive of fantasy life. This approach underplays the importance of her ability to understand the picture, to reflect these understandings, and help the patient work with them. Connections between the artistic product and the patient's daily life are not sought. There is virtually no attempt to form an insightful integration of the imaginal and the daily.

A paradoxical effect of this approach is to strengthen the alienation of imagination from "reason," of images from "reality." One is tacitly taught that images occur when one is in a special situation (an art room, at a sand tray, actively imagining, writing in a journal), and

not that art is but a medium to bring forth images already active in
our moment-to-moment lives.

SIX

Our critical comments thus far have hinted at a sixth approach.
Here the image is not merely one more expression amenable to
diagnostic interpretation. Here the image is respected in spite of our
possible fear or doubts. There is not prejudice against certain images
which leads one to suggest changes, substitutions, improvements,
deletions, or to ignore/repress them, or see them as psychoanalytic
disguises for latent meaning. Though the experience of actively
imagining is supposed beneficial in itself, the sixth approach urges
us beyond the simplicity of the fifth.

The sixth understands the particular image which arises as the
best possible way of representing meanings as yet unknown or not
fully grasped. We ask less "What does this image mean?" and more
"What are the images intrinsic to the activities, thoughts, and feelings
I am engaged in?" What images am I in when I feel exhausted, when
I am shy or ambitious, when I am relating to my husband, child, or
my own body? The image in its specificity lends us the imaginal back-
ground to each experience, thus raising the dayworld onto the plane
of metaphorical meanings. As image and experience interpenetrate,
the image is not discarded but becomes an eye through which one
perceives and senses.

Working from this approach the art therapist is far from an
appendage to diagnostic procedures, an arts and crafts clean-up lady,
a sanitizer and straightener of images, a watchdog for impending
fragmentation, or a kind, friendly presence while one paints and draws.
She is someone alert not just to the literal image which is drawn, but
to images in the patients' gestures, tones of voice, ways of interact-
ing, presenting complaints and history. Through this alertness she
helps the patient interact with the image being expressed in order to
see more metaphorically his or her daily struggles, fears, and preoc-
cupations. Her questions and suggestions are aimed at extending the
presentation of the image as it is, and in helping to establish a way of
reflecting on images such that they begin to move the imaginer from
the figured page to an awareness of multiple moments when an image is
being lived. The art therapist should attend to the structure of an

image, so that its myriad details are seen not as random expressions, distortions, or disguises, but as necessary to the precise meaning of the whole image.

When, for instance, a child refuses to go to sleep at night, kicks, screams, and protests, keeping not only herself but all others awake, we want to know, and to help her know, what this "going to sleep" is really about. For suddenly or gradually the situation of going to sleep has begun to take on different meanings, until our talking to her about going to sleep is not at all what she is concerned with, though she would be hard pressed to express in words just what that latter is. An eleven-year-old with a long history of illnesses, operations, of non-compliance with medical procedures that could end in shortening her life, began having trouble retiring after four months of hospitalization in a residence for children with psychological problems which exacerbate serious physical illnesses. She would refuse to go to her room. When forced she would wake the other children and involve them in her antics. She would engage in physical struggles with the staff and create distress for all. The most she could say to me, her therapist, was that she felt at these night times as though the nurses' station was too far away and they probably would not hear her if she called. She could not say why she might want to call, what she thought about during the fall-asleep time, or why her activity escalated in a way atypical of her. One day during this period she introduced into her squiggle drawings the theme of a child lying in bed at night.

Let me tell you a bit about how I proceed with children's squiggle drawings. I follow Winnicott's suggestion, combining these drawings with mutual story-telling. One person makes a squiggle on a sheet of paper with eyes closed. The other person looks at it, imagines what it might be and completes it. Then the process is reversed, and the second person makes a squiggle. When we have four to eight squiggles, the child and I select a few of the pictures and we tell a story together about them. We may pretend that they are illustrations to a book we are writing together. Some children will dictate to you from beginning to end their own story. Others will write a story themselves only if you look away from them and keep busy writing one yourself. Usually you can alternate sections. You as therapist can use your turn to encourage the child to say more, to focus on the feelings of a story character to articulate the underlying mood, or bring the child's

attention back to an element of the story she is ignoring because of its difficult nature. In sum, one tries to deepen or extend the child's own line of imagining rather than suggest alternatives. Children will almost always fill an empty space in a narrative. If the child says, "The grasshopper was looking for food," you can respond, "and he looked here and he looked there before…" and leave a space for the child to continue the story.

With this girl the following pictures were named and finished by her: a mushroom, a worm, a necktie, a mother bird and her baby, and a boy lying down in his bed (see Pictures 2-6). She was amenable to our using her pictures to write the story. I took the lead and began the story using her picture of a boy lying down in his bed. I wanted to help her bring forth the images around this situation of going to bed.

> *Therapist*: Once upon a time there was a boy lying down in his bed.
> *Child*: And the mother bird was singing to her baby bird.
> *Therapist*: And the boy heard this and it made him feel…
> *Child*: Lonely. And then he saw a necktie on the floor and he picked it up and wore it. It was his Dad's.
> *Therapist*: This necktie reminded him of his Dad, and when he thought about his Dad, he felt…
> *Child*: A little better. And then he found a worm and picked it up and gave it to the birds and they were singing and they were happy that the boy gave them a worm because they were hungry.
> *Therapist*: But the mother bird and her baby were thankful to the boy and wanted to do something to make him feel better. And so, they asked what they could do for him.
> *Child*: He said, "Do you know where my father is?" And they like tweeted. And he said, "Could you try and find my father because I don't know where he is?"
> *Therapist*: At this point, the boy felt very sad, and he began to cry, because he missed his father and didn't know where he was.
> *Child*: And then the birds went to go and look and found him. Then the boy whispered in his ear and said, "Let's do something to help the birds."
> *Therapist*: The mother bird wondered if the father knew how much the boy had missed him, as he had lain awake in bed that night.

Picture 4

Picture 5

Picture 6

> *Child*: And then the boy found a mushroom and gave it to
> his father.
> *Therapist*: He wondered if his Dad would go away again
> and the mother bird knew that this was what he
> was worried about.
> *Child*: And he knew his father wasn't going to go away
> again and so he lived happily ever after.

There is much one could say about these pictures and this story. Her mood changed as we completed the story. She appeared relieved, playful, closer to me. Indeed, as in the fifth approach to the image, the experience of the image emerging and developing already produced a positive change in her mood. This was so in spite of her involvement in a painfully disturbing issue—not knowing where father is. Her knowledge that she was opening to what the problem around going to bed was—not just with me, but with herself as well—brought relief. She seemed proud of herself, as she did on occasions in the past when she allowed some psychological work to occur. She wanted to make photocopies of the pictures and story for me. She took the originals into the hall where she lived, reading the story with great animation and pride to the staff and a best friend.

If we try to learn from the story and its pictures what image she was in at bedtime, we can say that going to bed was a time of being a virtual audience to other small creatures being mothered, though left out herself. She felt lonely. If we follow the story along, however, we find a number of transformations which occur in this initial situation. It is important to emphasize that these transformations are not gained by alterations in "reality"—in her relations with her actual family or the milieu staff. They occur spontaneously through her involvement with the images.

For the boy lying down in bed is a time of mother bird singing to baby. It is not his mother singing to him, but rather he is a lonely spectator to this mothering of which he is not the object. From this lonely feeling he is able to find a father-thing and to bring this near to himself. While baby bird is sung to by its mother he puts on Dad's tie, becomes as Dad, and feels "a little better." Once as Dad, or when in Dad-likeness, he is able to perceive the others' hunger—yes, hunger in even those that have mother's singing. He is able to find a worm, some food, and give it to them. And in his doing so, mother becomes

not the only one to sing; the baby sings as well. In the boy's being like Dad, the characterization of the baby bird has deepened from a passive and presumably gratified recipient of mother's melodies to being also hungry. Hungriness, loneliness, is no longer perceived in just the boy. The boy is not only able to perceive this hunger in others but to act on it as "giver"—indeed, he is able to give even to mother. When he gives to the birds he can address his not knowing where his father is, and he can ask for help in finding him. The father is found by the bird friends, and the child once again wants to give gifts—first to the birds and then to father. Being like Dad and finding Dad bring out feelings of his own abundance, which stands in genuine contrast to his initial loneliness and deprivation. This dramatic sequence not only helped to lift the going to bed difficulties onto a more imaginal level, but enabled the child to move on this level.

Problems with the literal father and with the staff's understanding of the dynamics of the child's bedtime struggle needed to be addressed, as her spontaneous conversations afterward showed. But in the dramatic sequence—before any correction of reality with the real father or staff had occurred—we find the image working out its own solutions. Though the explicit focus of the story is the lost father, the boy is involved in much more than this lostness. He has already found ways to be like the father. In the father's absence and in his presence, he wears the tie, he feeds the birds. He also allows himself to ask the birds about the father and try to enlist their help. Given this child's real-life situation, of being removed from her home and placed in the care of others, the step of engaging with the birds as helpers was important. She can communicate with the birds. This move in fantasy was not expressive of her usual indirection in dealing with her needs.

Father-things and the birds enable the child to shift from a position of initial loneliness in the face of others receiving to a more differentiated and articulated self. As the characterization of the imaginal other deepens, so reciprocally does the self's. As baby bird moves from gratified baby to hungry bird to helping and being helped, so does the boy become not only lonely, but perceptive, giving, asking, and grateful.

Is the father's staying only a matter of wish-fulfillment? Or has some shift occurred for her with regard to the feeling of the presence of the father, regardless of static objective circumstances? Was I as

therapist wrong to suggest the boy was worried about the father's going again? Indeed, as I look back on the end of the sequence, the child's concern was with the giving of gifts to the helpers. My intervention perhaps forced her to retreat back to the father, to give him the gift. Perhaps I reinforced her preoccupation with the father when she might have been healthily ready to let it be for then. The sad thing is that I won't know. My own preoccupation interrupted the stream of her fantasy at this point. I can only try to get more out of the way next time.

It is true that the child had serious concerns with her actual father. After this story-telling she became increasingly able to acknowledge her fearfulness that she would never see him again. In his depression, he had confused leaving his wife with losing his daughter, and had not been able to reassure either himself or her of the continuance of the relationship independent of his marriage. Her father needed to be reminded of the importance of his tie to his daughter, and that he could establish a relationship with her independent of the destiny of his marriage. The child needed to hear that her father's leaving her mother was dependent on his relationship to the mother, and not on her—as the fantasy of gifts to the father in the story suggested. Listening to the dramatic sequence helped the bedsettling staff to see more clearly that the annoying and infuriating behavior which at times seemed directed at them could be understood as the child's struggling with feelings of loneliness, of motherlessness, of uncertainty as to where the fathering was. Once they could respond to this situation, by taking time to read to her or talk to her about her day as she snuggled into bed, or enlisting her help with the younger children, the need for punishment ceased.

These attempts to aid the child in her concrete relations are crucial. Unfortunately, as clinicians our focus on them often diminishes our appreciation of what has already been accomplished and experienced through participation with the image.

Aristotle claimed that the best interpreter of dreams was one who could grasp similarities. When we work with images we want to be alert with our patient for similarities and analogies. With the bedtime girl I used the story to focus on bedtime per se, but if we approach any image through analogy we realize that there are many moments when a child is acting as though in that image. For instance, we would

want to be alert to when she "puts Dad's tie on," when she feels all the mother-singing is for others, etc. With adults, you can ask when they feel like or inside a particular image they have presented. They can keep the image close to awareness as they move through the week and find instances of when the world that surrounds them is "as-if" the one in the image. I am arguing against a one-to-one correspondence between image and event. I am arguing for how the image precisely describes different ways of being in the world (and different worlds to be in).

For instance, Boss (1958: 116) writes of a man whose dreams were filled with all varieties of magical mothers. Boss claims that the man had surrendered his existence to being a child and thus he called out in both waking and dreaming life for his world to be peopled with mothers. Similarly, an emotionally detached engineer whom Boss treated dreamed only of inanimate objects and lower forms of life for months. There were no people in his images, as his life was not attuned to them (*ibid*: 113). In this way the image is not discontinuous with everyday existence, but describes in its own way the world of the imaginer.

And what, you might ask, is its "own way?" My answer to this has been to learn from dreams the structure of an image. Note that dreams are essentially dramatic. Though characters may be depicted in a present moment, there are allusions to their past and future. The dream releases us from the confines of daily time and space. One can dream of being in any era, country, time of year or day, type of landscape. The dream can also release us from our habitual identity, attitudes and actions; a woman can be a man; a man a child; a sad person angry. Also when we are dreaming, the dream is not experienced as occurring in our heads, but rather we are surrounded by its world.

An image has a totality to it, such that one part calls out another. A certain character could only have one kind of room to live in, or tone of voice with which he speaks. In a drawing when one part of an image emerges, often a question allows the rest to unfold: Where does this take place? What time of day is it? What does the air feel like? What is the atmosphere of this place? Who is present? What happens here? What just happened? Where are you in relation to this scene? If the picture is of a person, one might ask what he/she is

thinking about, where he/she is, where one is in relation to the figure. One might ask what seems familiar about the person or the mood around the person. One can suggest that the painter step inside the picture, into the place or into a relation with the figure depicted. But always the focus is on the image.

Jung said, "Only what is oneself has the power to heal." From this point of view all the good intentions that attempt to transpose images, to disinfect horrifying ones, close the door to exploring images, introduce positive images—all these seemingly benevolent efforts— sidetrack a person from what has the power to heal. But given the fears and prejudices of much of our discipline concerning the unconscious, how can we be trusting enough to convey to another an openness to images which arise spontaneously and which stand in an autonomous relation to the conscious personality? Perhaps the only way to develop this faithfulness is through one's own experience with the imaginal. Just as analysts are required to experience the entire process of analysis in order to be in a position to help create a narra- tive from the patient's streams of association, we who work with images must stay close to the images that form the structure of our own psychological experience. We must write out our dreams, illus- trate them, speak to their characters, paint spontaneously, seek for the images that determine our responses to others, to ourselves, our patients and our life. It is in this process that we will gain a trust in images. Gradually the small ways we reveal our theoretical alliance to this viewpoint will become more apparent to our colleagues. Gradually too we will betray the people and the images we work with less.

Bibliography

P. Berry, "On Reduction." *Spring 1973.*

M. Boss, *The Analysis of Dreams* (New York: Philosophical Library, 1958).

H. Corbin, *Creative Imagination in the Sufism of Ibn 'Arabi* (Princeton: Princeton UP, 1969).

A. Guggenbühl-Craig, "Summary of a contribution to the Dallas meeting." Collection of papers for a seminar on archetypal psychology held at the University of Dallas, January 1977.

J. Hillman, *The Dream and the Underworld* (New York: Harper & Row, 1979).

C. G. Jung, "The transcendent function," *The Structure and Dynamics of the Psyche* (*CW 8*).

E. Kramer, *Art as Therapy With Children* (New York: Schocken, 1971).

R. Schafer, *A New Language for Psychoanalysis* (New Haven: Yale UP, 1976).

M. Watkins, *Waking Dreams* (New York: Harper & Row, 1976).

D. W. Winnicott, *Therapeutic Consultations in Child Psychiatry* (New York: Basic Books, 1971).

FURTHER READINGS
IN ARCHETYPAL THEORY

Books

•Patricia Berry. *Echo's Subtle Body* (Dallas: Spring Publications, 1982).
•David Freedberg. *The Power of Images* (Chicago: Univ. of Chicago Press, 1989).
•James Hillman. *The Myth of Analysis* (Evanston: Northwestern UP, 1972).
 •*Re-Visioning Psychology* (New York: Harper & Row, 1975).
 •*The Dream and the Underworld* (New York: Harper & Row, 1979).
 •*The Soul's Code* (New York: HarperCollins, 1996).
 •*Archetypal Psychology: A Brief Account* (Woodstock, Conn.: Spring , 1997).
 •*Healing Fiction* (Woodstock, Conn.: Spring, 1997).
 •*Suicide and the Soul* (Woodstock, Conn.: Spring, 1997).
 •*The Force of Character* (New York: HarperCollins, 1999).
•Thomas Moore. *Care of the Soul* (New York: HarperCollins, 1992).
 •*The Soul of Sex* (New York: HarperCollins, 1998).
 •*The Planets Within* (Great Barrington: Lindisfarne Press, 1990).
•Mary Watkins. *Waking Dreams* (Woodstock, Conn.: Spring, 1984).
 •*Invisible Guests* (Woodstock, Conn.: Spring, 2000).

Essays appearing in *Spring: A Journal of Archetype and Culture*
•Charles Boer, "Poetry and Psyche," *Spring 1979.*
•Charles Boer and Peter Kugler, "Archetypal Psychology is Mythical Realism," *Spring 1977.*
•Edward Casey, "Toward an Archetypal Imagination," *Spring 1974.*
•Wolfgang Giegrich, "Killings," *Spring 54* (1993).
•Naomi Goldenberg, "Archetypal Theory after Jung," *Spring 1975.*
•James Hillman, "An Inquiry into Image," *Spring 1977.*
 •"Further Notes on Image," *Spring 1978.*
 •"Once More into the Fray," *Spring 56* (1994).
•Mary Watkins, "The Characters Speak Because they Want to Speak," *Spring 1983.*

CONTRIBUTORS

Patricia Berry is an analyst in private practice in Cambridge, Massachusetts. She is the past president of the Inter-Regional Society of Jungian Analysts, current president of the New England Society of Jungian Analysts, and author of *Echo's Subtle Body: a Contribution to Archetypal Psychology*. She earned a doctorate from the University of Dallas, lived in Zürich (1965-78), and trained at C. G. Jung Institute in Zürich, where she later taught. She has also taught at the University of Dallas and has lectured widely.

Henry Corbin (1903-1978) was Professor of Islamic Religion at the Sorbonne and Director of the Department of Iranic Studies at the Institut Franco-Iranien in Teheran. He was a regular speaker at the Eranos Conferences in Ascona, Switzerland. In the last decade of his life, he founded the Université Saint Jean de Jerusalem. Much of his thought focused on what he called the *mundus idealis*, the world of visionary ideals. His major books and publications include *Avicenna and the Visionary Recital* (Spring Publications, 1980), *Creative Imagination in the Sufism of Ibn 'Arabi* (trans. 1969), *The Man of Light in Iranian Sufism* (1978), *Le Paradoxe du monotheisme* (1981), *Spiritual Body and Celestial Earth: from Mazdaen Iran to Shi'ite Iran* (1977), *Swedenborg and Esoteric Iran* (trans. 1995), *Temple and Contemplation* (trans. 1986), and *The Voyage and the Messenger* (trans. 1998).

Gilbert Durand was formerly Titular Professor of Sociology and Cultural Anthropology at Grenoble and the founder and director of the Centre du Recherche sur l'Imaginaire at Chambéry. He was a regular speaker at the Eranos Conferences in Ascona, Switzerland, from the 1960s to the 1980s. His many articles have appeared in English and French.

Wolfgang Giegerich is a Jungian psychoanalyst and writer in Steinbach, (Munich) Germany. His most recent book is *The Soul's Logical Life*.

James Hillman is a psychologist, lecturer, and the originator of archetypal psychology. He is the author of more than twenty books, including *Re-Visioning Psychology*, *The Soul's Code*, and most recently, *The Force of Character*, plus many essays. He has held teaching positions at Yale University, The University of Chicago, Syracuse University, and The University of Dallas. He was also one of the founders of the Dallas Institute of Humanities and Culture. Formerly he was the director of studies for the C. G. Jung Institute in Zürich and the Senior Editor of *Spring Journal*. He is currently a visiting lecturer at Pacifica Graduate Institute and the publisher of Spring Publications.

Thomas Moore is a writer, scholar, lecturer, and musician. He was a monk in a Catholic religious order for twelve years and has degrees in theology, musicology, and philosophy. A former professor of religion and psychology and Southerm Methodist University in Dallas, he is the author of numerous books and essays including *Care of the Soul*, *Soul Mates*, and *The Soul of Sex*. He is also the co-founder and former director of the Institute for the Study of the Imagination.

Benjamin Sells is a lecturer, lawyer, and sailing captain. He holds degrees in philosophical psychology and law and is a former practicing attorney in Chicago. He is author of two books, *The Soul of the Law* and *Order in the Court*, and numerous articles on imagination and cultural life. He is co-founder and co-director of the Institute for the Study of the Imagination and is owner/operator of Fairwind Sail Charters outside Chicago, Illinois.

Mary Watkins teaches psychology at Pacifica Graduate Institute in Santa Barbara, California. She holds a doctorate in clinical psychology from Clark University and is the author of three books, including *Waking Dreams* and *Invisible Guests*.